pop
sixties

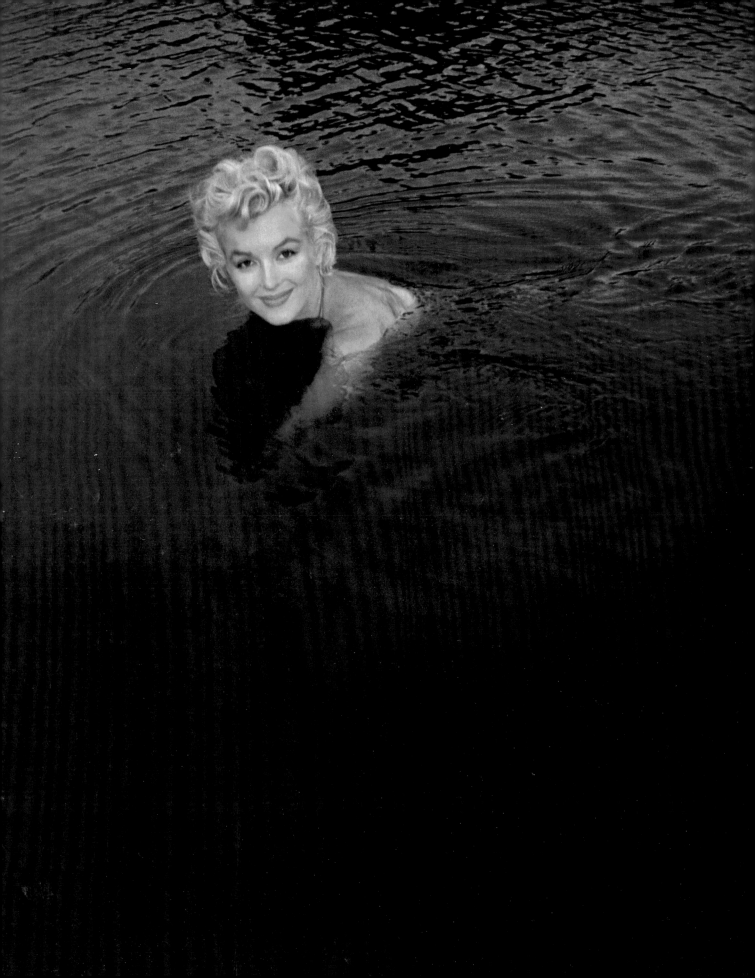

pop sixties

ABRAMS
NEW YORK

MAGNUM PHOTOS

Introduction by ANTHONY DECURTIS

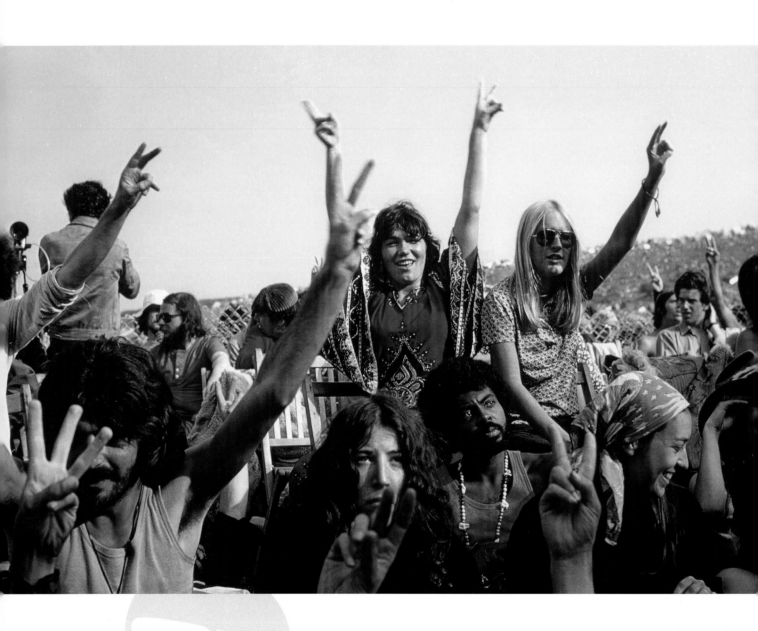

DAVID HURN

Isle of Wight Festival,
England, 1969.

A REVOLUTION IN CONSCIOUSNESS

the pop 60s BY ANTHONY DECURTIS

In his dryly ironic poem "Annus Mirabilis," the English poet Philip Larkin declares that sex was invented in 1963, at some precise moment between the lifting of the ban on the publication of D. H. Lawrence's *Lady Chatterley's Lover* and the release of the first Beatles album. Sex didn't originate in the Sixties, of course, however miraculous those years may have seemed. But from the general availability of oral contraceptives—better known as "the Pill"—to court cases that made it possible for sexually frank novels to be openly sold, barriers were breaking down in every sphere of life, with sex at the very top of the list.

And as sex goes, so goes the nation, at least to some extent. Because like all the cultural currents flowing through that loosely defined era we think of as the Sixties, sexuality both drove and was driven by other changes taking place at the time. It's hard to imagine, for example, more defining figures of the period than the Beatles. Yet in 1987 George Harrison said, "It's a bit too much to accept that we're supposedly the designers of this incredible change that occurred. In many ways we were just swept along with everybody else."

•

Decades can never be neatly defined, and the more multifaceted they are, the less they yield to strict chronology. So when people talk about the Sixties, what are they really talking about? Were the seeds of the Sixties planted with Elvis Presley's cataclysmic appearances on *The Ed Sullivan Show* in 1956? Did they start with the dramatic civil rights struggles in the South? Was it when the Beatles arrived in the United States in February of 1964? How important was the election to the presidency of John F. Kennedy in November of 1960, or his galvanizing inaugural address in January of the following year? In that justly renowned speech he called a generation to social action in immortal, ringing words: "Ask not what your country can do for you; ask what you can do for your country."

And when did the Sixties end? Perhaps with the election of Richard M. Nixon in 1968, or with his reelection in 1972? With the brutal mayhem unleashed by the Hells Angels at the Rolling Stones' concert at the Altamont Speedway in California in December of 1969? With the Manson murders four months earlier? With the shootings at Kent State in May of 1970?

The calendar, clearly, is not the best means of telling the story of the Sixties. That's because what we think of as the Sixties is not so much a specific period of time, but a state of mind, a revolution of consciousness, a conviction that anything was possible. All these years later, it is difficult to convey how utopian the world was back then. The belief that society would radically transform for the better was assumed. Each new breakthrough, each small, positive development seemed inevitable and suggestive of broader, unstoppable changes.

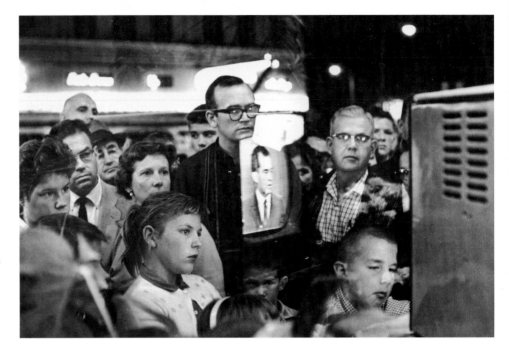

Cynics might see those beliefs simply as fantasies of youth, the accidental function of overly indulgent parents and a booming post–World War II economy. And, indeed, times were good. The baby boom, rock & roll, movies, and the proliferation of mass media—portable transistor radios, to be sure, but television, in particular— helped create a youth culture that not only had different tastes from its parents' generation, but also had the numbers and the spending power to make those tastes a dominant force in the market- place. Television made it possible for those tastes to be shared simultaneously, and unified a generation that might have otherwise been split apart by vast geographic, social, economic, and racial differences.

Far from being a transparent medium, television began playing a role not only in transmitting the essential stories in our society, but also in shaping them. Richard Nixon's five o'clock shadow—a visual metaphor for the shady past of a man who was already known as "Tricky Dick"—would never have been a factor in his close loss to John Kennedy in the 1960 presidential election had not seventy million Americans (roughly 40 percent of the country's population at the time) watched their televised debates. Those broadcast images also established Kennedy's fresh-faced youthfulness and, in what became a jocular catchword at the time because of the senator's Massachusetts accent, "vigah." That Kennedy was barely four years younger than Nixon scarcely mattered. Kennedy represented a new set of ideas, a break from the Eisenhower era with its roots in World War II. And he worked better on TV.

That's not simply a clever joke. As Andy Warhol's bright, shiny Pop Art epitomized, the Sixties were the moment in which the surfaces of things began to matter as much as the depths. For Warhol, the supermarket and tabloid front pages became more aesthetically important than anything that might be enshrined in a museum. It was a prescient view. His repetitive prints of Jackie Kennedy in mourning or of Marilyn Monroe—who died under suspicious circumstances at thirty-six in 1962, an iconic martyr, a pop-culture tragedy— presaged a society that would prove unable to get enough of damaged celebrities, particularly beautiful women. (And we would not even know until later how much those

CORNELL CAPA
A crowd watching the Nixon/ Kennedy presidential debate on television, 1960.

two particular women had in common.) It was a vision that simultaneously worshipped and wrought revenge on the famous, wounded subjects in its unrelenting gaze.

The product of a perfect cultural storm, the Sixties emerged from a confluence of wildly disparate events that created a pop renaissance of a magnitude we had not seen before and haven't experienced since. It was almost a kind of aesthetic defense mechanism in response to events that sometimes seemed to be spinning out of control faster than anyone could understand, let alone chronicle. If the role of artists is to hold a mirror up to the world around them, the world of the Sixties was in no mood to sit still long enough for its image to be passively reflected. The only alternative was to invent new ways to see and hear, new ways to think and move. Artists in every field broke through creative boundaries because an audience existed that was up for anything cutting-edge and vital. Audiences, meanwhile, consistently had their assumptions challenged, their tastes upended and, consequently, broadened and deepened. They expected no less from movies, music, theater, and painting, and they were rarely disappointed.

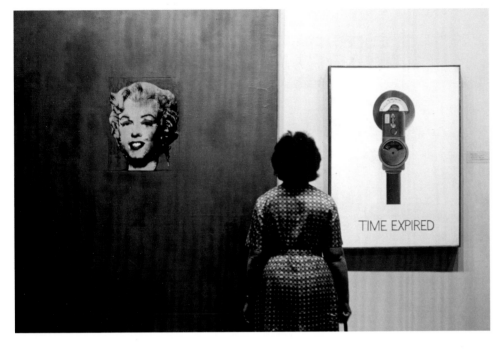

BURT GLINN
The Museum of Modern Art, New York, 1964.

The many glinting reflections of mass media, the movement of our society from a literal to a visual culture, from modernism to postmodernism, created a world of unintended, uncontrollable consequences. Everyone was looking at everyone else at all times— another voyeuristic Warhol insight—and what they saw wasn't exclusively what they were intended to see. Incidental aspects of a life that the public historically had little access to now became exposed to scrutiny. The boundaries between the public and the private, between the personal and the political—distinctions that are essentially meaningless today—began their disintegration in the Sixties.

For example, just as important as Kennedy's inaugural address or any of his policies was the fact that he had a young, beautiful, fashion-conscious wife and young children. We now know all too well how troubled and complex the Kennedys' marriage was. But the images of Camelot that defined his brief presidency set a future-oriented tone of hopefulness and idealism, and helped loose an insurgency that had impacts well beyond anything Kennedy himself might have imagined, or even desired.

It's often been noted that the Beatles' arrival in New York in February of 1964 provided solace to a country devastated by the Kennedy assassination just a few months earlier. But the metaphoric links between Kennedy and the Beatles run deeper than mere temporal proximity. The notion of Camelot, of course, summoned romantic images of England, as the Beatles did. At their early press conferences, the Beatles bantered wittily with reporters,

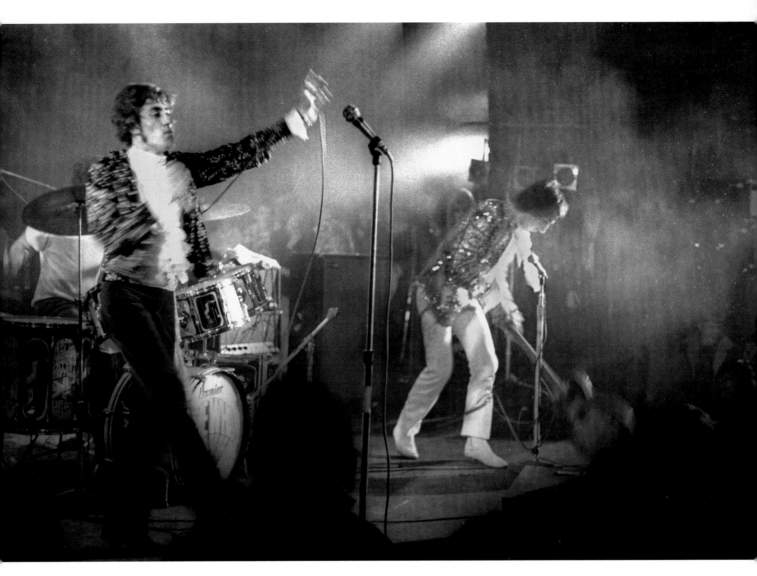

deflecting condescension and outright hostility with cleverness and charm, much as Kennedy did. If the ascension of Lyndon B. Johnson to the presidency seemed a throwback to the Fifties, at least in terms of personal style, the Beatles brought the future roaring back into focus. The floodgates had opened.

The Beatles launched what came to be called the British Invasion. London was swinging, and America began to rock in time. Once again, in a series of unintended consequences, *The Ed Sullivan Show*, about as conservative a variety-show venue as could be imagined, brought into America's living rooms images of increasingly unlikely looking young men, at once scruffy and feminized, who would redefine existing notions of masculinity. When Mick Jagger insouciantly walked onto the stage of the Sullivan show wearing not a suit, not a tie, but a gray sweatshirt, he struck a shocking blow in the generational war that was beginning to break out. Buoyed by the Rolling Stones' insinuating rhythms, which brought black American music back to its homeland, Jagger seemed simultaneously tough and girlish, beautiful and ugly, and exquisitely sexual.

Rock musicians quickly became a new aristocracy, subject to no existing rules whatsoever and inventing whatever rules would apply in the future. Marijuana and LSD

ELLIOTT LANDY
The Who, Fillmore East,
New York, 1968.

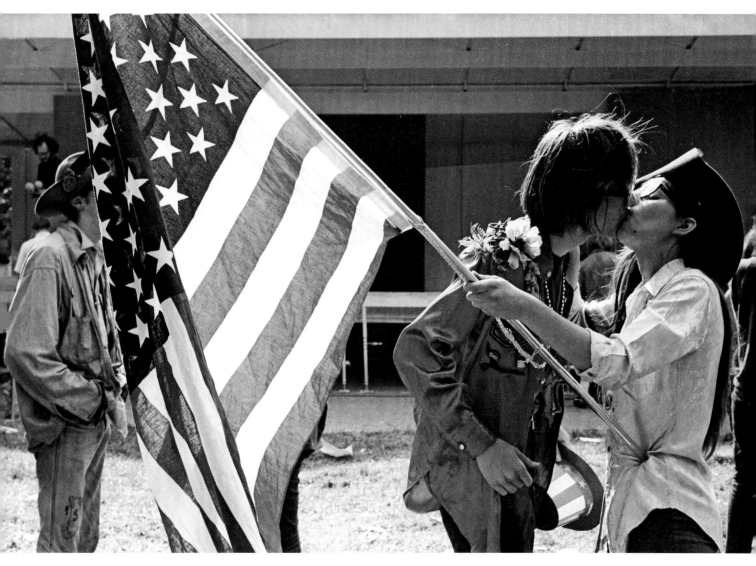

ROGER MALLOCH
Hippie couple,
Chicago, Illinois, 1968.

became inextricable parts of youth culture, and music, movies, and fashion reflected that woozy, brightly colored psychedelic development. Clothes got wilder, more colorful, exotic, and sexier. Hair grew longer, and music got louder. Nudity flourished. Miniskirts, Nehru jackets, Op-Art patterns, and Edwardian styles became commonplace. Fashion trends had historically moved from the top down socially, from older people to younger. The notion of the teenager had gained currency in the Fifties, but it would have been ludicrous to think that adults would have styled themselves after such icons of rebellion as James Dean, Marlon Brando, or Elvis Presley.

The Sixties reversed that process. The sheer numbers of young people created a "youthquake," an eruption from down below that unsettled and reoriented the traditional order of things. Young people became the arbiters of what was fashionable, and parents began mimicking the styles and tastes of their sons and daughters. The "generation gap" cracked open, and "Don't trust anyone over thirty" became a catchphrase. Designers liberated iconic imagery such as military uniforms and the American flag's stars and stripes, and recast them for a generation in rebellion against everything those images stood for. A new army and a new nation were on the rise.

"Bliss was it in that dawn to be alive, / But to be young was very heaven!" William Wordsworth had written from England about the French Revolution in the eighteenth century, and those lines could easily serve as the epigraph to the Sixties. In a way characteristic of all Romantic periods, youth came to seem the repository of wisdom, and aging a continual process of decline— loss of innocence, naturalness, beauty, and vision, all of which the young had in abundance. "I hope I die before I get old," the Who declared in their 1965 anthem "My Generation," one of the decade's harshest judgments on its elders. The song's sentiment was not merely a dewy-eyed wish to stay forever young, but a caustic verdict on the state of the world the young were entering: I hope I never grow up to be like you.

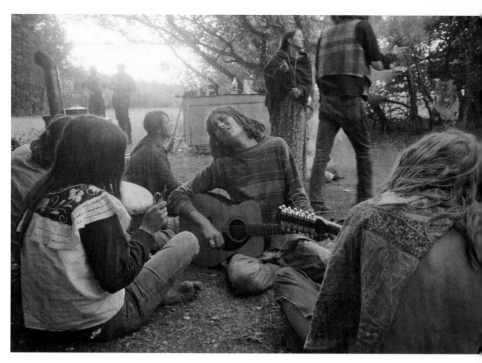

•

All of the changes in the air created a heady utopian atmosphere. It seemed for a brief time as if there was no point fighting against the powers that be. How could they withstand the force of all the good vibes? It was as if young people had come to accept the Marxist idea that the state would simply "wither away," either won over or rendered obsolete by rock & roll, flower power, free love, and psychedelic drugs. The most compelling manifestation of this viewpoint occurred in 1967 with the dawning of the Summer of Love. The Beatles' extraordinary album *Sgt. Pepper's Lonely Hearts Club Band* provided both the soundtrack and the mission statement for the brave new world that was surely to come. That summer the album seemed to be playing everywhere. "I get high with a little help from my friends," the band blithely announced, and legions heard a message of generational unity. "I'd love to turn you on," John Lennon sang, sounding as if he were delivering news from another dimension. His wish expressed the conviction that only cleansing the doors of your perception through drugs could lead you to the new paradise taking shape. There was no war on drugs and no just saying no. The Summer of Love was all about yes!

Young people flocked to San Francisco's Haight-Ashbury, lured by the mind-bending music emerging from that city, and from California in general. It was a resurgence of the idea of California as the pot of gold at the end of the American rainbow, the realization of our country's utopian manifest destiny. The Jefferson Airplane, the Grateful Dead, Big Brother and the Holding Company (and, most notably, the band's lead singer, Janis Joplin), and Quicksilver Messenger Service made San Francisco the nation's most significant hippie ghetto. New York's East Village provided a countercultural anchor on the East Coast, and college towns across the country became liberated zones. The belief was that somehow it was going to be possible to live a generous, openhearted, sexually free, communal life,

CONSTANTINE MANOS
Robert Kennedy on the presidential campaign trail, Philadelphia, 1968.

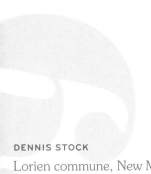

preferably in the country, but even in the heart of massive cities that seemed the very definition of alienation, a term much bruited about at the time. Like the state, those monumental concrete urban prisons would eventually wither away, the gates of Eden would open, and the greening of America would produce a more humane, and human-scale, environment for all.

That moment of transformative hope proved all too short-lived, however. The politics of protest, inherited from the civil rights movement, soon focused on the Vietnam War, which by the mid-Sixties was raging out of control. The draft made the war an issue that touched the lives of all young people, and as Vietnam increasingly came to be seen as a deathly quagmire, the prospect of fighting and dying for no clear reason seemed unacceptable. In its rage against the military-industrial machine, the counterculture became less of an independent alternative to the corrupt mainstream than a frustrated, increasingly violent mirror image of it.

In one of the decade's most stunning contrasts, the Woodstock Festival and the Tate-LaBianca murders both took place in August of 1969. The Woodstock nation and the Manson family rose to public view at the same moment, just as the magical decade was drawing to a close. The apex of the counterculture's vision of a communal way of life and the most horrific version of what such a vision could degenerate into nestled side by side in mud and blood.

The assassinations of the Reverend Martin Luther King Jr. and Robert Kennedy in 1968—grim echoes of John Kennedy's shooting five years earlier—created the sense that nonviolent change was impossible. "Violence is as American as cherry pie," the black activist H. Rap Brown declared, and his sarcasm perfectly caught the cultural moment. The savage attacks on demonstrators by the Chicago police at the 1968 Democratic Convention only reinforced that viewpoint. By the end of the decade, many American campuses were virtual war zones where the battle over the country's future was being fought.

Neither the state nor the infrastructure of the so-called Establishment had any intention

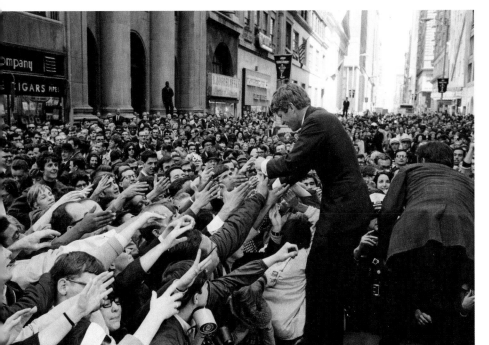

DENNIS STOCK
Lorien commune, New Mexico, 1969.

of withering away, it turned out. Quite the opposite. Working-class whites saw campus war protesters as spoiled brats too cowardly to fight for their country. In the South, particularly, a white backlash against the gains of the civil rights move-ment and the rise of the more militant Black Power activists kicked in hard. Richard Nixon, who had retired from politics in 1962 after bluntly assuring the media, "You won't have Nixon to kick around anymore," won the presidency in 1968 after running on a law-and-order platform.

Nixon and his running mate, Spiro Agnew (both of whom would eventually resign from office in disgrace), stoked the fears of the so-called Silent Majority—that

is, mainstream Americans who, confused by the rebelliousness of their children and shifting racial, sexual, and cultural norms, wanted the momentous changes of the Sixties stopped, and fast. That election campaign set the template for the next forty years of viciously fought culture wars in America. Amid that ongoing struggle, the election of Ronald Reagan as president in 1980 began an attack on Sixties values that persists to this day. In that conflicted sense, as well as many others, the Sixties are as alive now, and as viscerally relevant, as they ever were.

Young people today often look back to the Sixties as a time when things they take for granted in their own lives—fingertip access to music of all kinds, the right to their own culture and style, an endless variety of amusements—had a greater depth of meaning. Many veterans of the Sixties, meanwhile, have proven reluctant either to step off the cultural stage or to acknowledge anything profound or even interesting in the contributions of subsequent generations. Their own experience of the Sixties was so compelling as to drain significance from everything that followed. Ironically, for them, that most forward-looking of eras became an irresistible source of nostalgia. Bob Dylan's dictum—"Don't look back"—was forgotten.

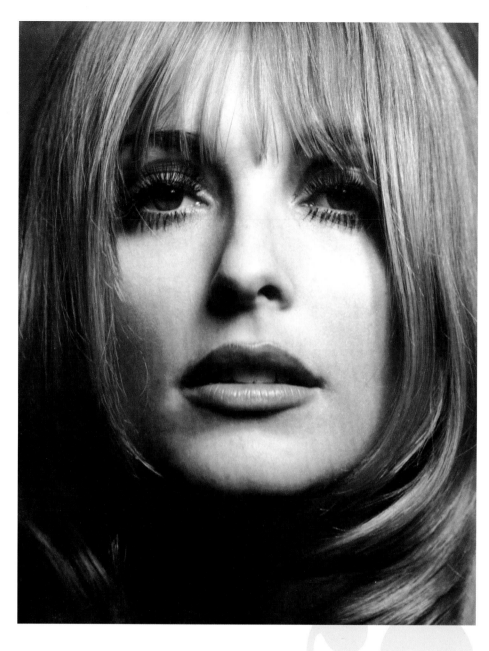

PHILIPPE HALSMAN
Sharon Tate, 1966.

Both views are incomplete, and unnecessary. The Sixties weren't simply *Happy Days* with drugs and politics. And plenty of exciting stuff—some of it even initiated by folks younger than boomers!—has happened since then. But the Sixties was a time when things mattered, and that's what people miss, whether they were there or not. Often vilified for its hedonism, the decade was finally about consequences. Major issues were at stake, change was everywhere, lines were drawn, and it was essential to take a stand. The very survival of the nation seemed in the balance.

In other words, it was a time much like now. That, in fact, may well be the greatest legacy of the Sixties—it was a time so rich and varied, so colorful and complex, so riveting and charged that all eras to come will be able to see elements of themselves in it. Whether what we see is enlightening, frightening, or the distorted reflection of a fun-house mirror will say as much about the times we live in as anything that was going on back then.

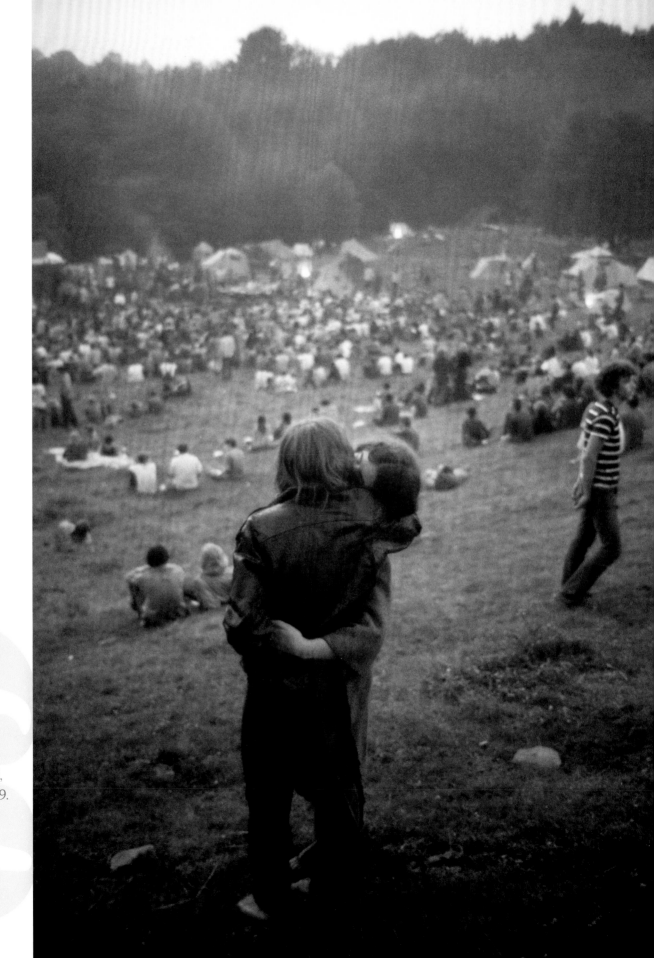

ELLIOTT LANDY
Woodstock
Festival, Bethel,
New York, 1969.

Good morning. What we have in mind is breakfast in bed for 400,000.

HUGH ROMNEY
(WAVY GRAVY)

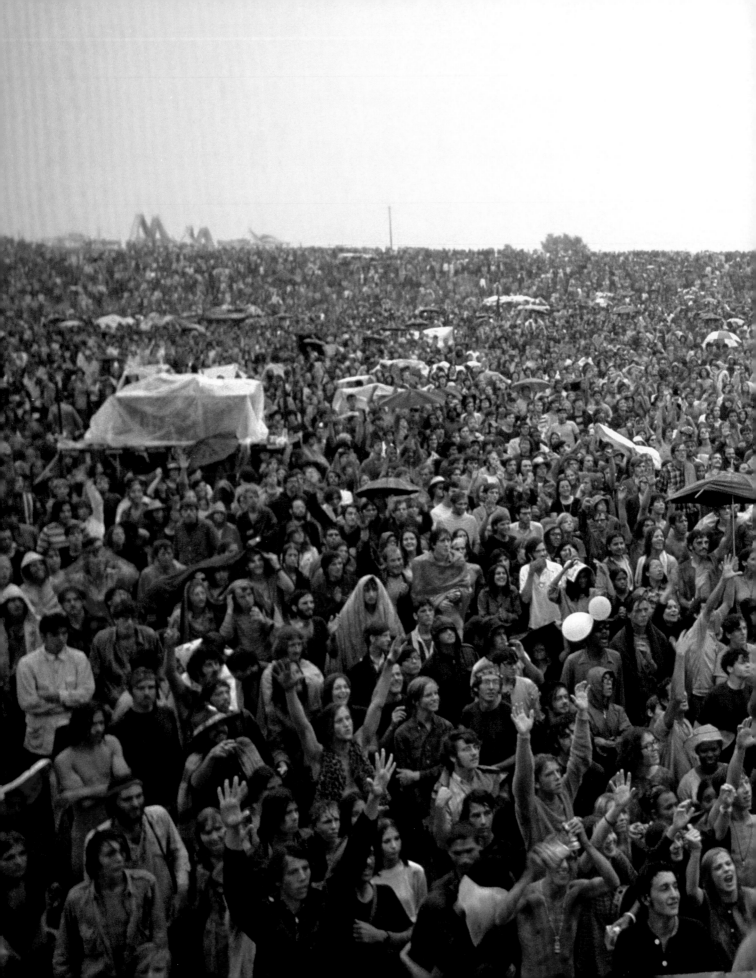

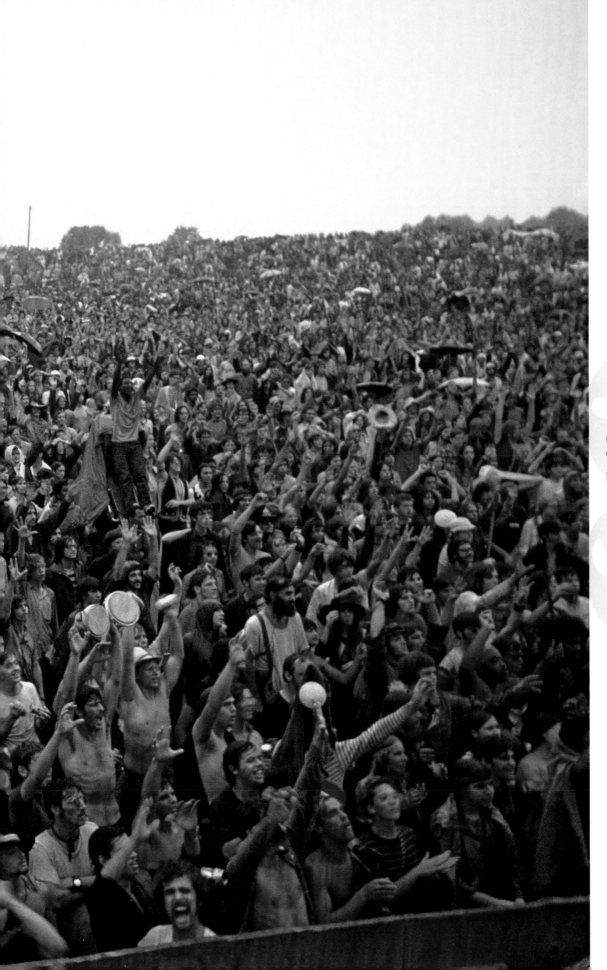

Isle of Wight Festival, England, 1969.

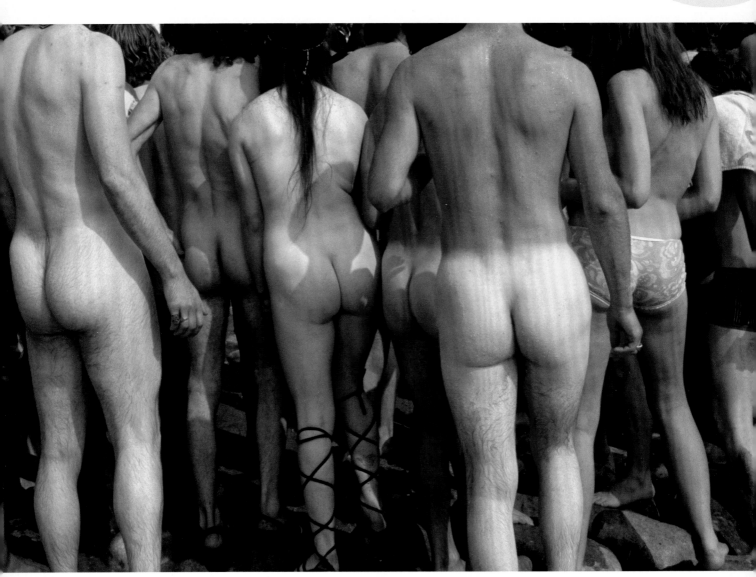

BRUCE GILDEN
Coney Island, New York, 1969.

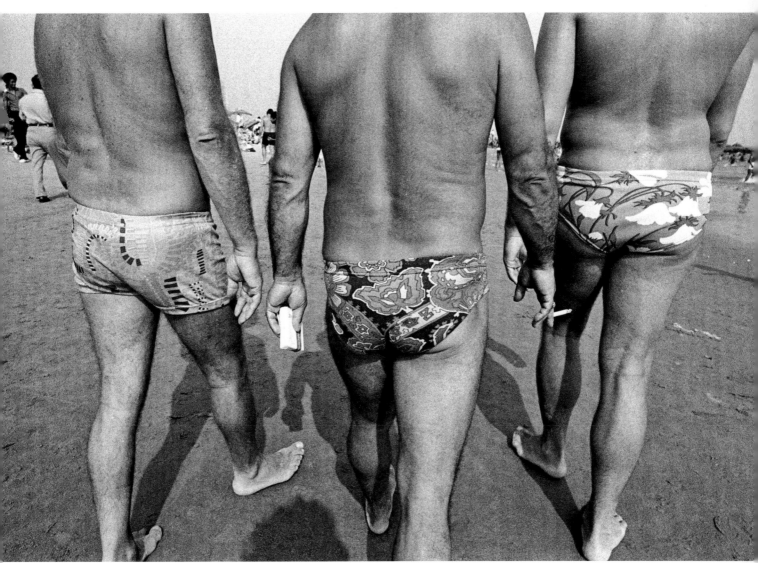

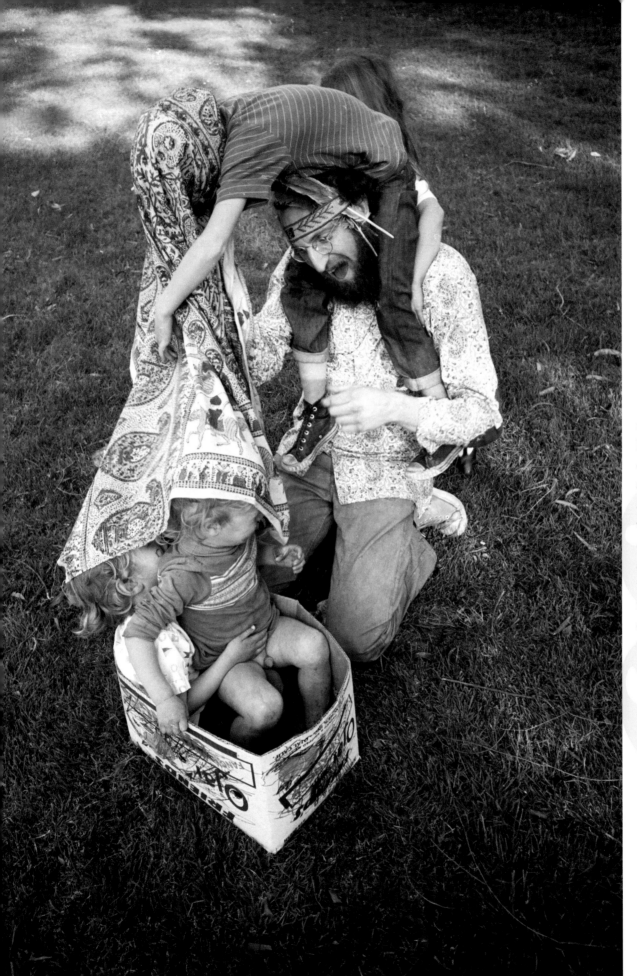

In the latter half of the sixties, a generation with an energy and vision appeared on the horizon— a dramatic force that brought the American conservative scene to a halt, 1969.

Many parents brought children, Isle of Wight Festival, England, 1969.

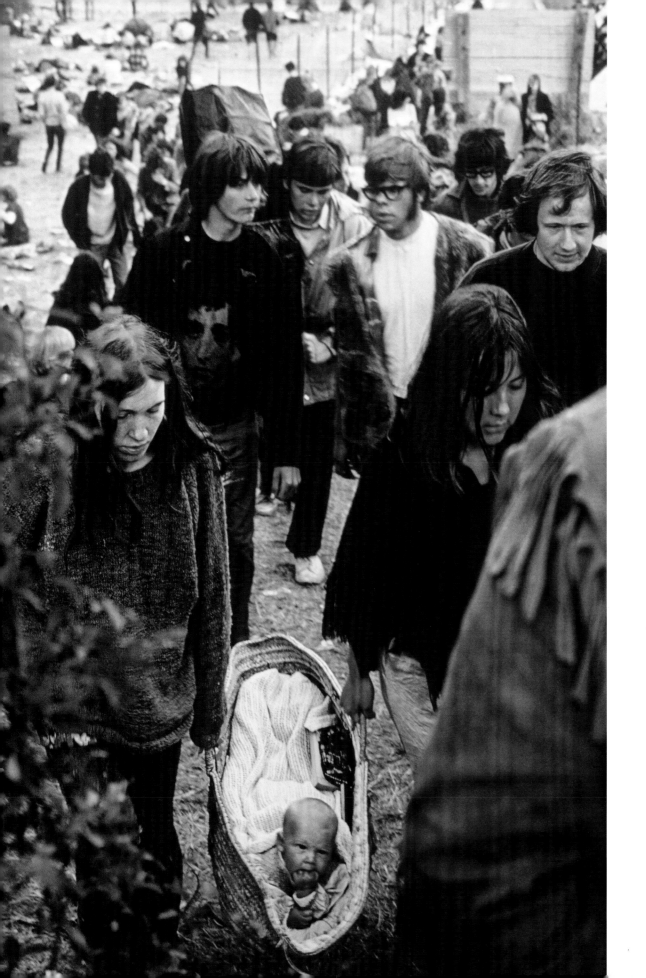

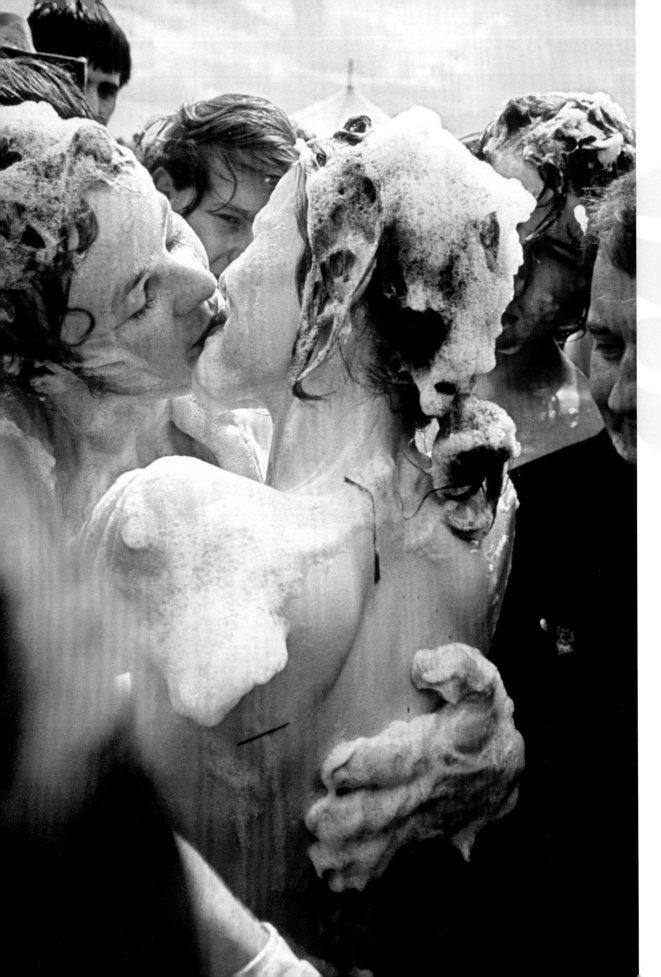

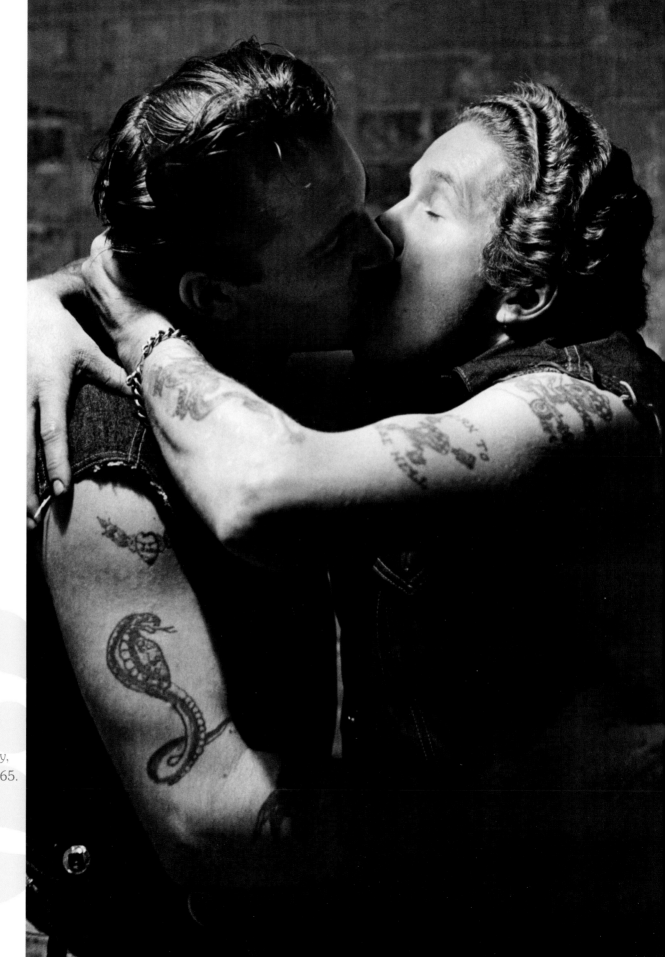

DANNY LYON
Corky and
Funny Sonny,
Chicago, 1965.

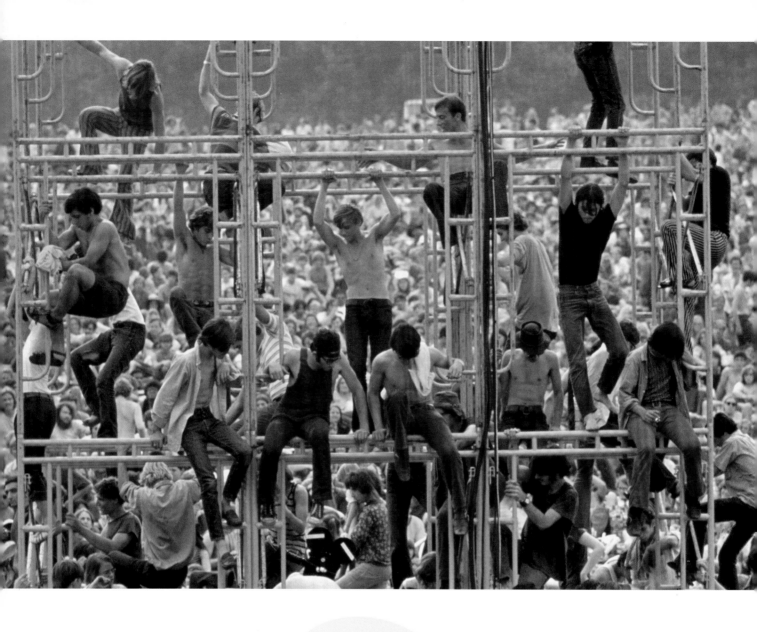

ELLIOTT LANDY

Fans angle for a better view, Woodstock
Festival, Bethel, New York, 1969.

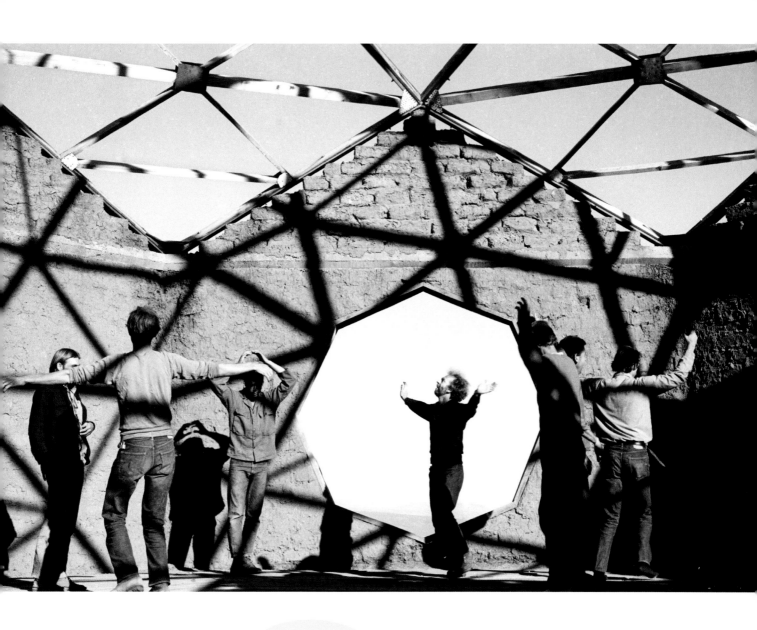

DENNIS STOCK

Spiritual dancing during the
construction of a geodesic dome
at Lama, New Mexico, 1969.

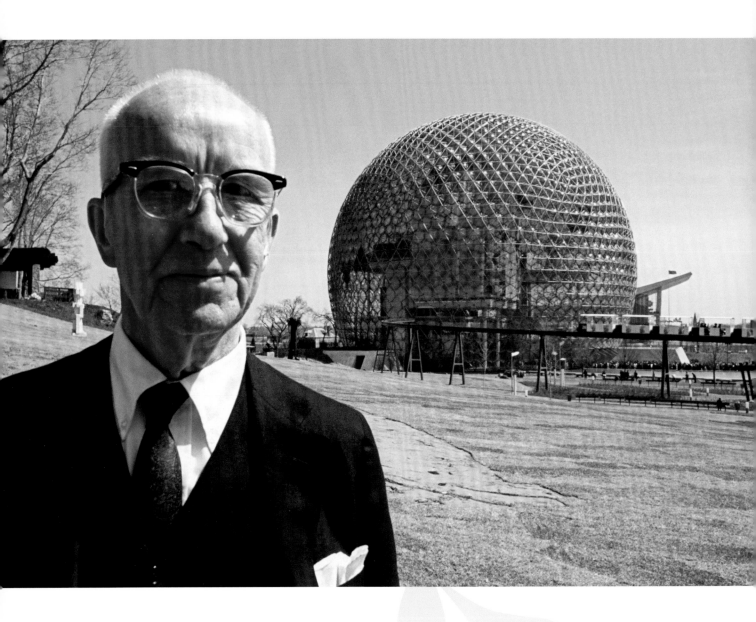

DENNIS STOCK
R. Buckminster Fuller and
his geodesic dome at the
Montreal World Fair, 1967.

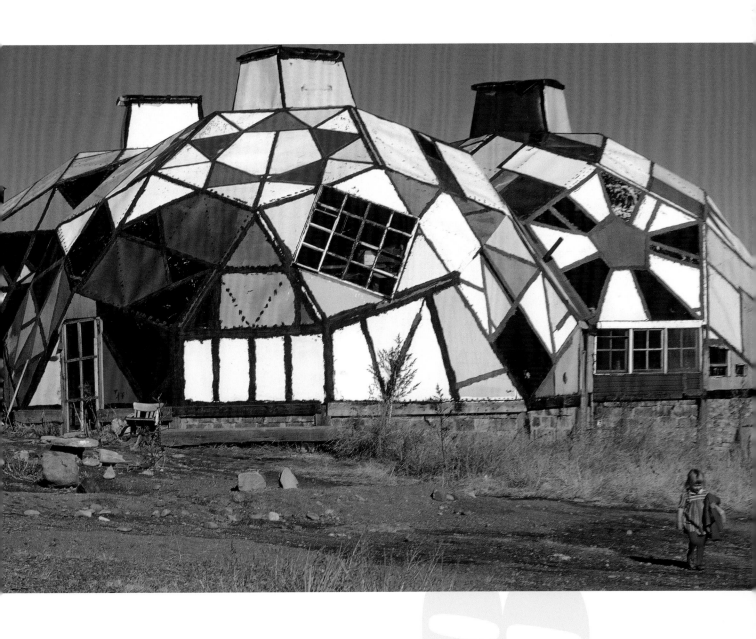

EVE ARNOLD
Drop City hippie commune,
New Mexico, 1968.

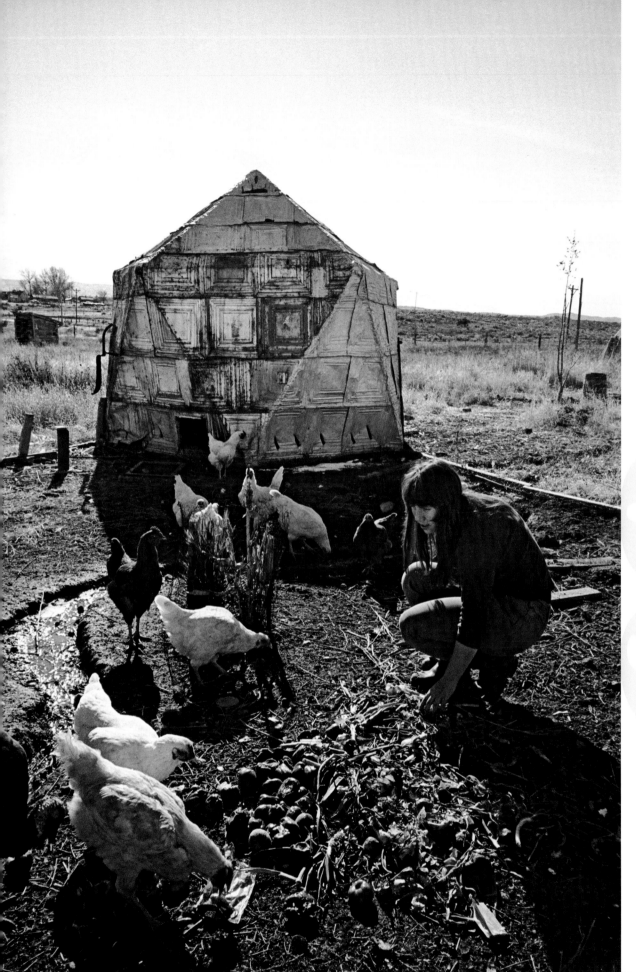

EVE ARNOLD
Drop City hippie commune, New Mexico, 1968.

DANNY LYON
Geodesic dome, 1968.

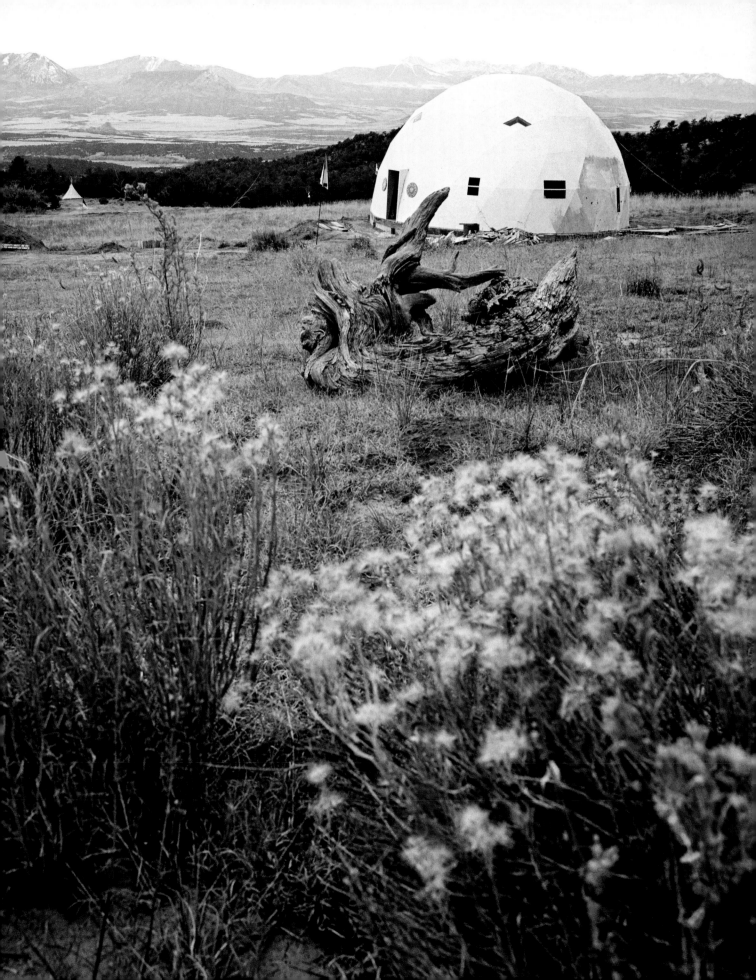

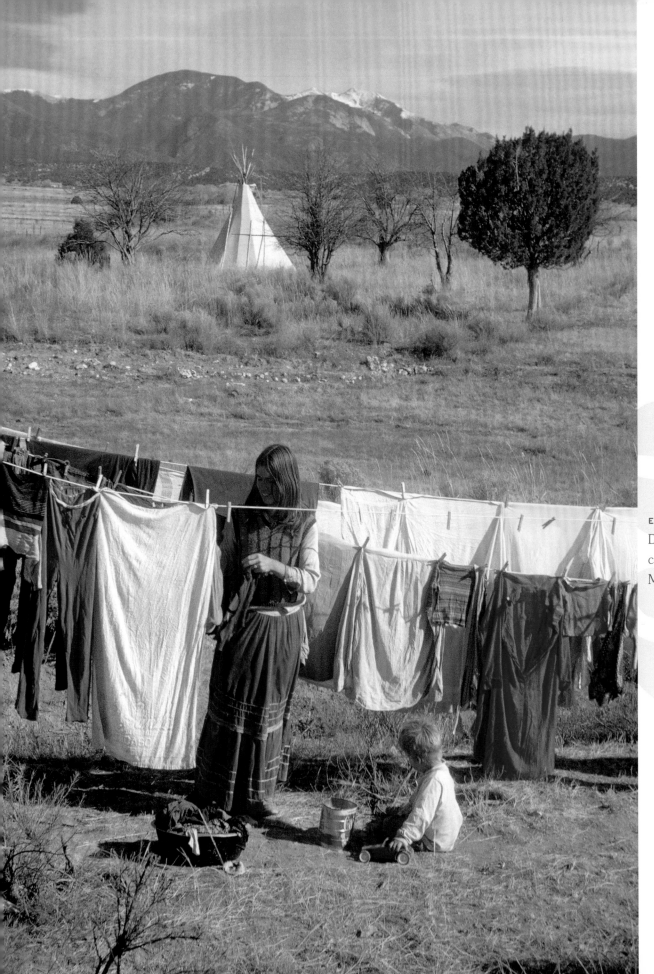

EVE ARNOLD
Drop City hippie
commune, New
Mexico, 1968.

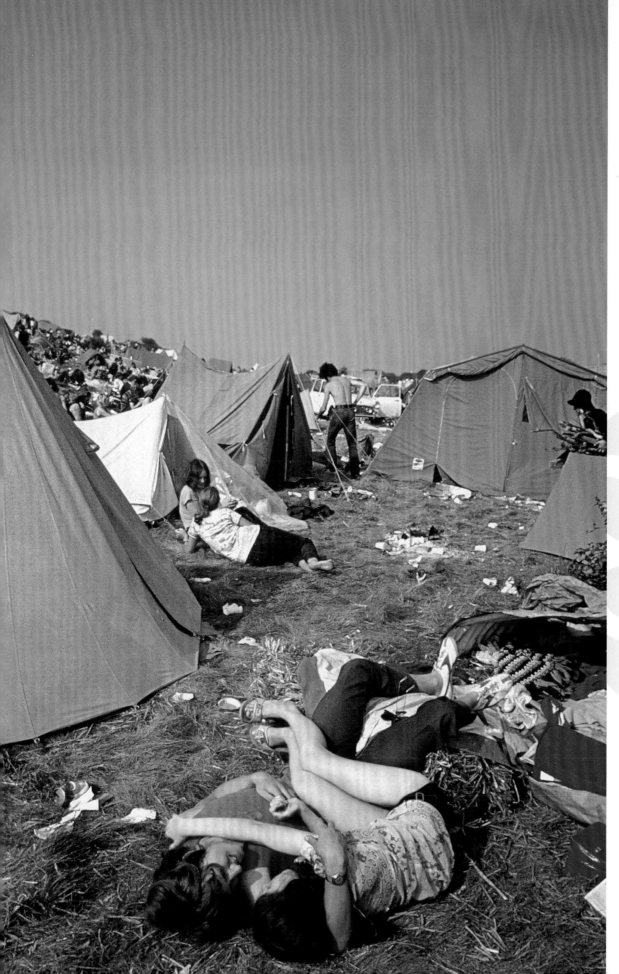

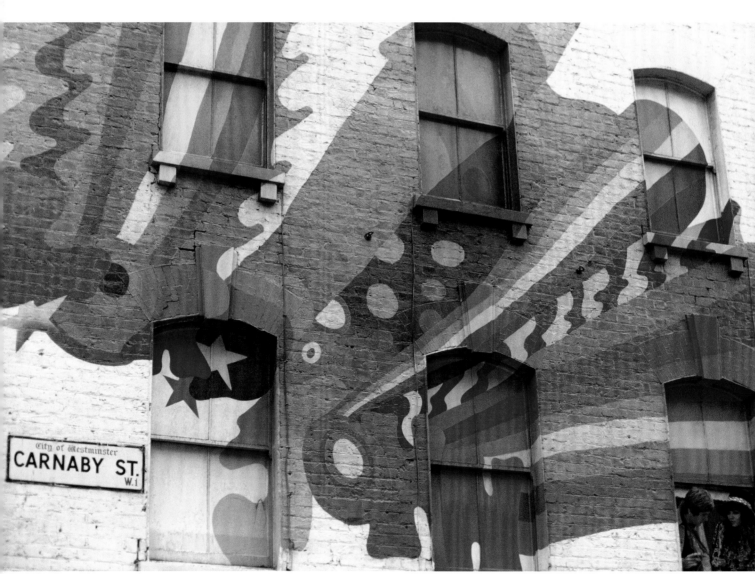

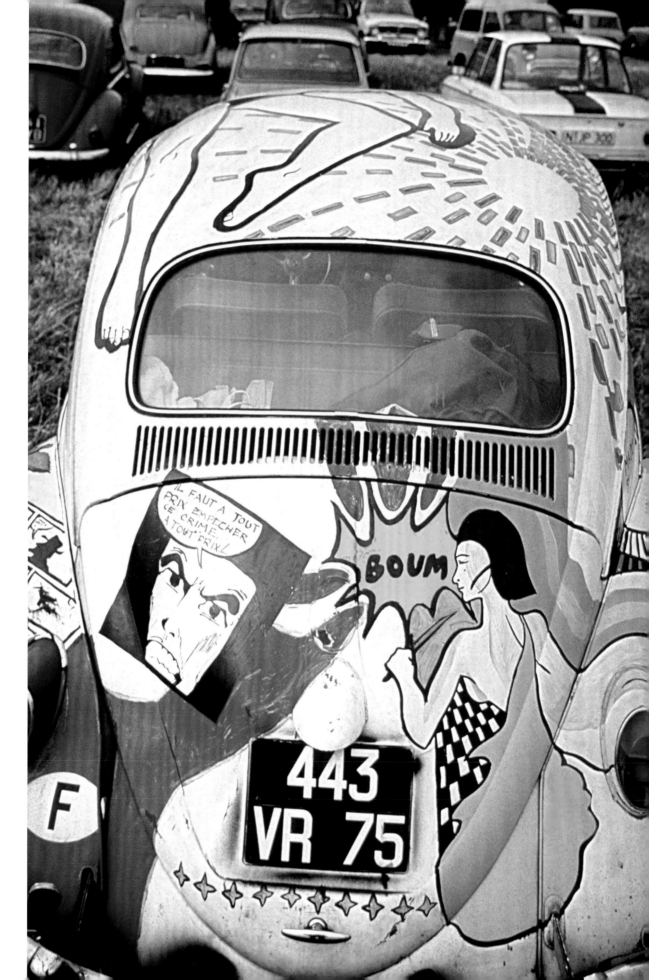

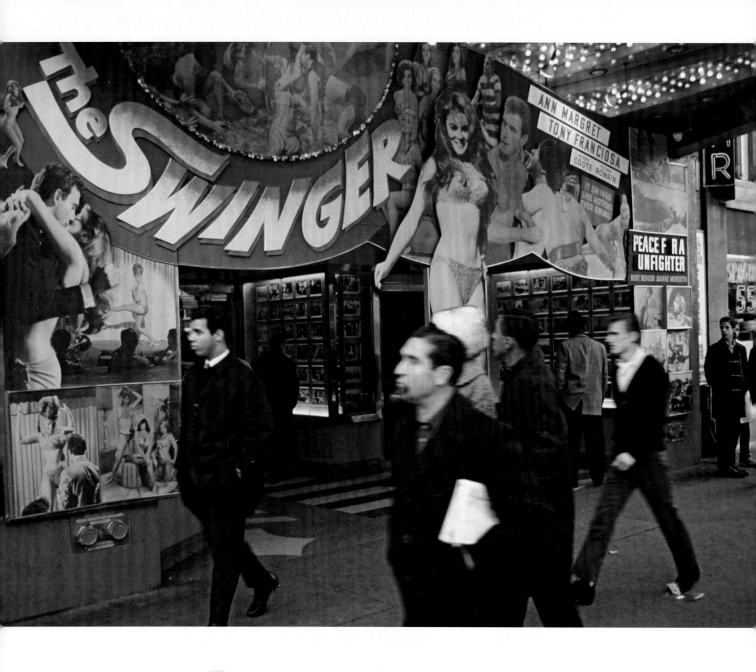

DANNY LYON

Broadway at 42nd Street,
New York, 1966.

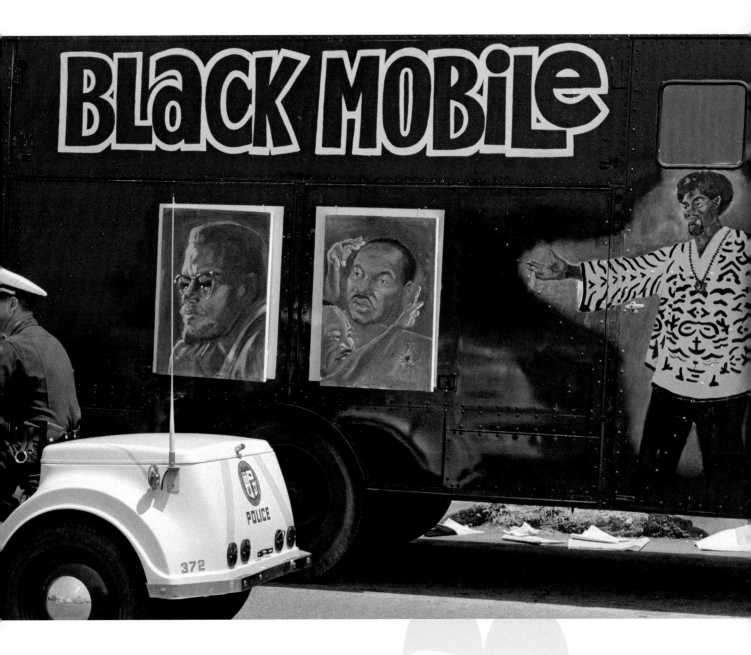

DENNIS STOCK
A Black Power movement
vehicle in Watts, California,
1968.

The only people mad ones, the mad to live, mad saved, desirous the same time, never yawn or place thing. . . .

for me are the ones who are to talk, mad to be of everything at the ones who say a common-

JACK KEROUAC, *ON THE ROAD*

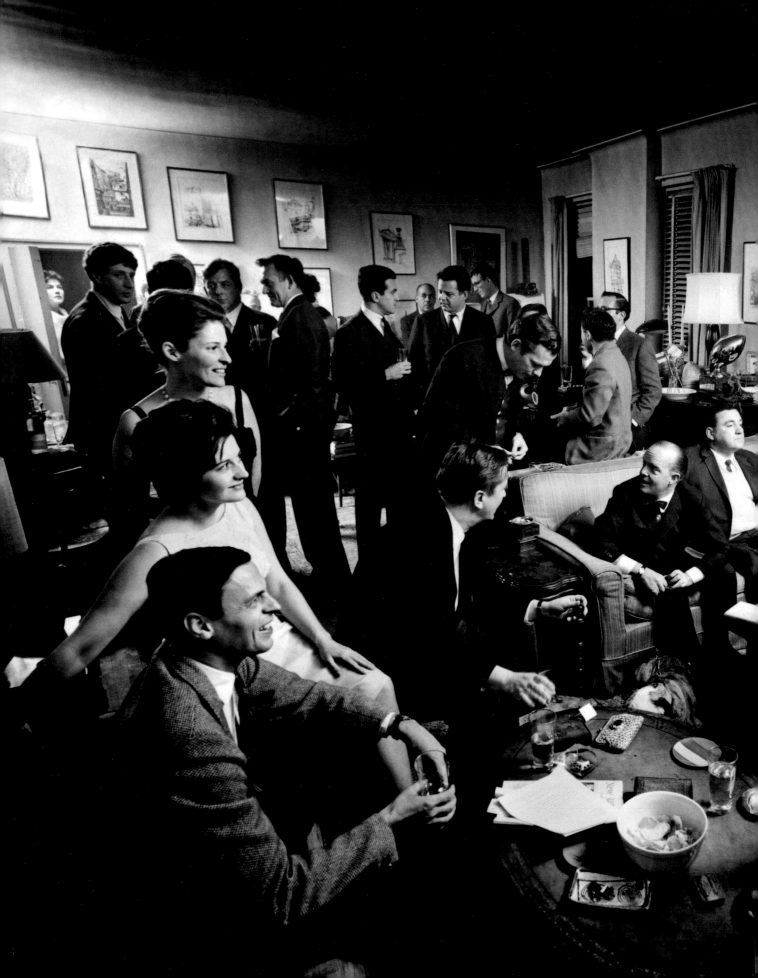

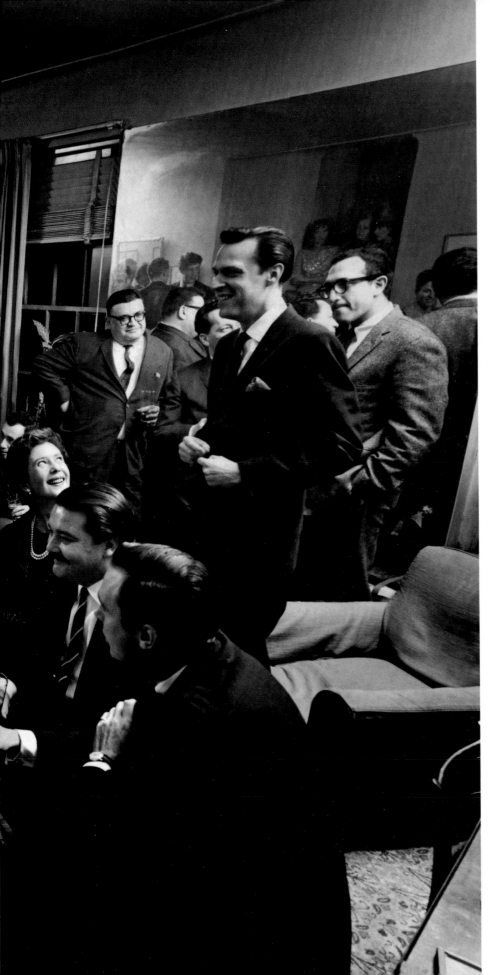

CORNELL CAPA

Literary cocktail party at George Plimpton's Upper East Side apartment. Guests included Jonathan Miller, Gore Vidal, Ricky Leacock, Robert Laskey, Paul Heller, Ralph Ellison, Peter Matthiesen, Walter Bernstein, Jack Richardson, Arthur Kopitt, Frank Perry, Eleanor Perry, Arthur Penn, and Truman Capote, New York, 1963.

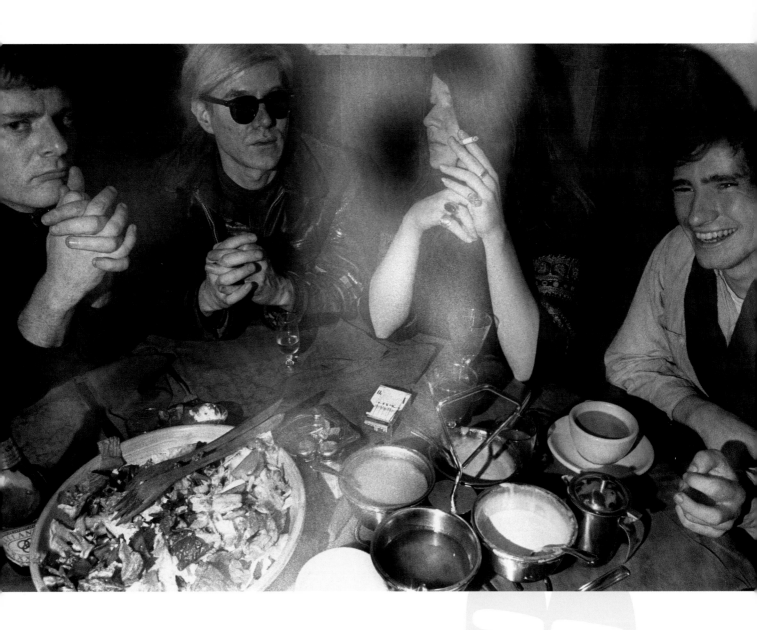

ELLIOTT LANDY
Paul Morrissey, Andy Warhol, Janis
Joplin, and Tim Buckley at Max's
Kansas City, New York, 1968.

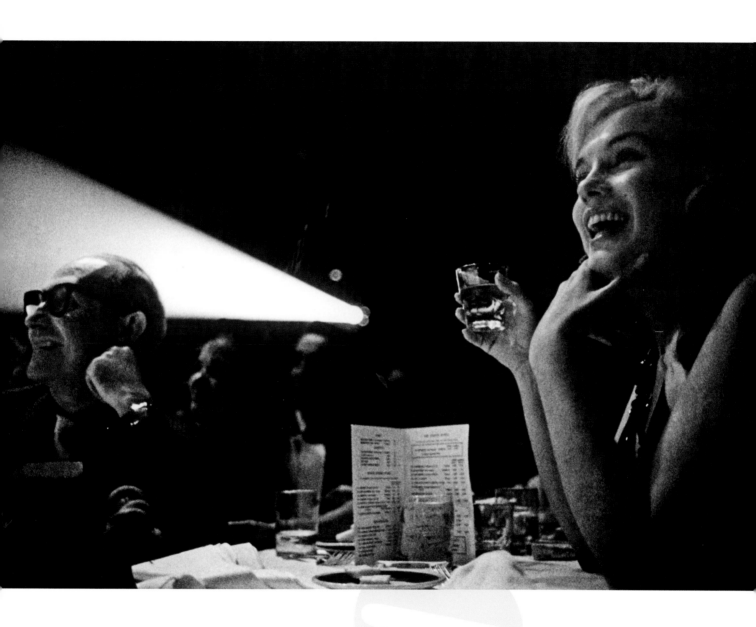

Marilyn Monroe during the filming
of *The Misfits*, Reno, Nevada, 1960.

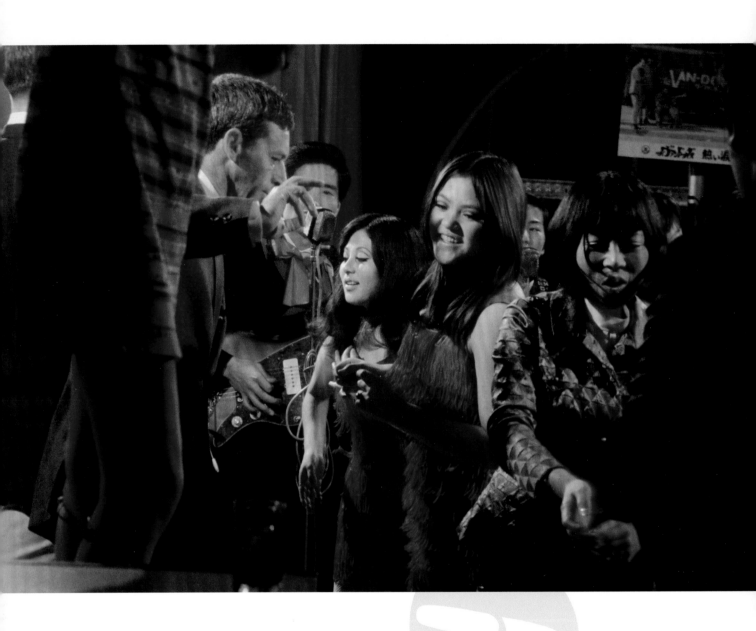

BURT GLINN

Saturday night at
the Tokyo-A-Go-Go,
Tokyo, 1969.

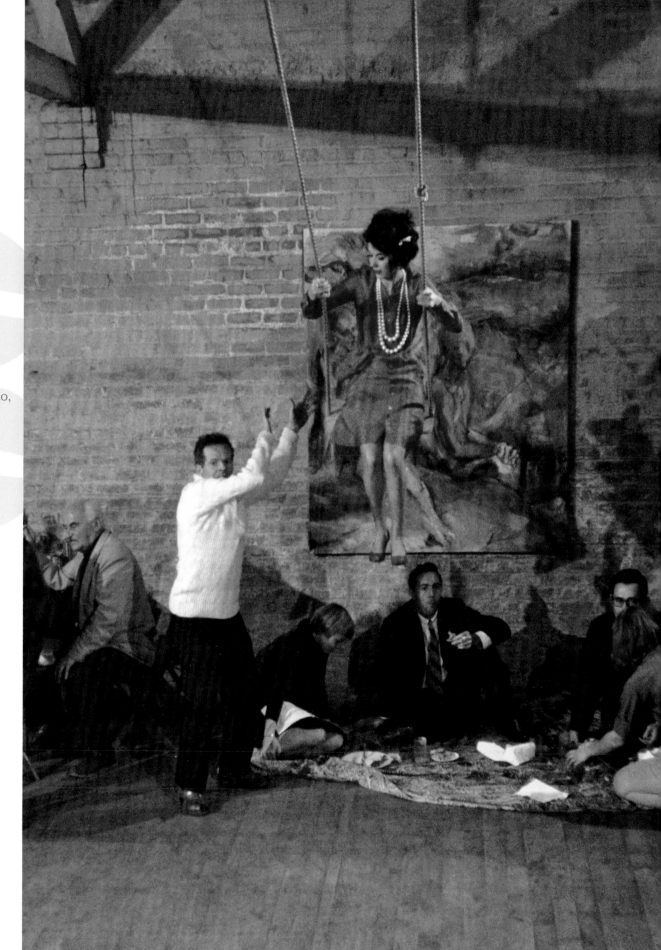

BURT GLINN
Bohemian
loft party,
San Francisco,
1960.

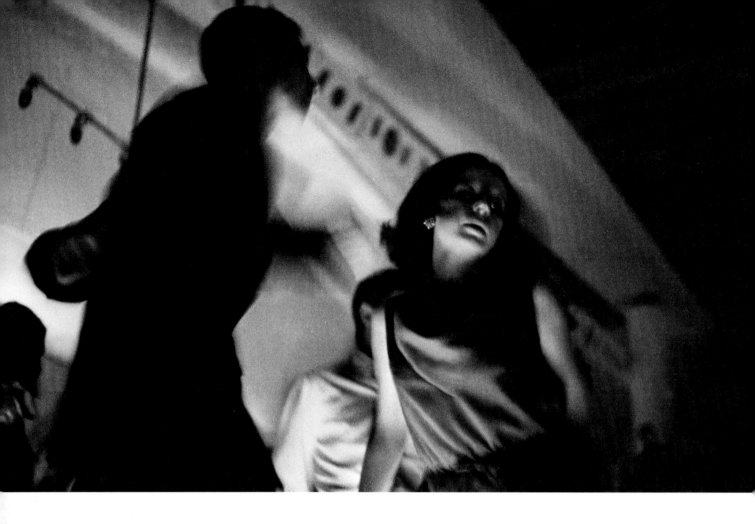

FERDINANDO SCIANNA

Dancing at the Piper Club,
Rome, 1965.

FERDINANDO SCIANNA

Dancing at the Piper Club,
Rome, 1965.

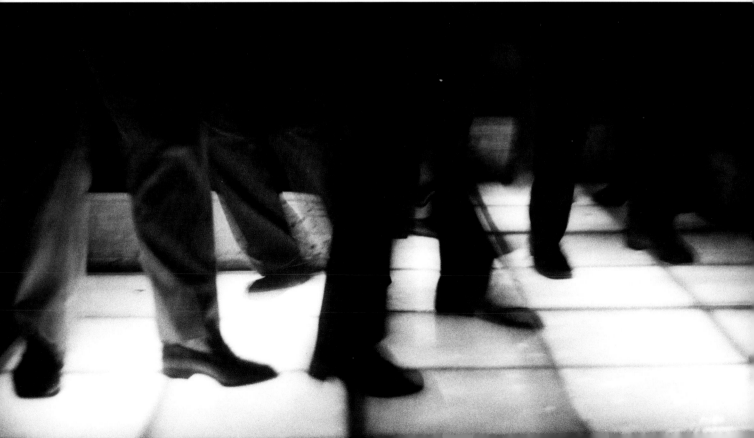

ELLIOTT LANDY
Procol Harum, Joshua Light Show,
Fillmore East, New York, 1968.

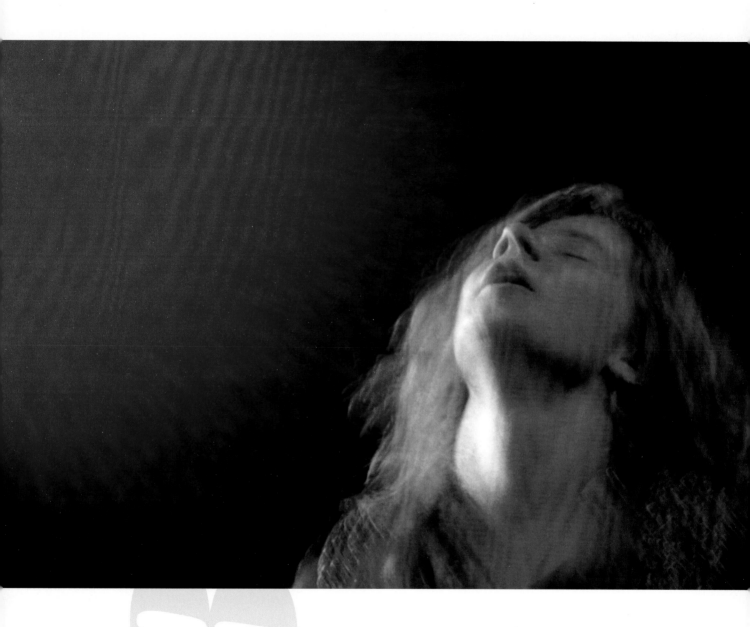

PAUL FUSCO

Janis Joplin performing at The Fillmore,
San Francisco, 1968.

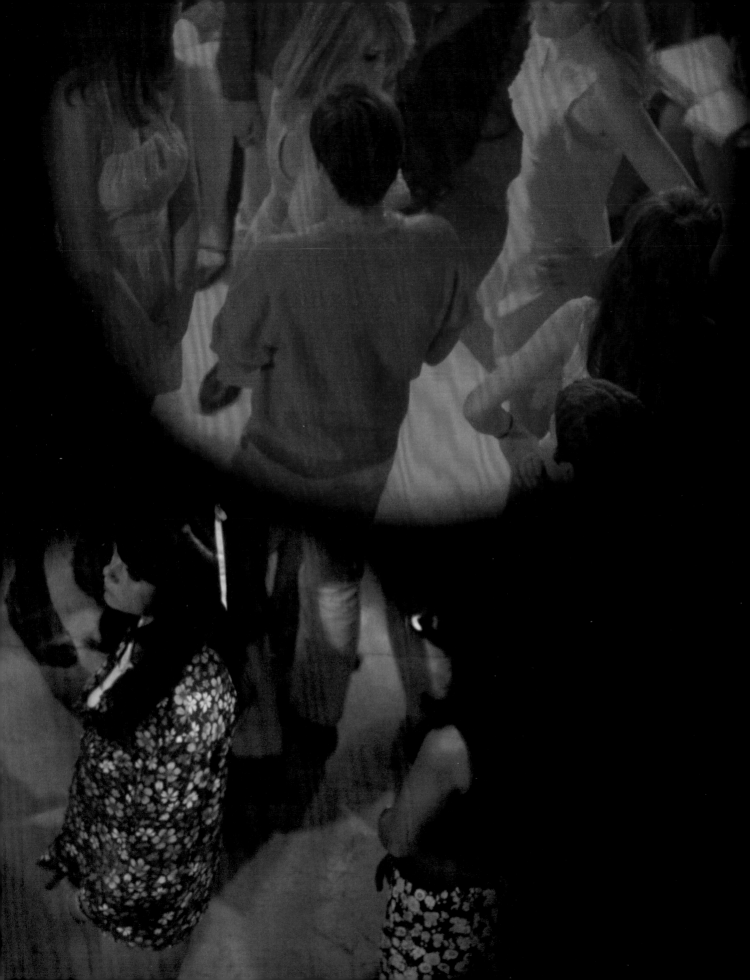

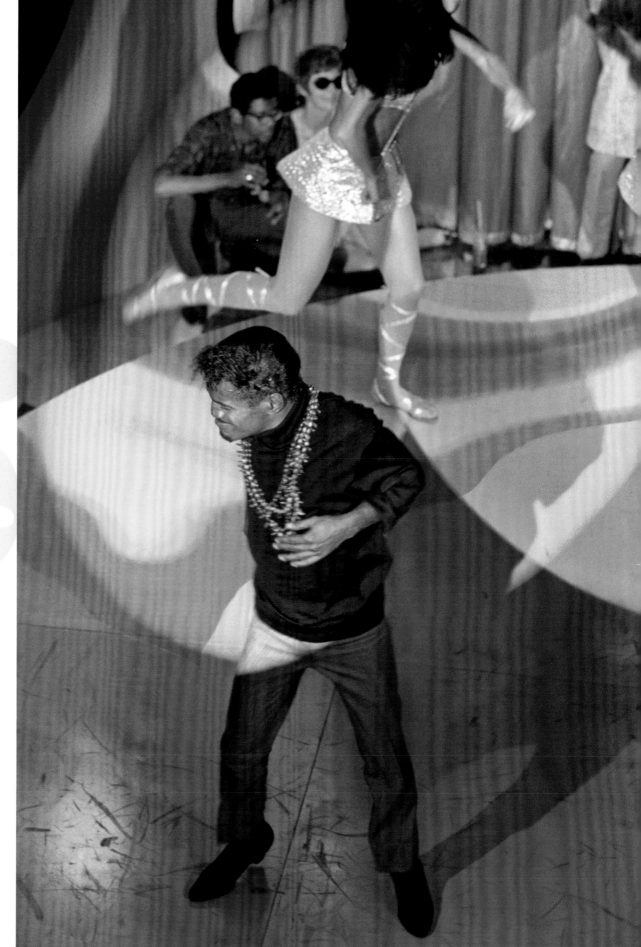

EVE ARNOLD
On the set of
Salt and Pepper,
starring Sammy
Davis Jr.,
London, 1967.

EVE ARNOLD
Sammy Davis Jr.
on the set of *Salt
and Pepper*,
London, 1967.

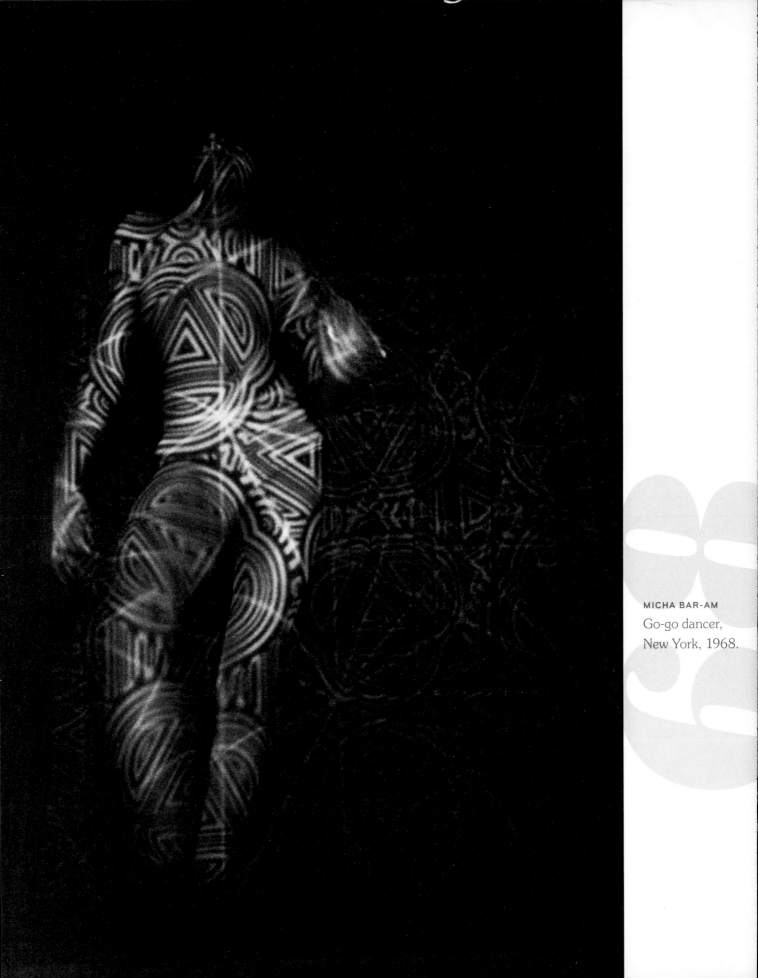

MICHA BAR-AM
Go-go dancer,
New York, 1968.

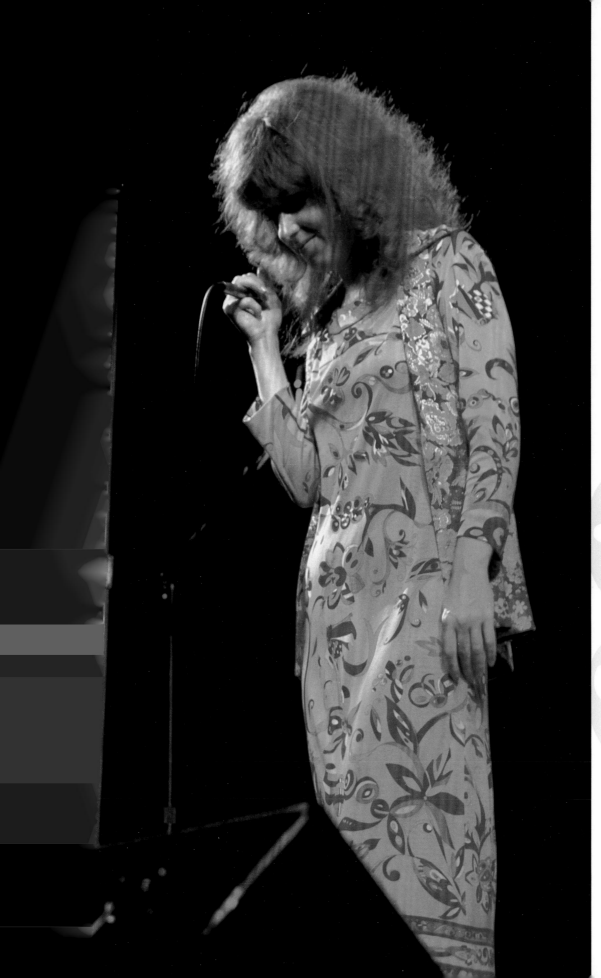

ELLIOTT LANDY
Grace Slick of
Jefferson Airplane,
Fillmore East,
New York, 1968.

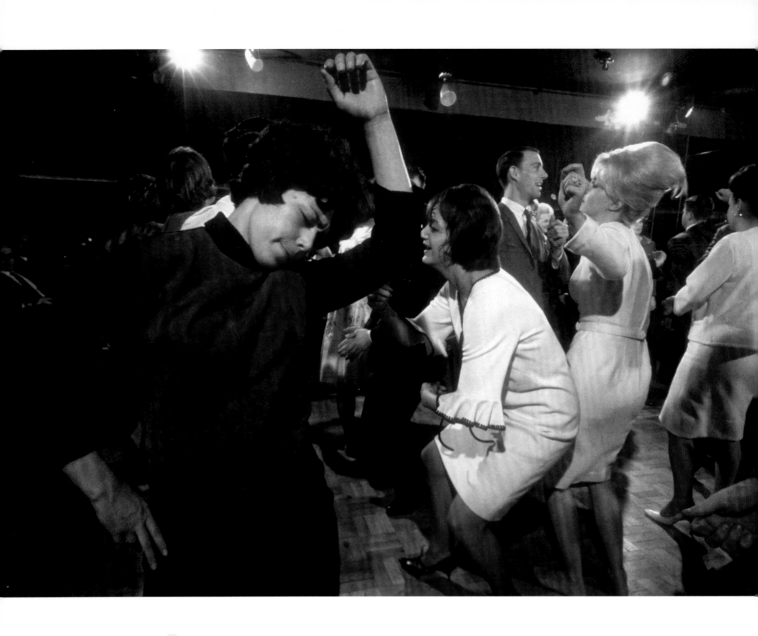

BURT GLINN
Disco nightclub,
Dallas, Texas, 1965.

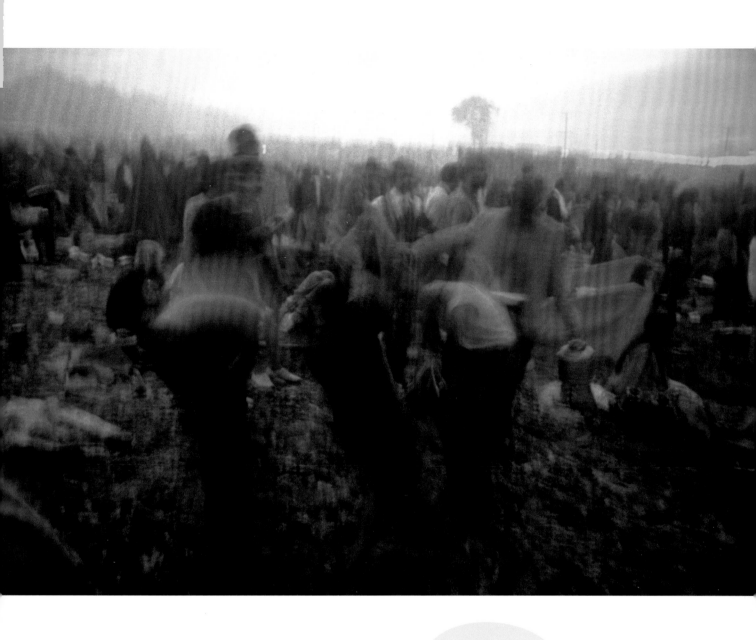

ELLIOTT LANDY
Woodstock Festival,
Bethel, New York, 1969.

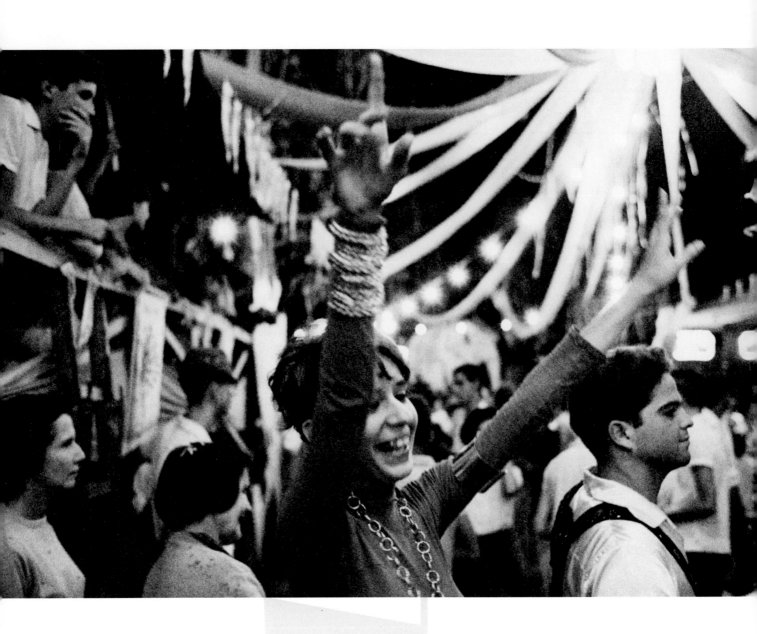

ELLIOTT ERWITT
Carnaval, Brazil, 1961.

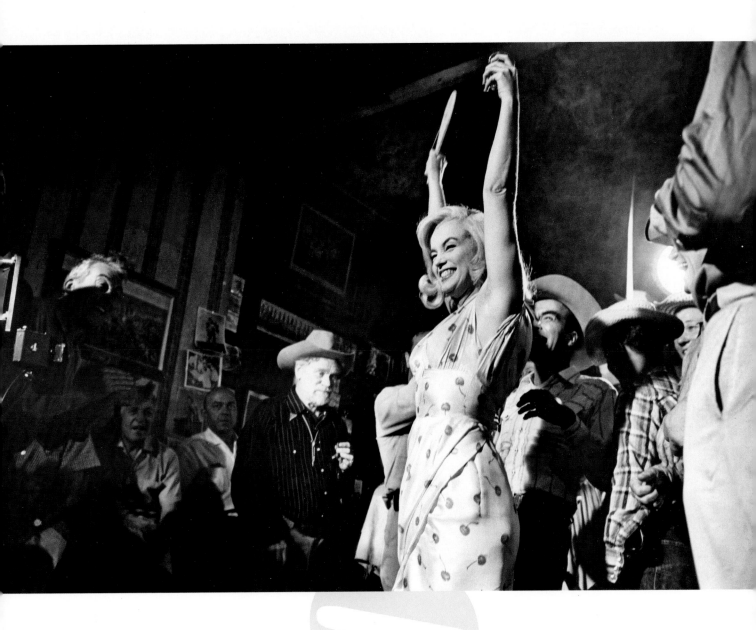

Marilyn Monroe during the filming
of *The Misfits*, Reno, Nevada, 1960.

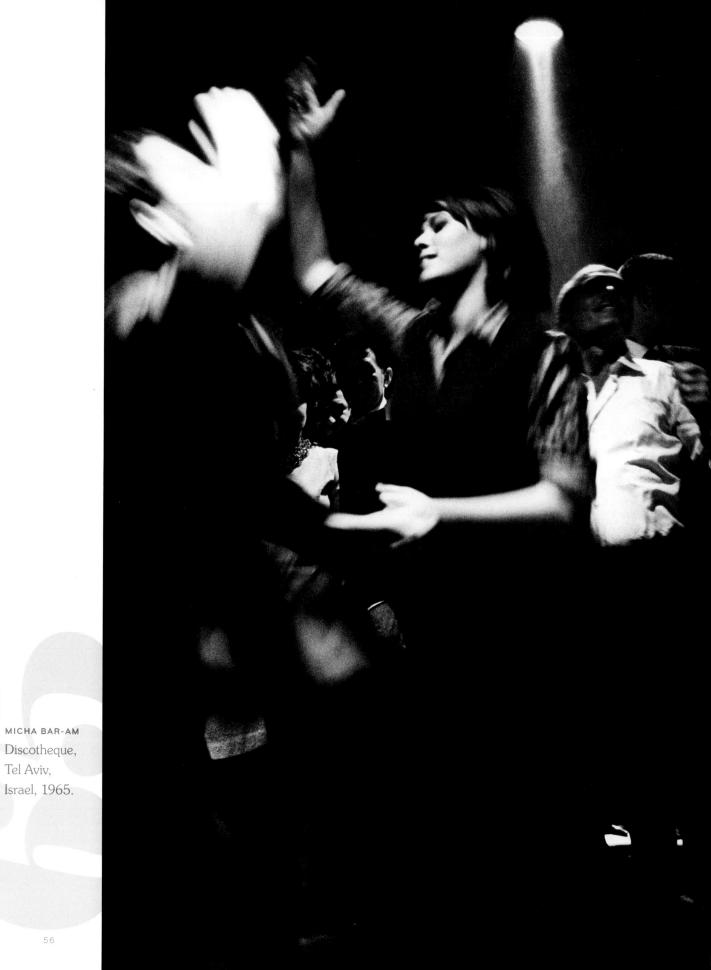

MICHA BAR-AM
Discotheque,
Tel Aviv,
Israel, 1965.

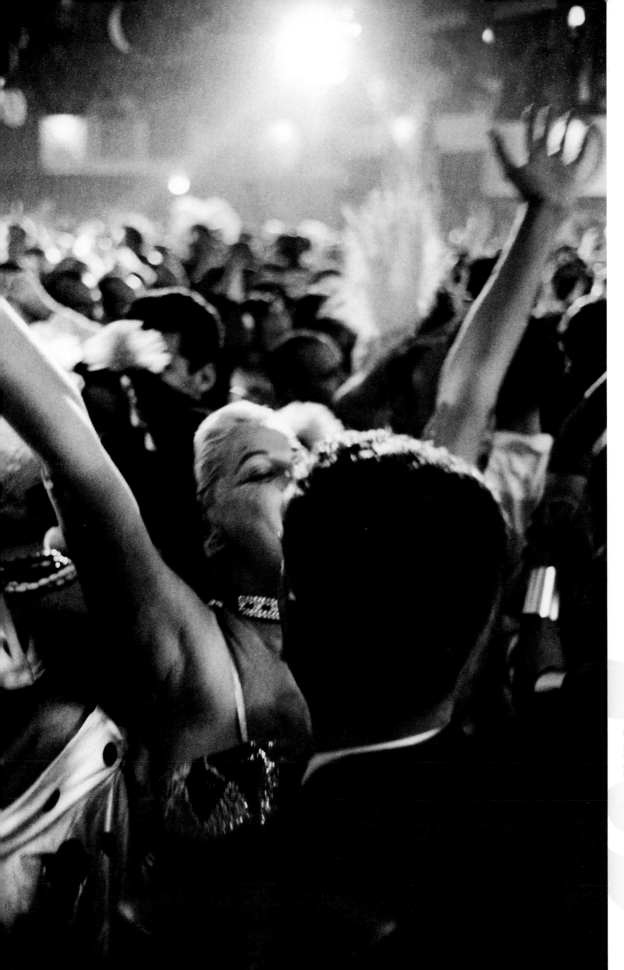

ELLIOTT ERWITT
Rio de Janeiro,
Brazil, 1961.

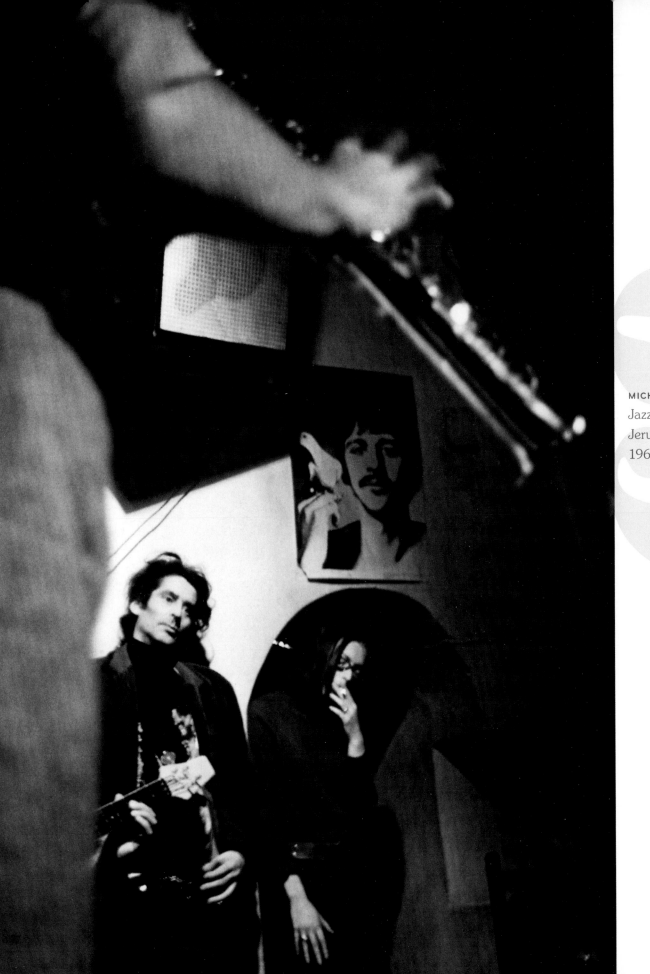

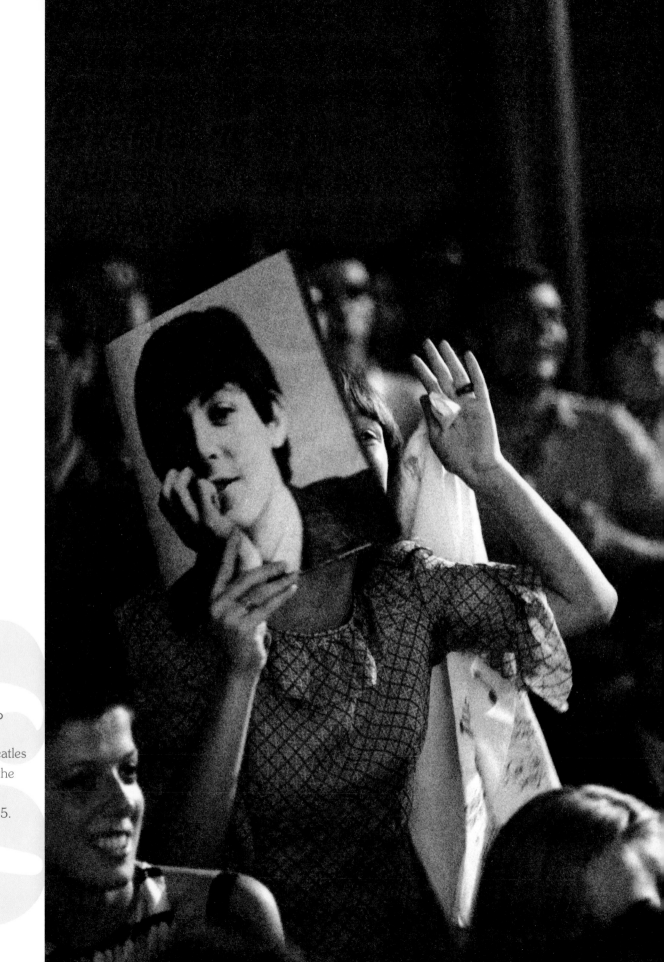

FERDINANDO SCIANNA

Fan at a Beatles concert at the Piper Club, Rome, 1965.

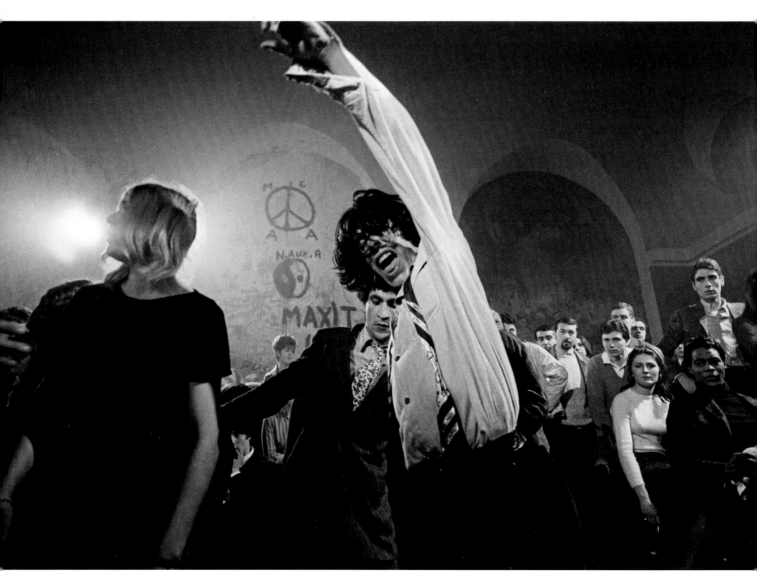

LEONARD FREED
Office party,
New York, 1966.

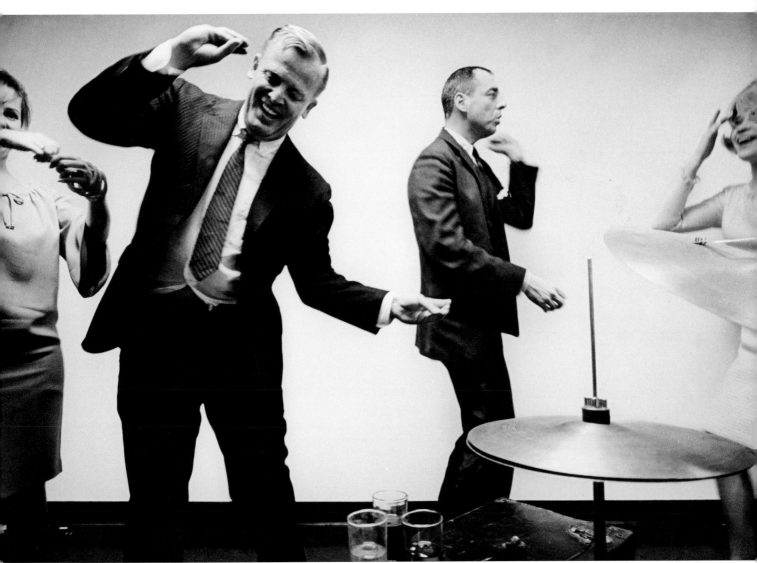

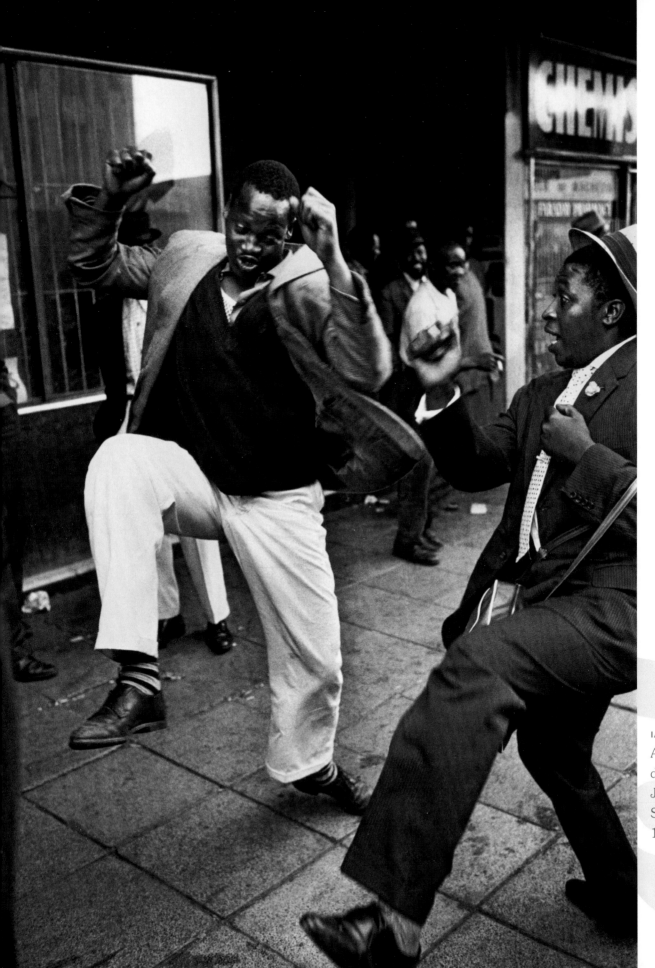

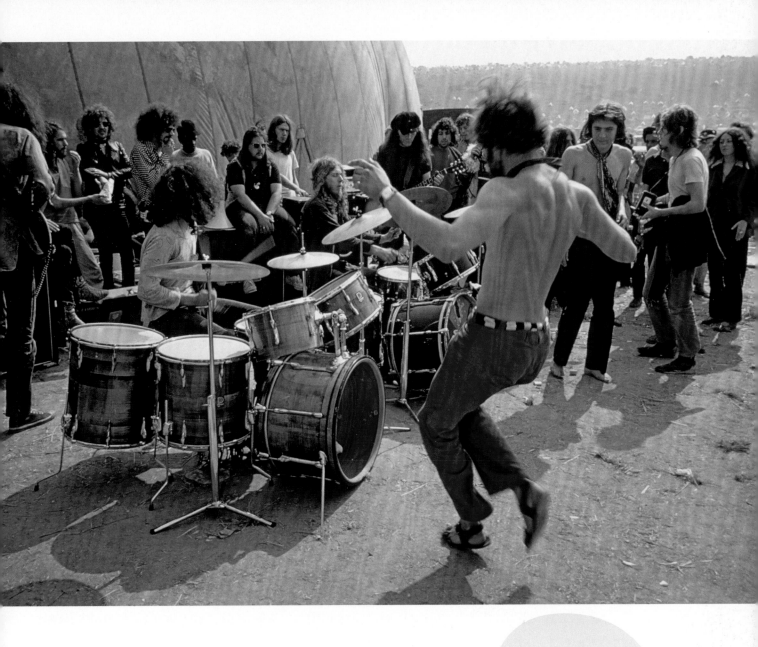

DAVID HURN

The Pink Fairies, an anarchist rock group, play for a fan, Isle of Wight Festival, England, 1969.

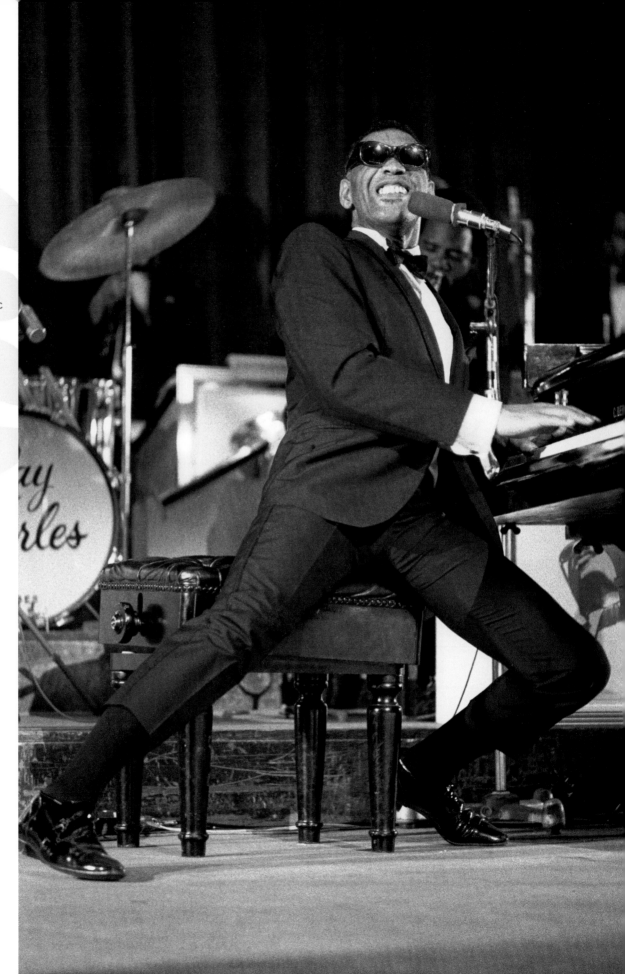

GUY LE QUERREC
Ray Charles,
Paris, 1969.

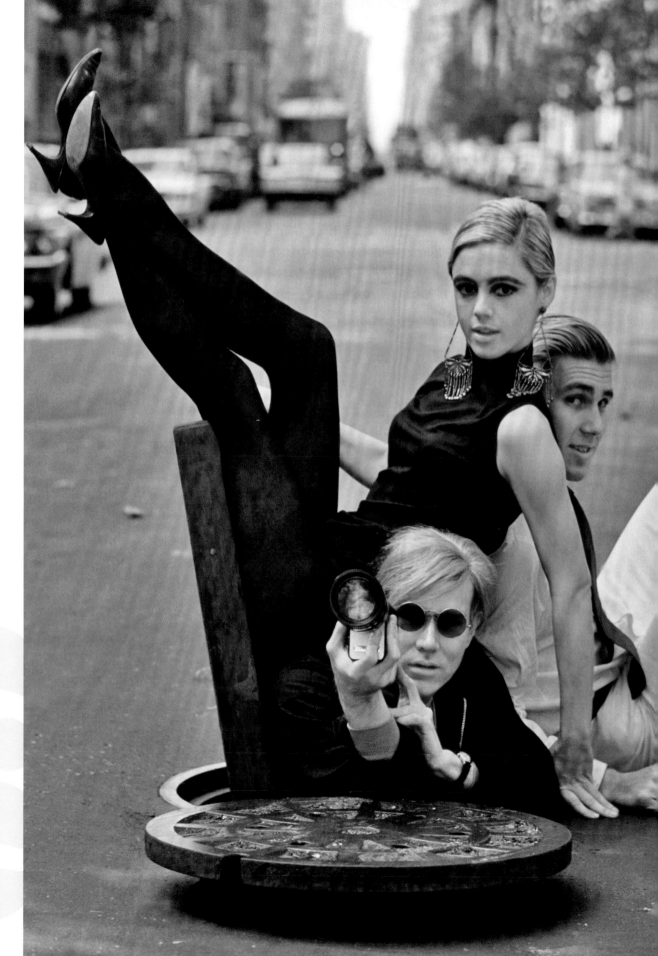

BURT GLINN
Andy Warhol
with Edie
Sedgwick and
Chuck Wein,
New York,
1965.

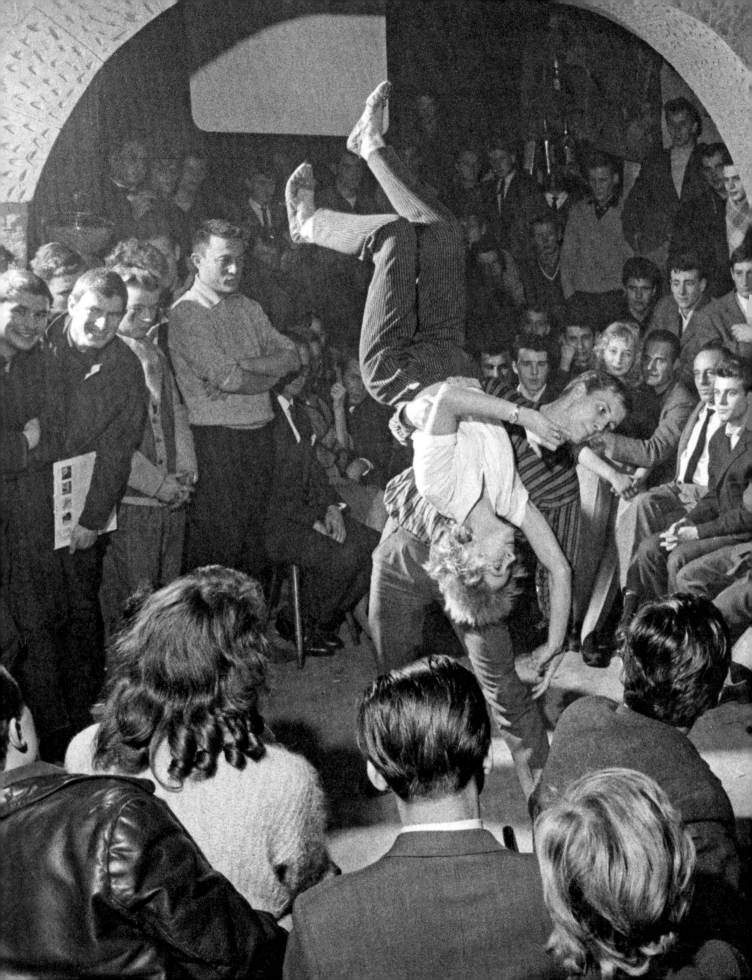

RENÉ BURRI
Dancing at
the Eierschale,
West Berlin,
Germany, 1960.

We stand today a new frontier of the 1960s—unknown and perils—unfulfilled hopes

on the edge of
—the frontier
a frontier of
opportunities
a frontier of
and threats.

JOHN F. KENNEDY, ACCEPTANCE SPEECH AT THE 1960 DEMOCRATIC NATIONAL CONVENTION

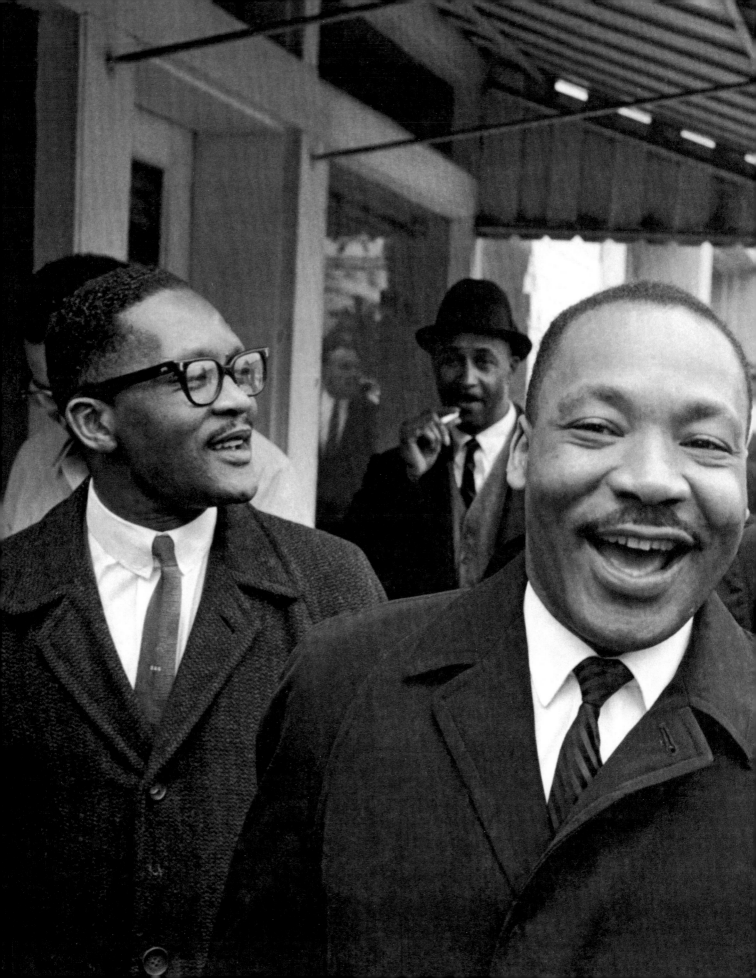

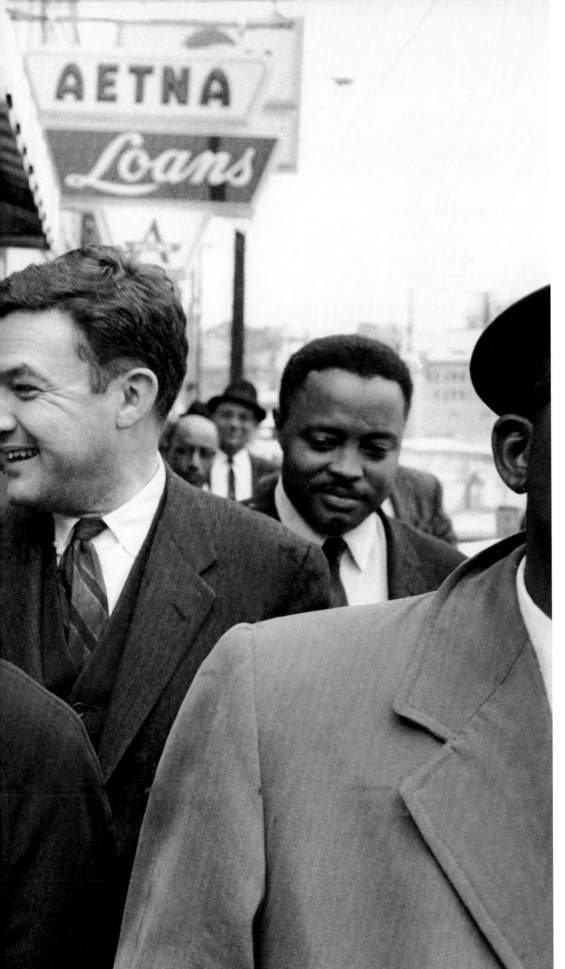

Martin Luther King Jr.
smiles triumphantly after
a Montgomery federal
judge grants permission
to begin the Selma-to-
Montgomery march,
Selma, Alabama, 1965.

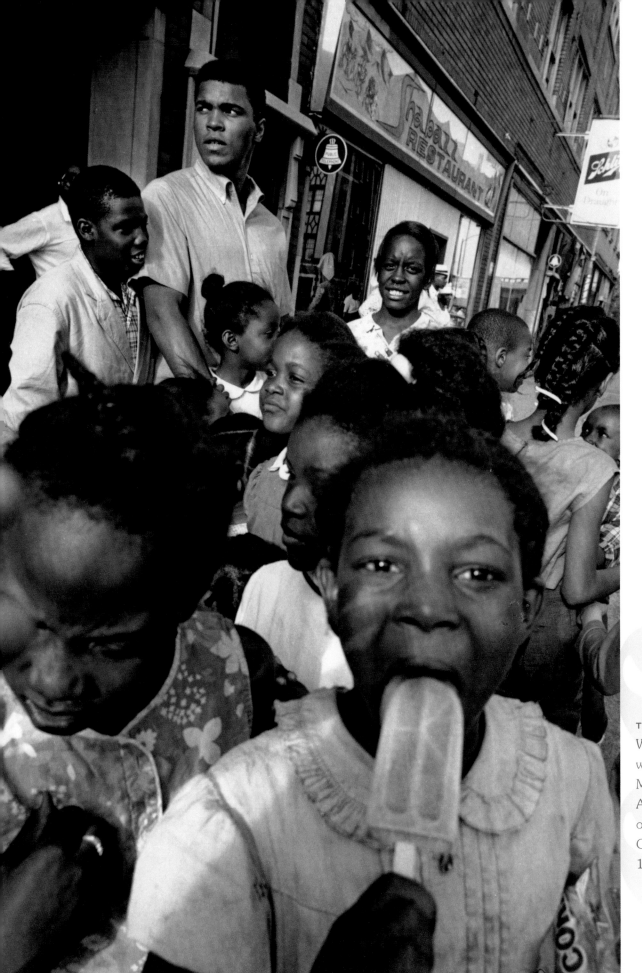

THOMAS HOEPKER
World heavy-
weight champion
Muhammad
Ali amid a group
of children,
Chicago, Illinois,
1966.

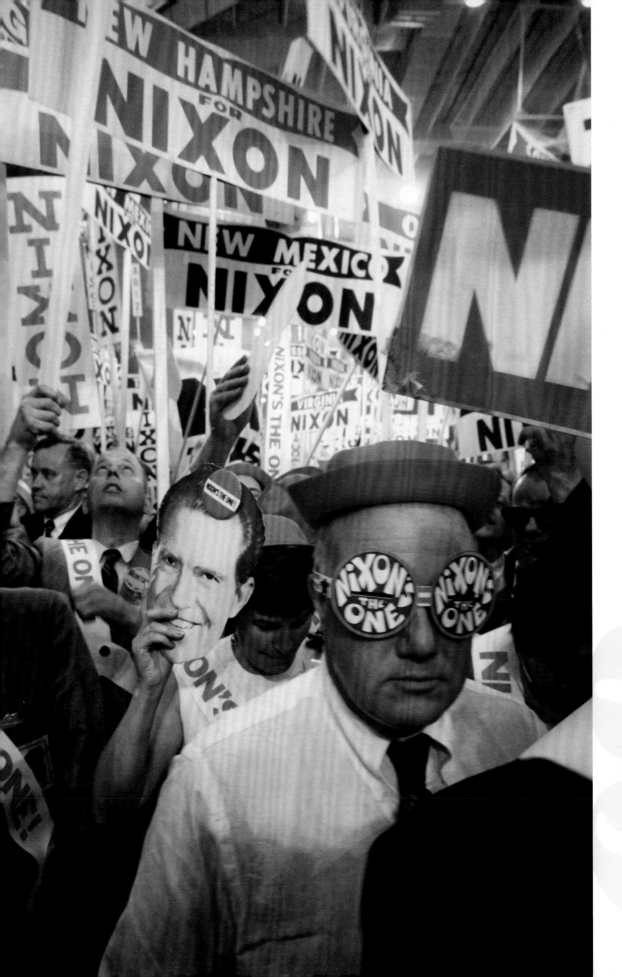

BURT GLINN
The Republican
National
Convention,
1968.

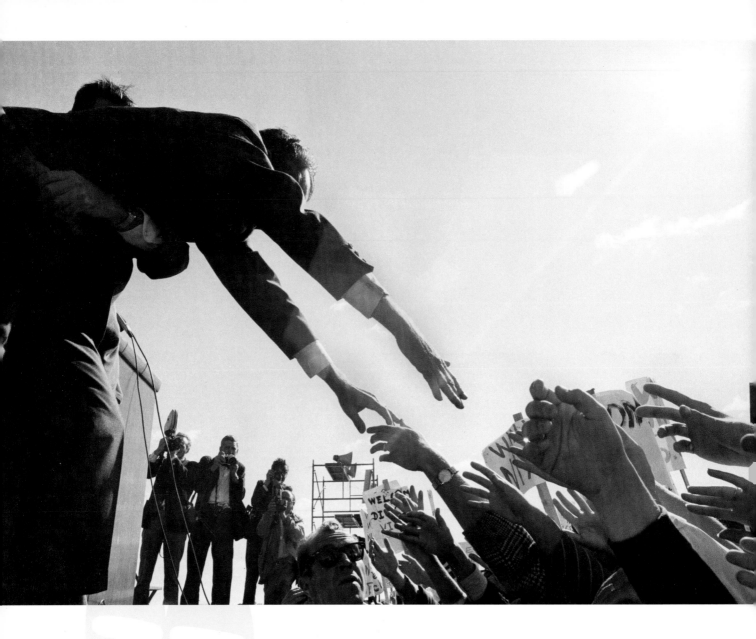

RAYMOND DEPARDON

Richard Nixon on a Republican
campaign tour, Boise, Idaho, 1968.

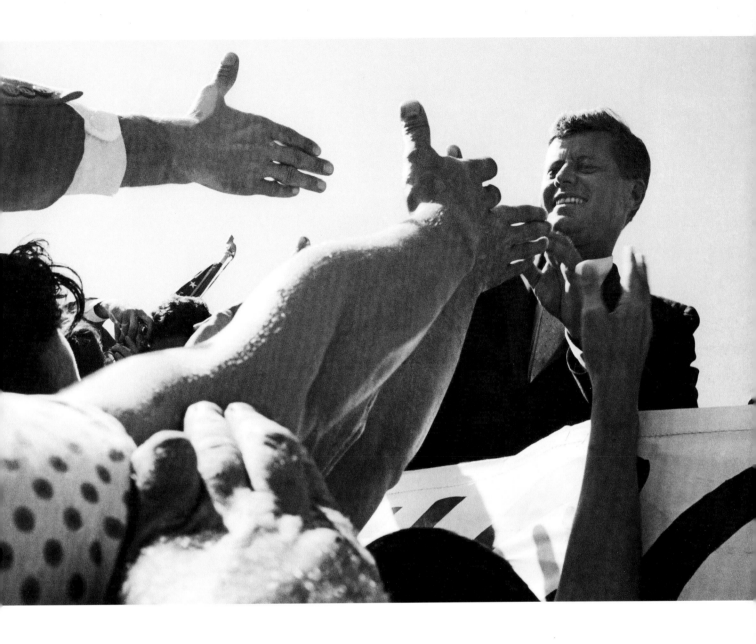

CORNELL CAPA

John F. Kennedy during the nationwide
whistle-stop campaign tour that took him
to twenty-five towns in five days, 1960.

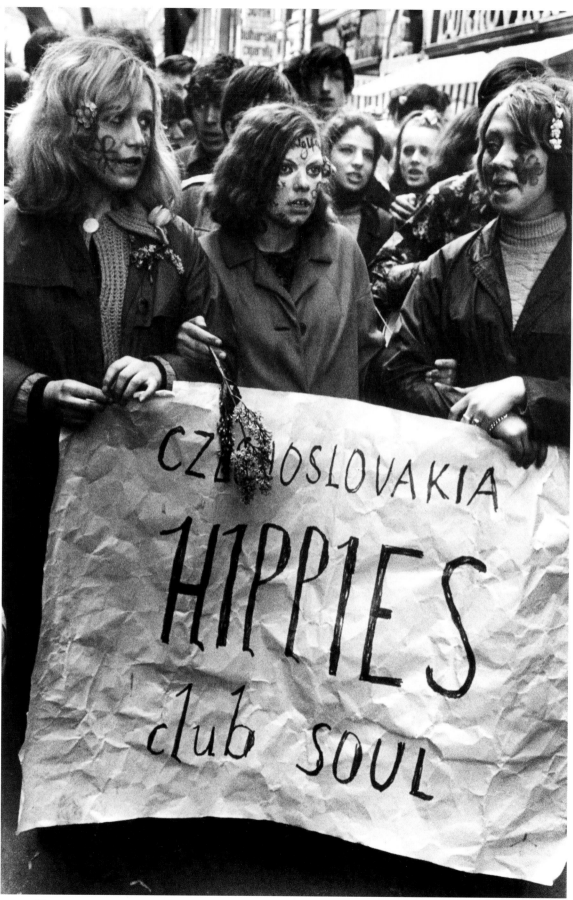

JOSEF KOUDELKA
Czechoslovakian hippies during May Day Parade, Prague, 1968.

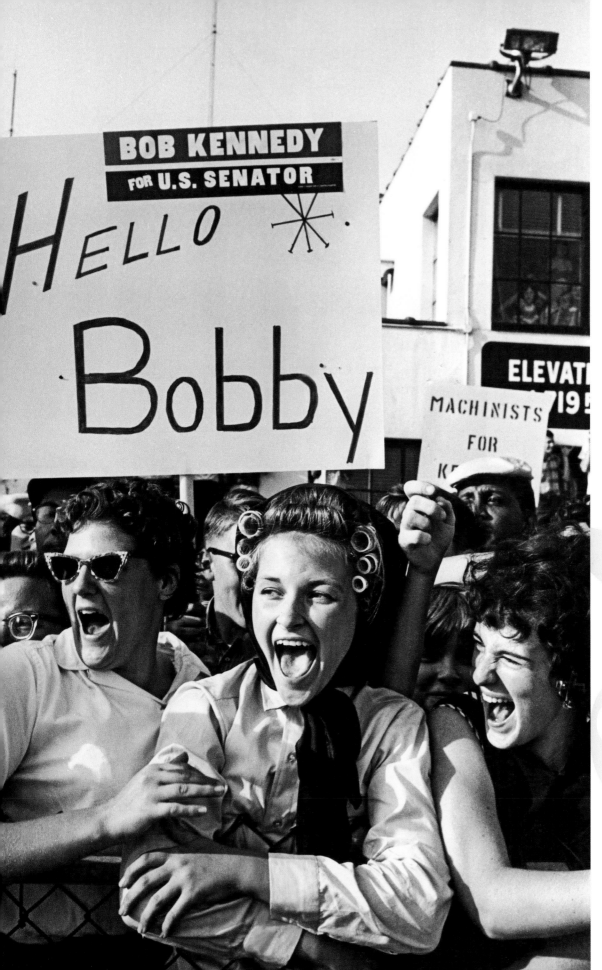

CORNELL CAPA
Supporters of Robert
Kennedy give a new
definition to "Bobby
Soxers" during his
Senate campaign,
New York, 1964.

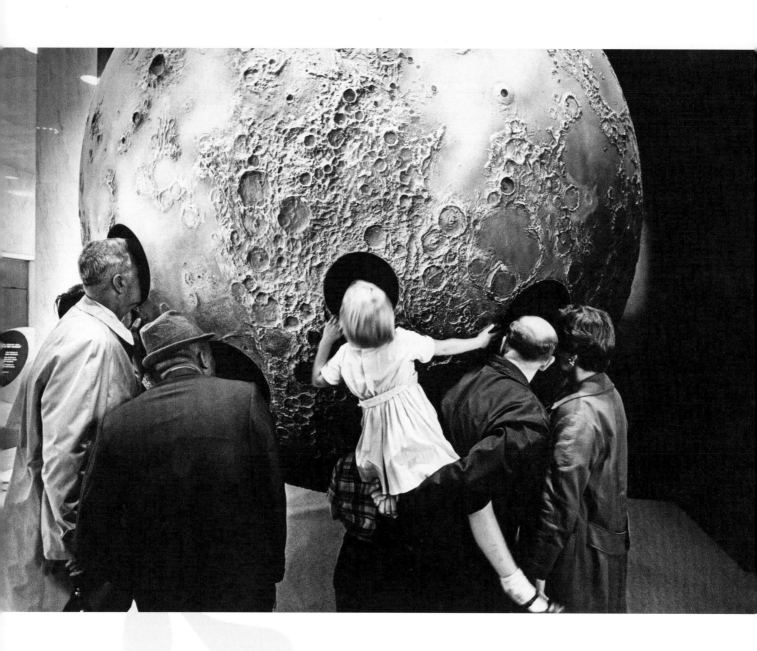

ELLIOTT ERWITT

The Smithsonian Institute,
Washington, D.C., 1967.

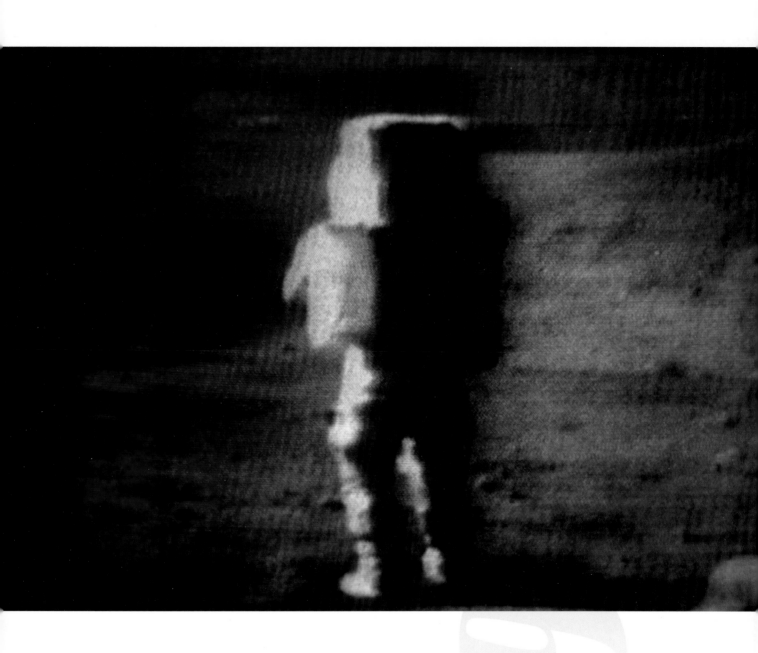

HARRY GRUYAERT
BBC II TV shots of Apollo XII, the
second manned mission to land on
the moon, London, 1969.

If someone
love and peace
must have
behind in the
problem.
peace are

thinks that
is a cliché that
been left
'60s, that's his
Love and
eternal. JOHN LENNON

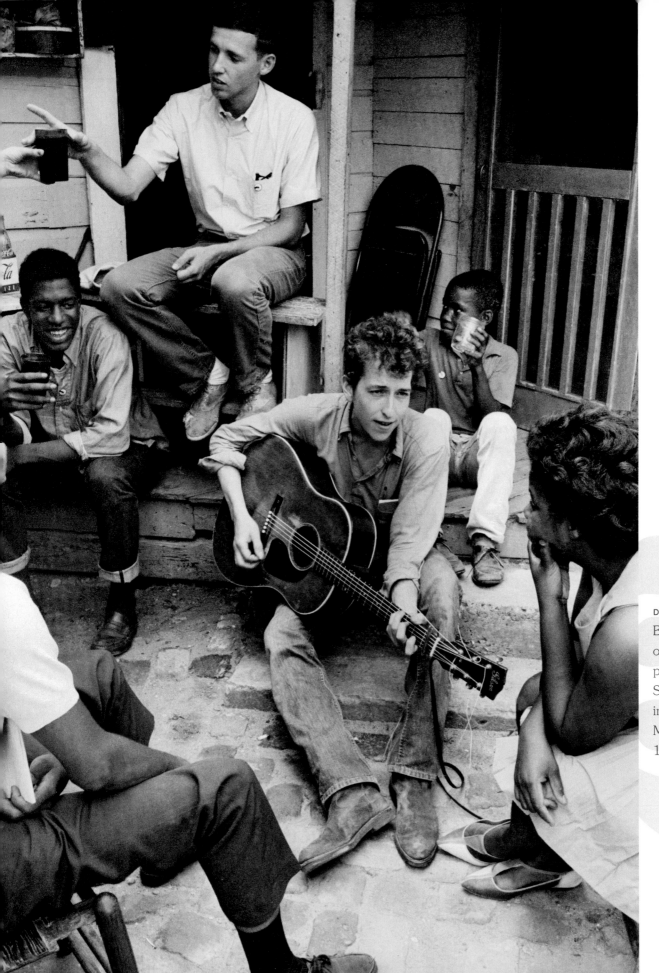

DANNY LYON
Bob Dylan plays on the back porch of the SNCC office in Greenwood, Mississippi, 1963.

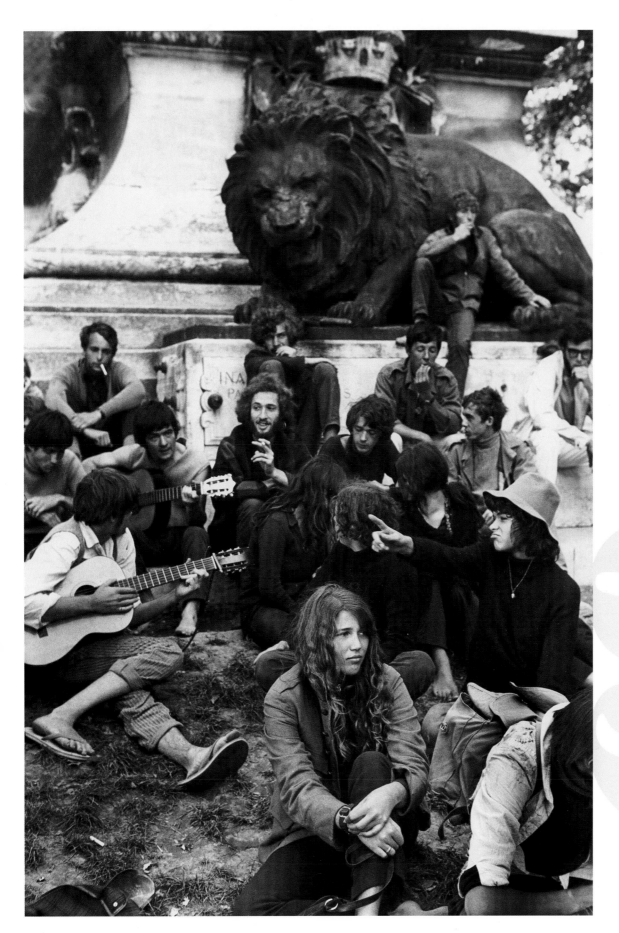

HENRI CARTIER-BRESSON Vaucluse department, Avignon, France, 1969.

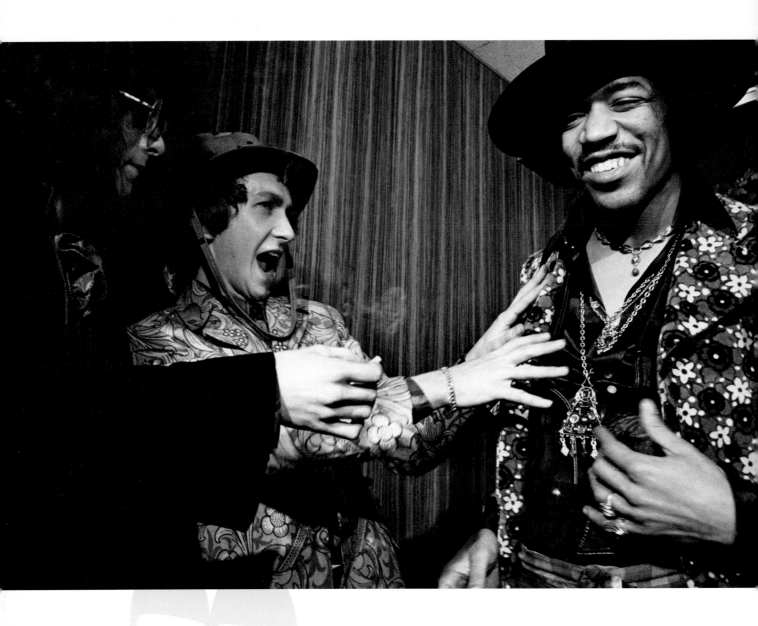

ELLIOTT LANDY
Jimi Hendrix at
a press conference
on top of the Pan
Am Building,
New York, 1968.

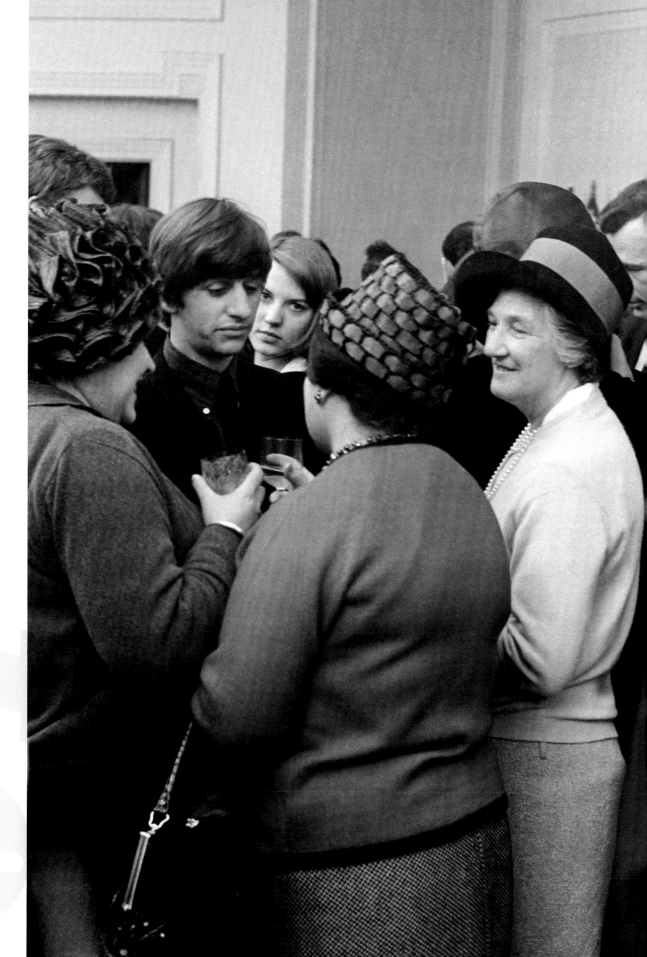

DAVID HURN
Ringo Starr
surrounded
at a cocktail
party, London,
1964.

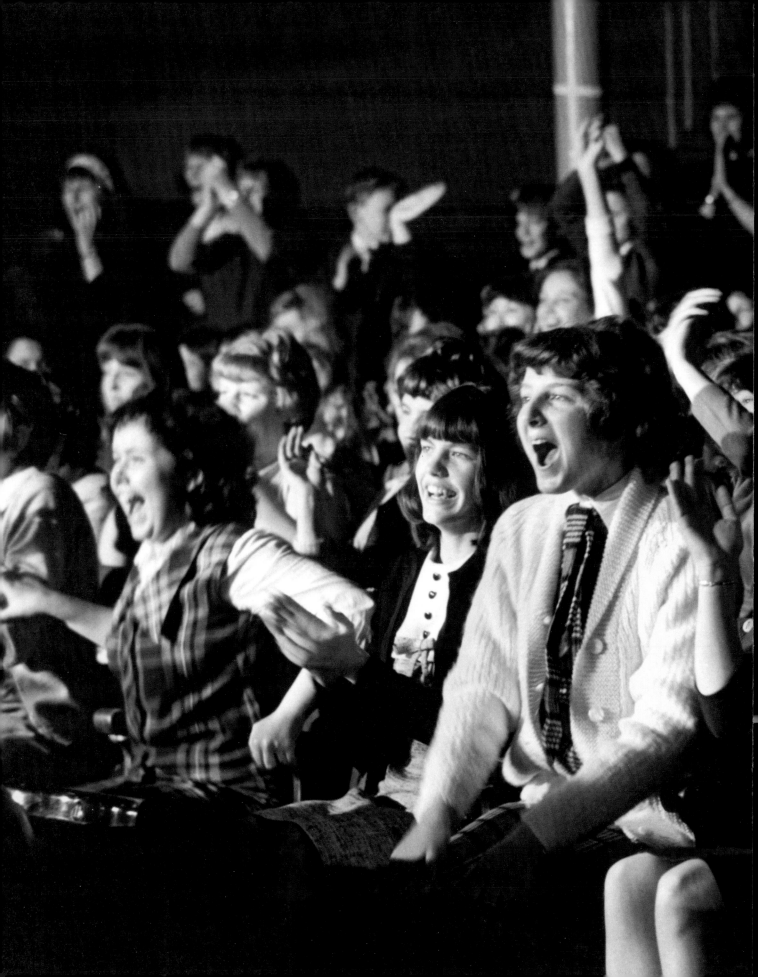

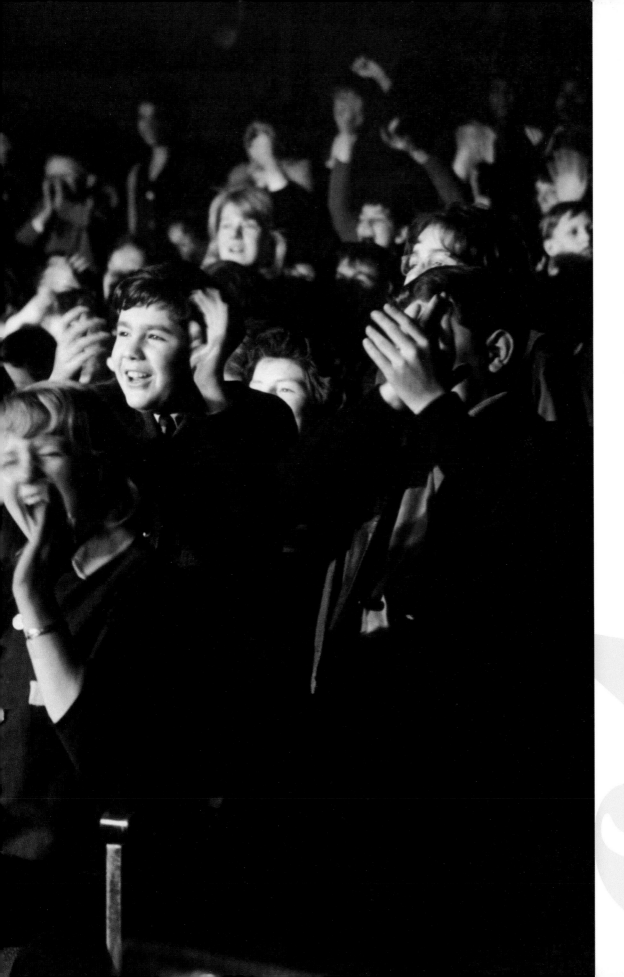

DAVID HURN
Beatlemania,
London, 1964.

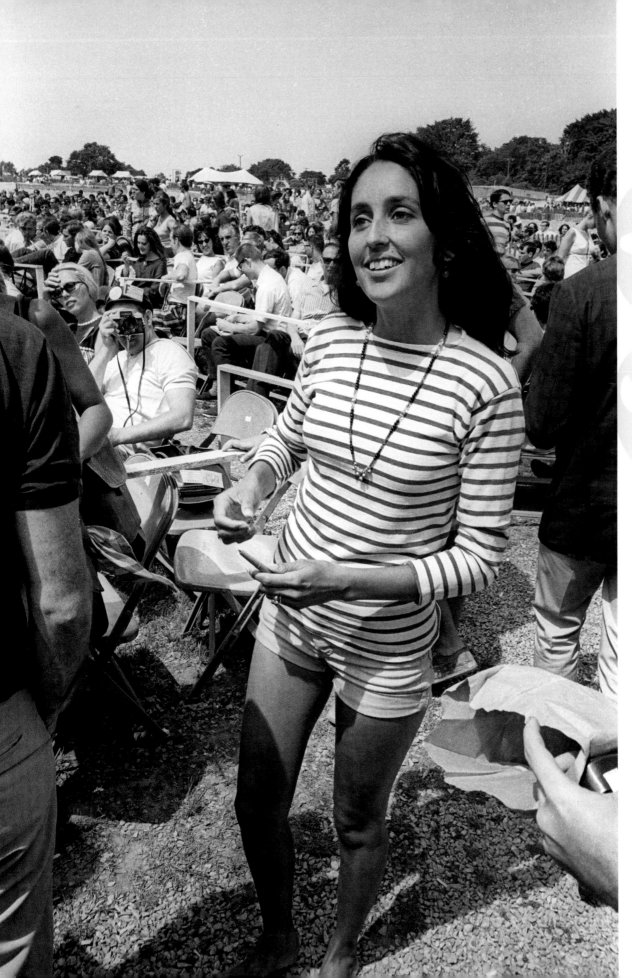

ELLIOTT LANDY
Joan Baez, Newport Folk Festival, Newport, Rhode Island, 1968.

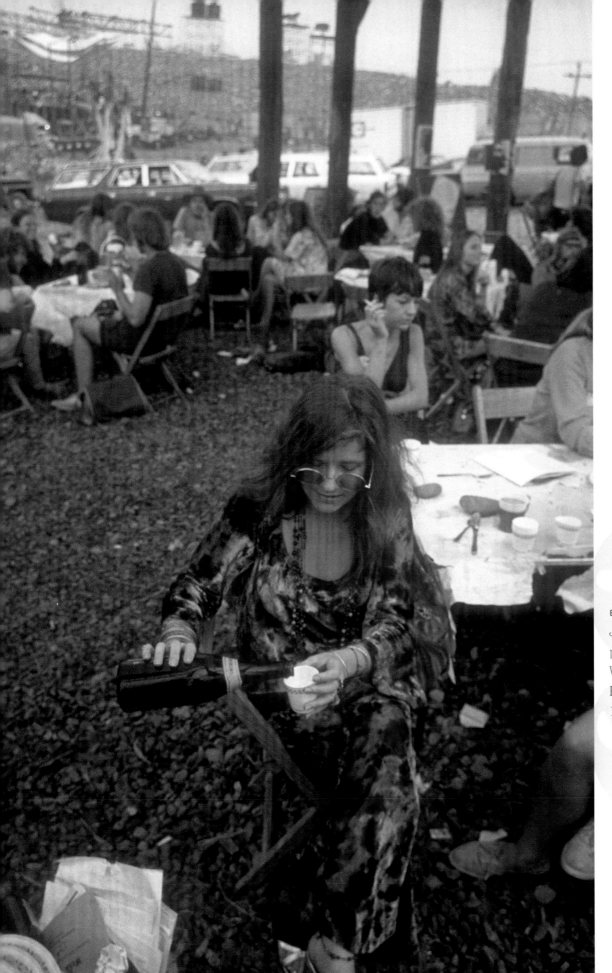

ELLIOTT LANDY
Janis Joplin in the performer's pavilion, Woodstock Festival, Bethel, New York, 1969.

ELLIOTT LANDY

Van Morrison and his wife, Janet, outside
their home, Woodstock, New York, 1969.

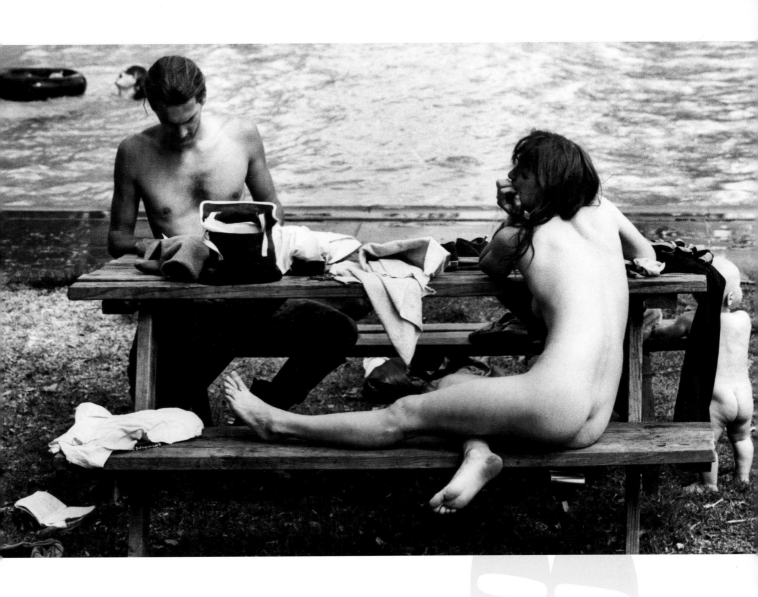

DENNIS STOCK
The McCoy commune, Novato,
California, 1968.

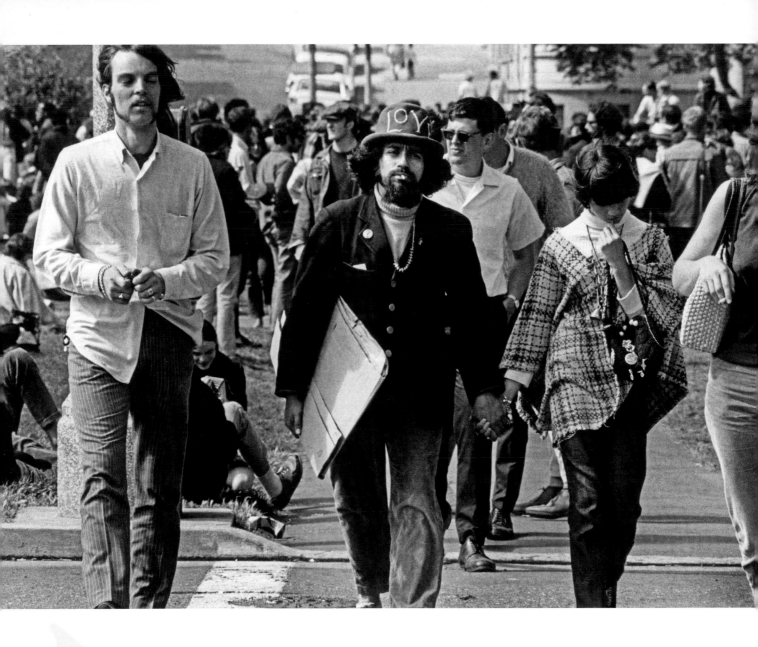

WAYNE MILLER
Haight-Ashbury district,
San Francisco,
California, 1967.

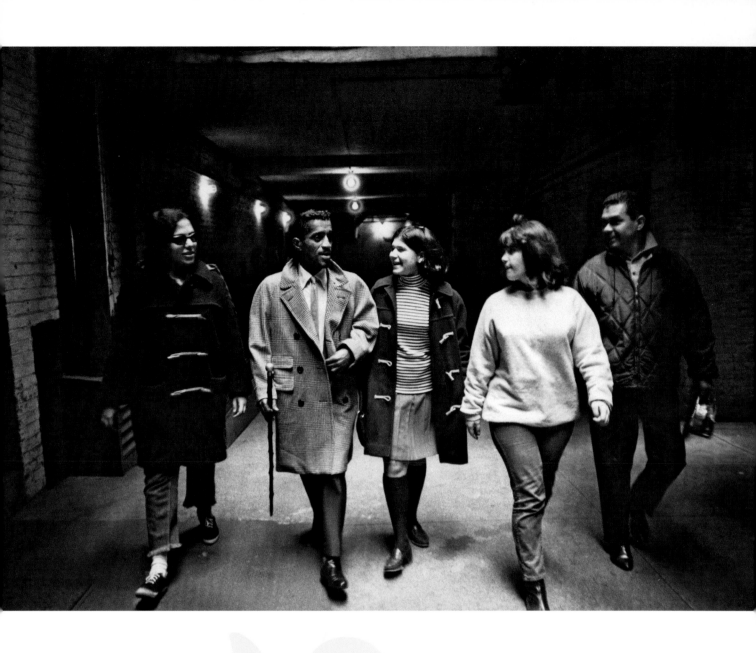

Sammy Davis Jr., New York, 1965.

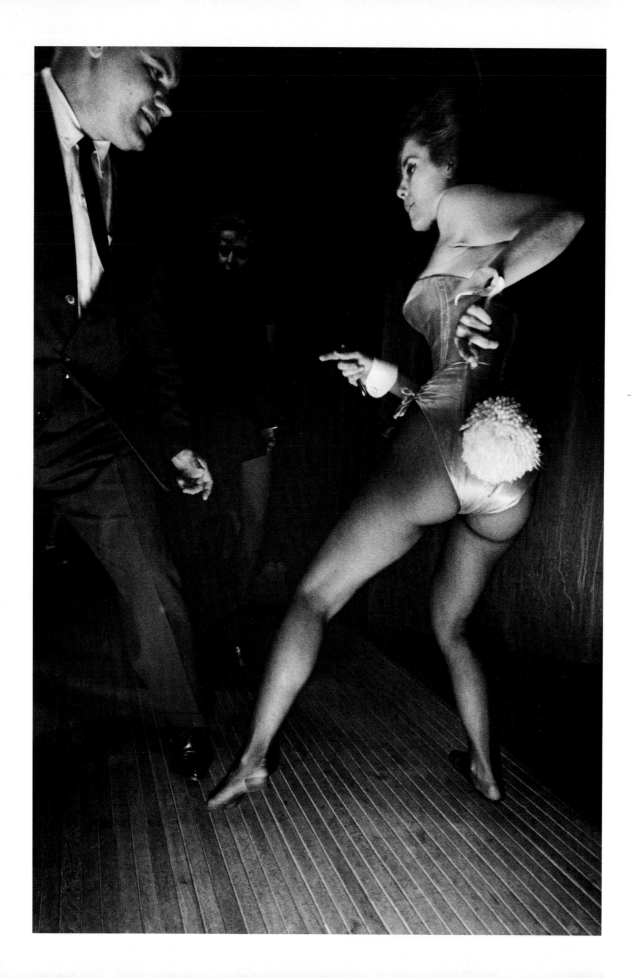

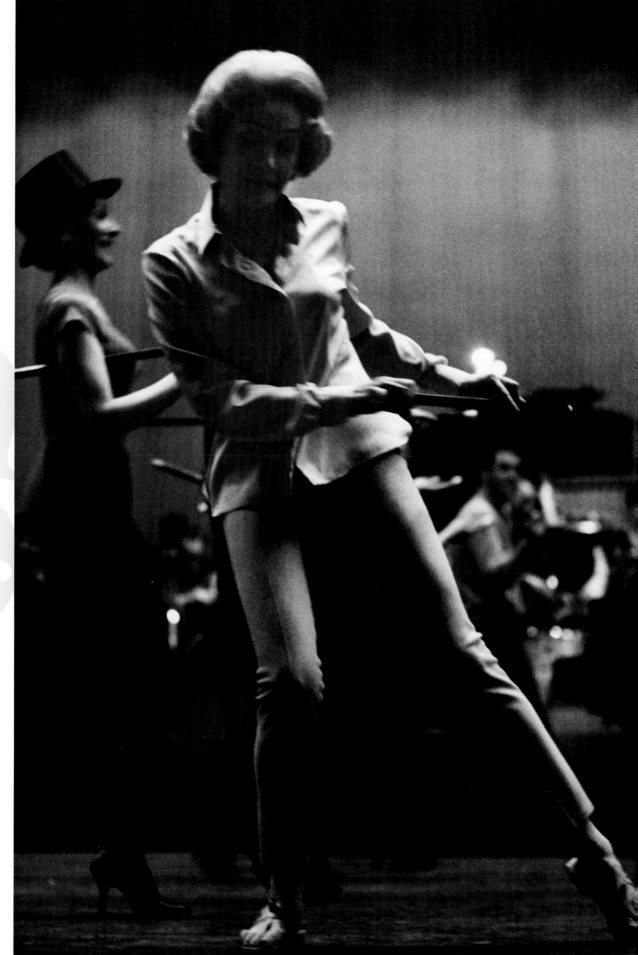

ELLIOTT ERWITT
Playboy Club,
Chicago, Illinois,
1962.

EVE ARNOLD
Marlene Dietrich
during a dress
rehearsal at the
Olympia, Paris,
1962.

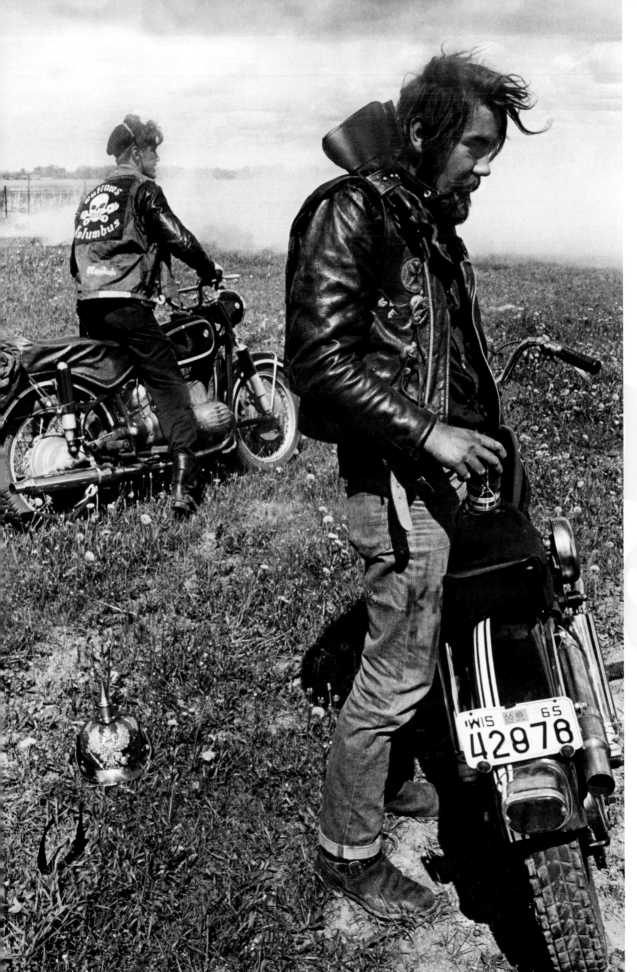

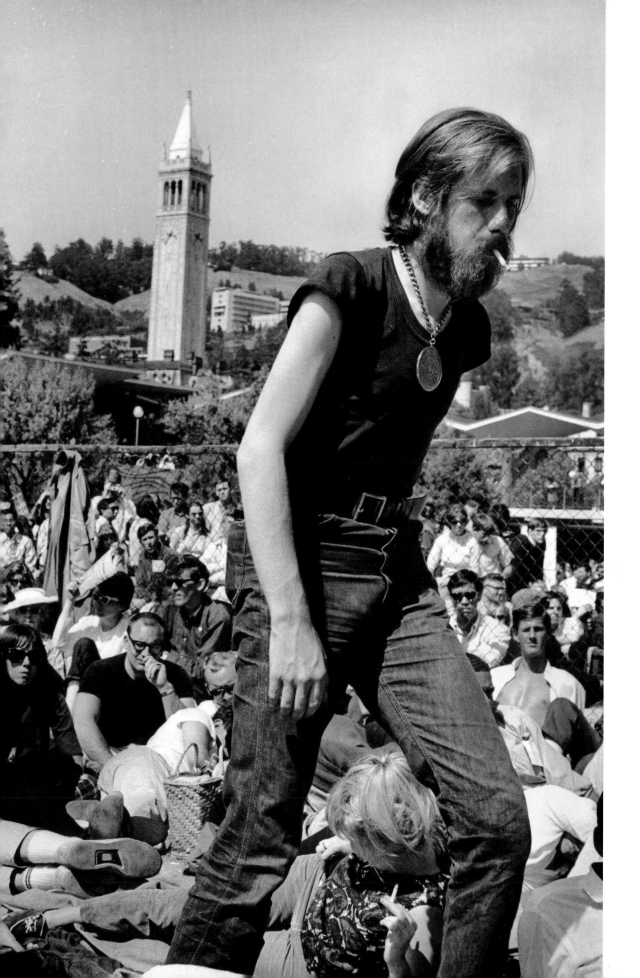

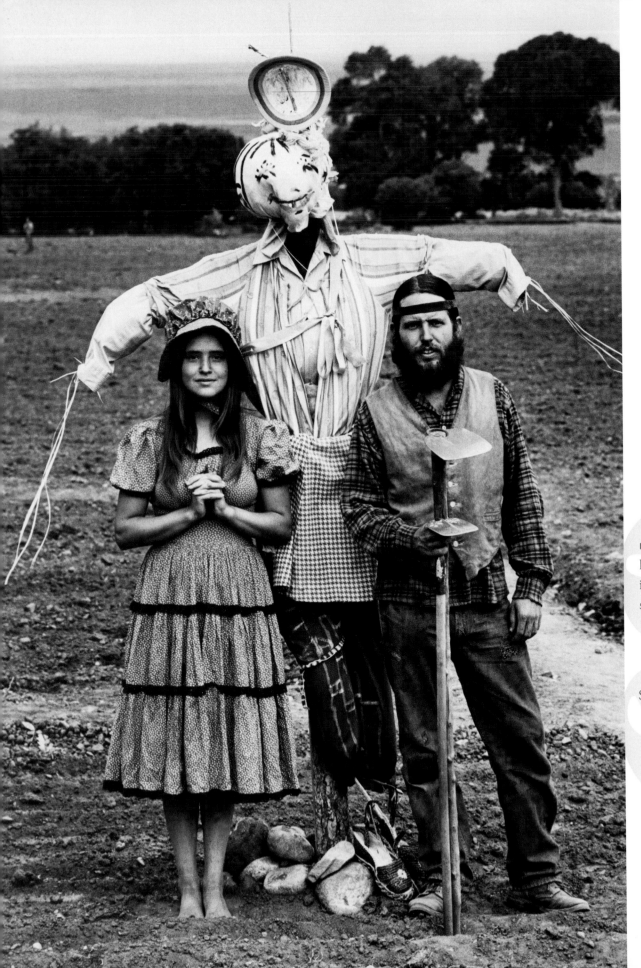

DENNIS STOCK
Portrait of a couple in *American Gothic* style, 1969.

NICOLAS TIKHOMIROFF
Serge Gainsbourg and Jane Birkin wearing Cerruti creations at their apartment on Rue de Verneuil, Paris, 1969.

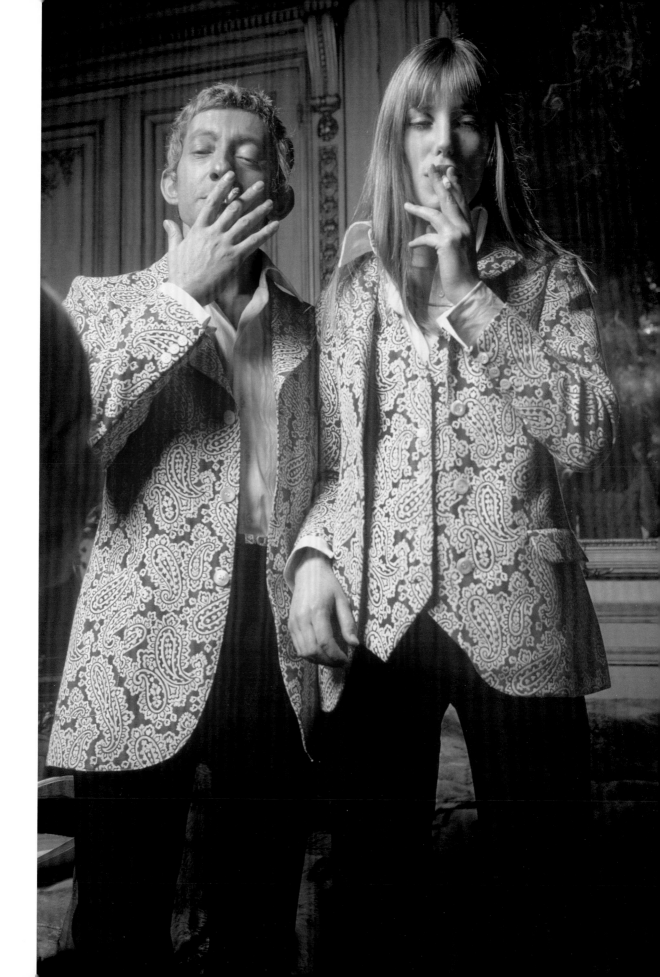

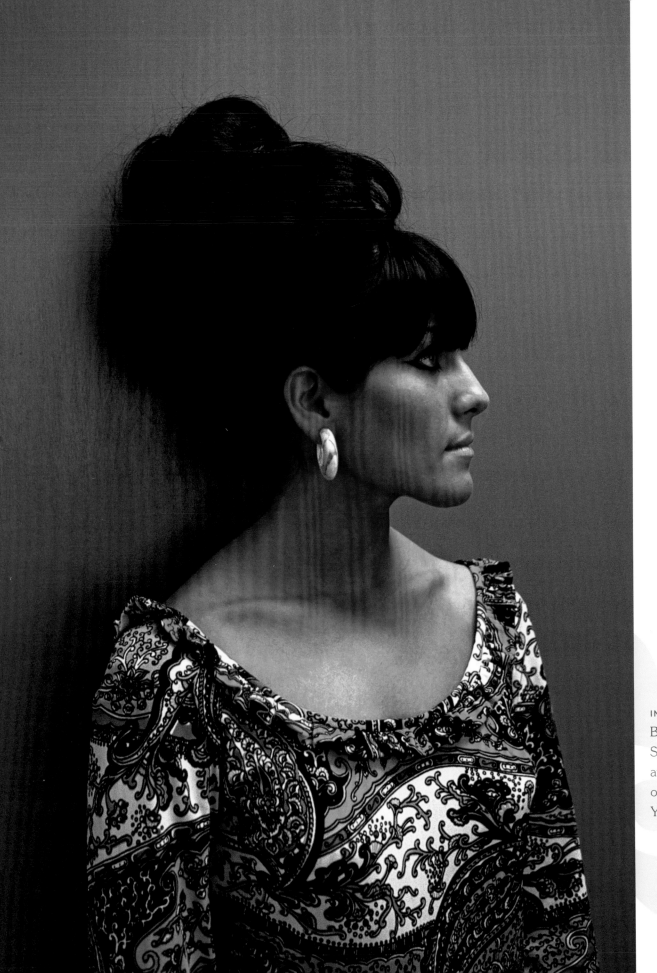

INGE MORATH
Bookkeeper
Sharon Goldberg
at the Magnum
office, New
York, 1965.

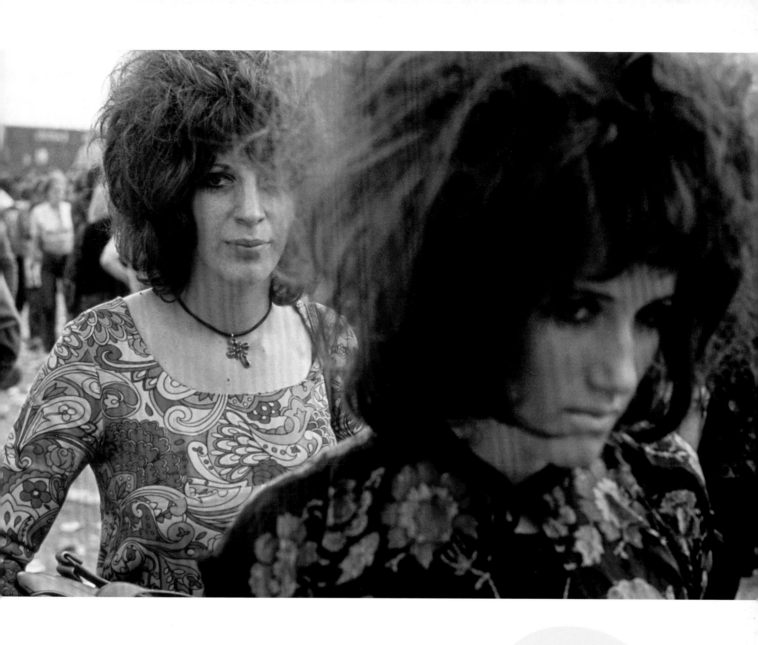

Isle of Wight Festival, England, 1969.

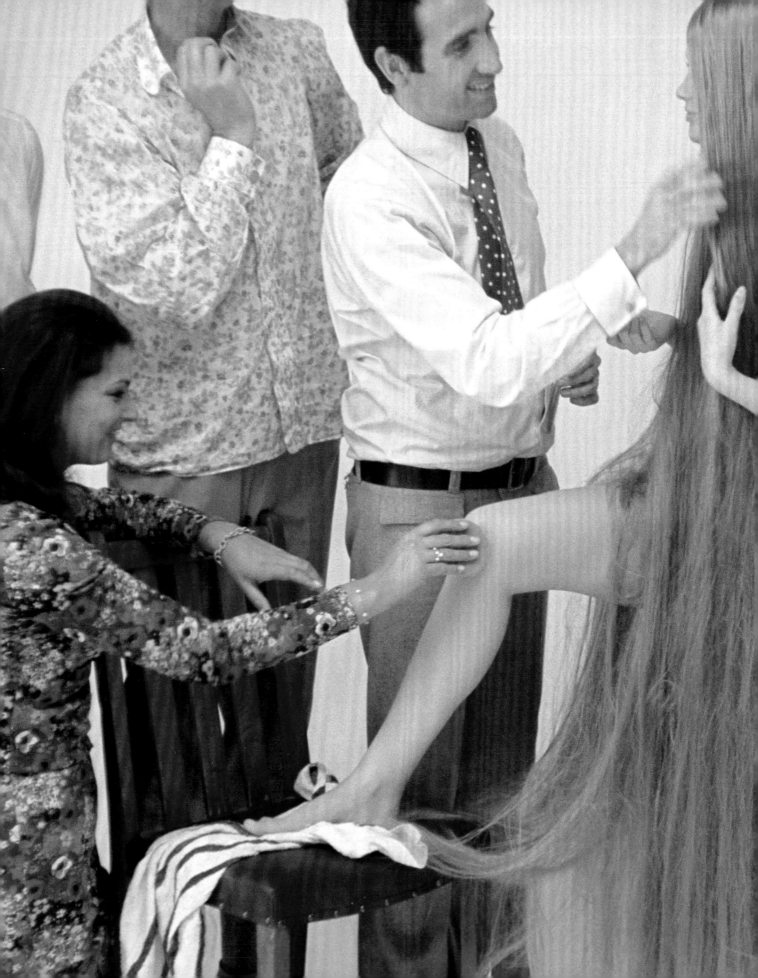

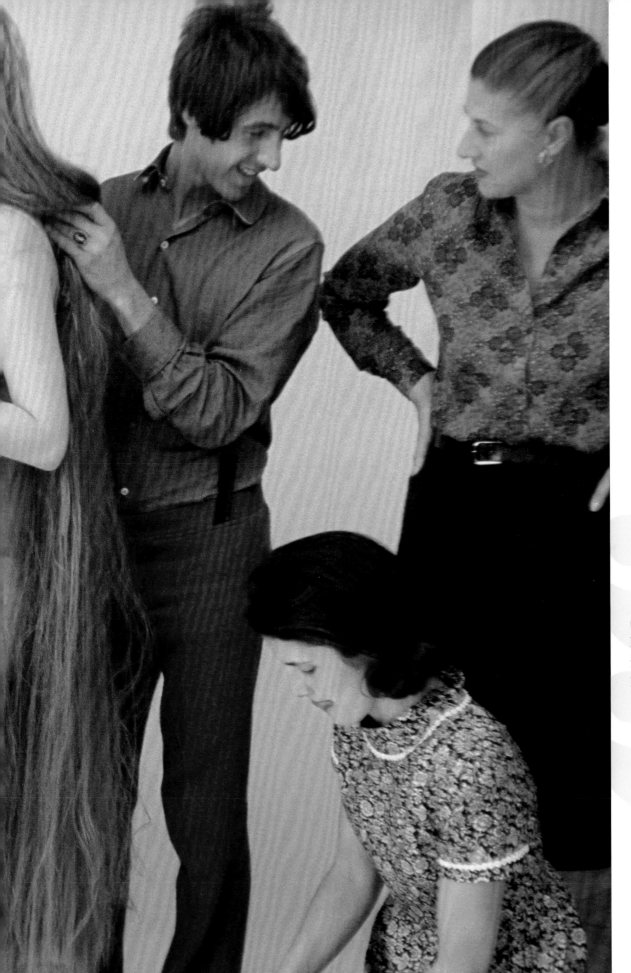

EVE ARNOLD
British *Vogue*
fashion shoot,
London, 1966.

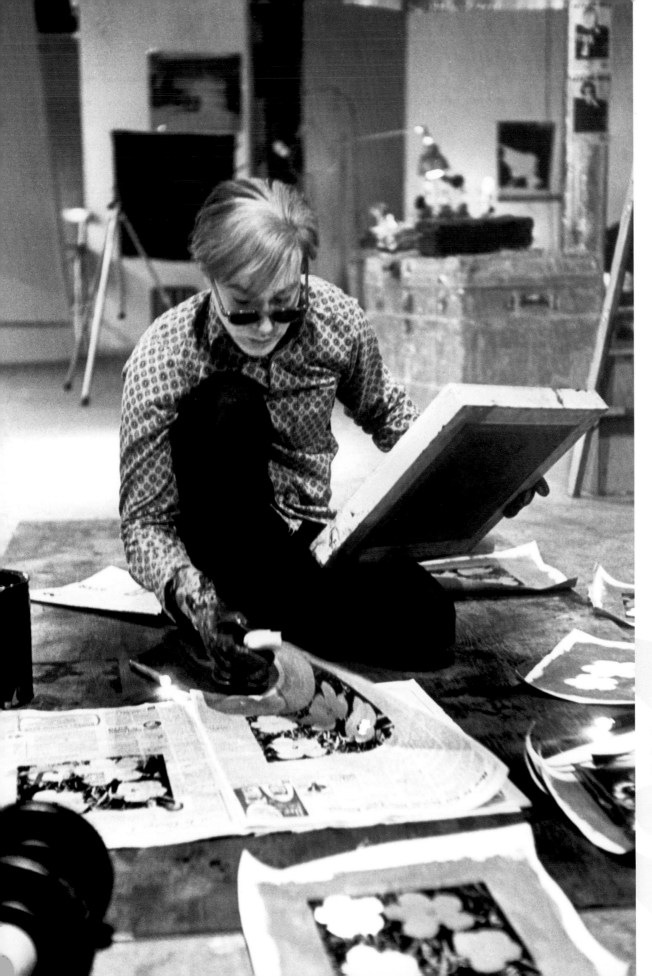

EVE ARNOLD
Andy Warhol,
New York,
1964.

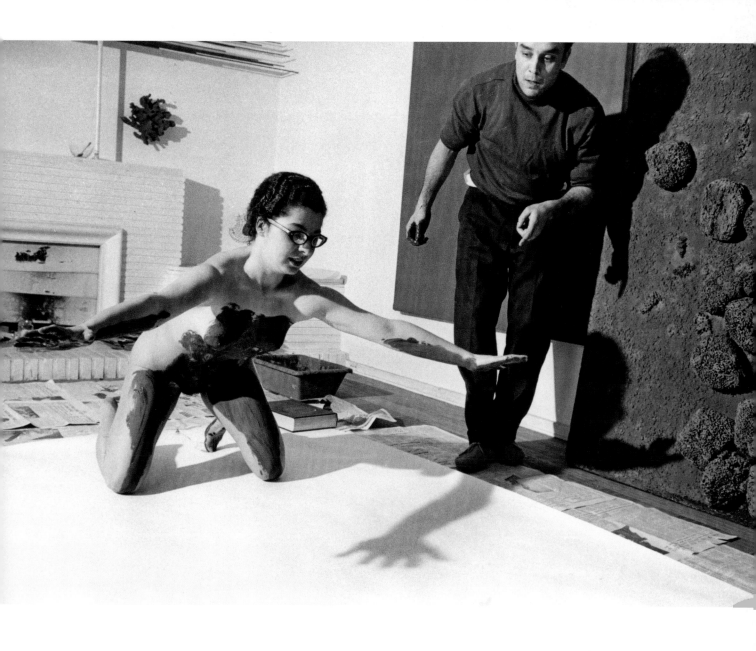

ELLIOTT ERWITT

Yves Klein directing a model for his
body art paintings, Paris, 1961.

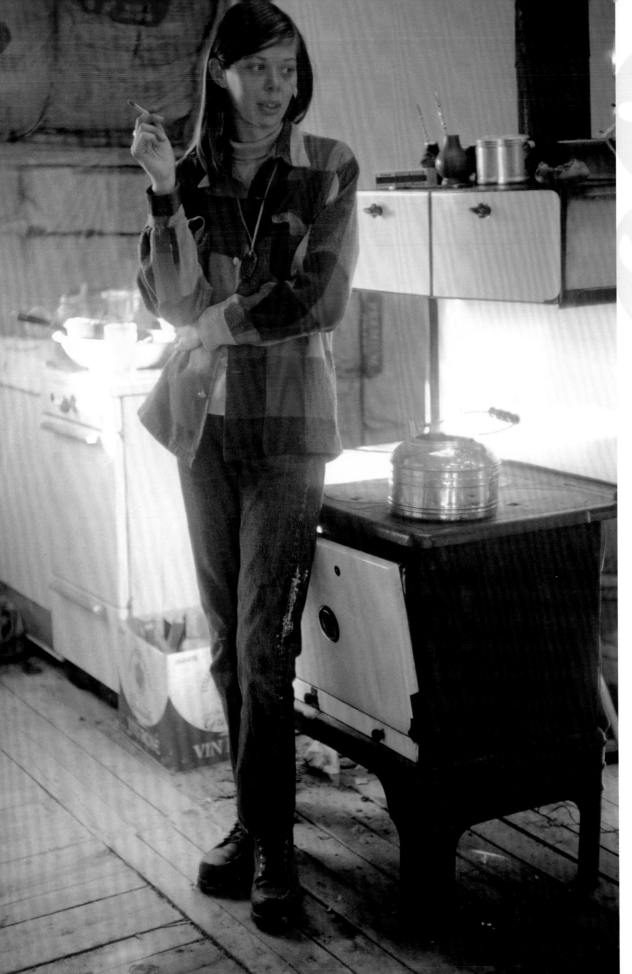

EVE ARNOLD
Drop City hippie
commune, New
Mexico, 1968.

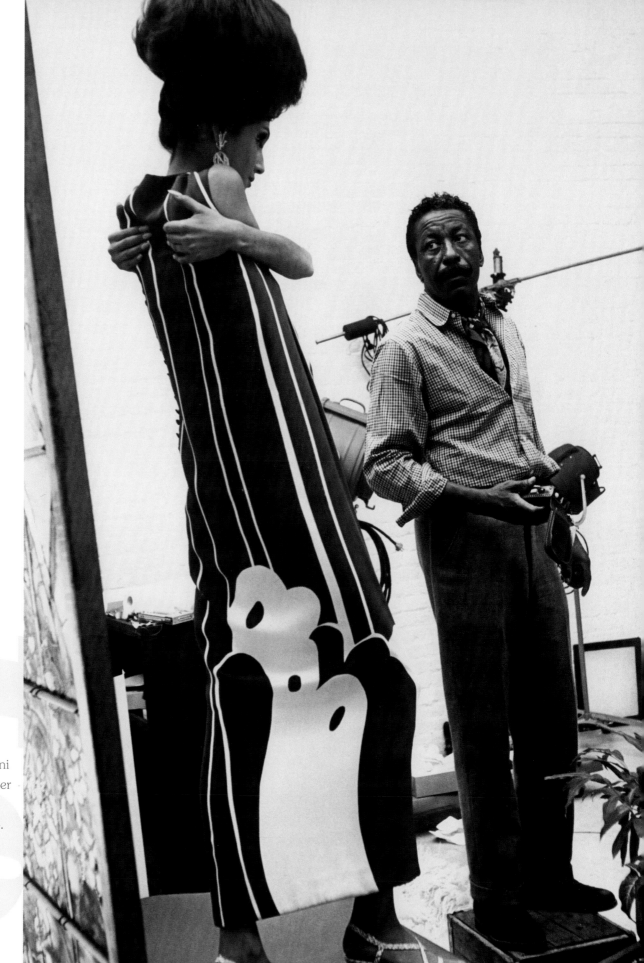

EVE ARNOLD
Italian model
Benedette Bargini
with photographer
Gordon Parks,
New York, 1964.

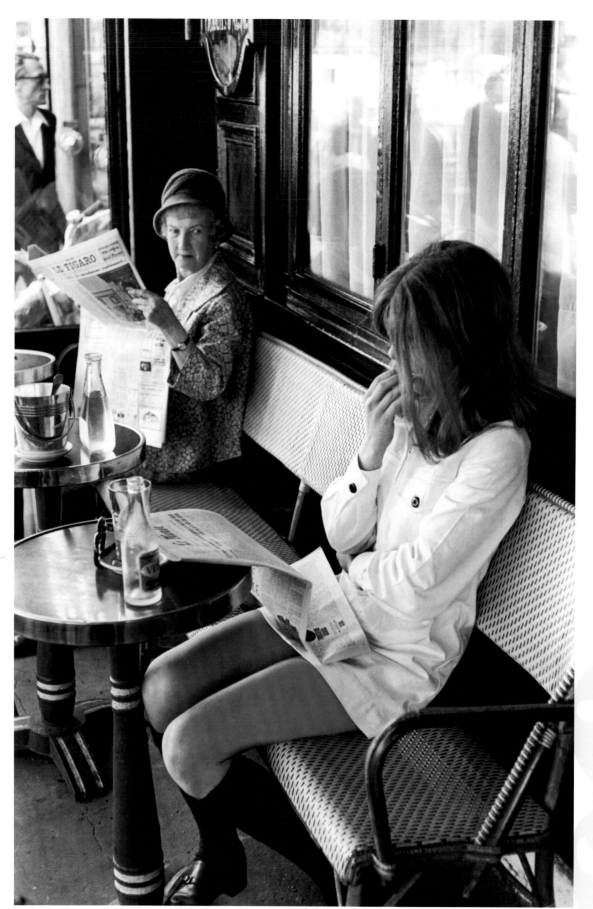

HENRI CARTIER-BRESSON
Brasserie Lipp,
Saint-Germain-
des-Prés, Paris,
1969.

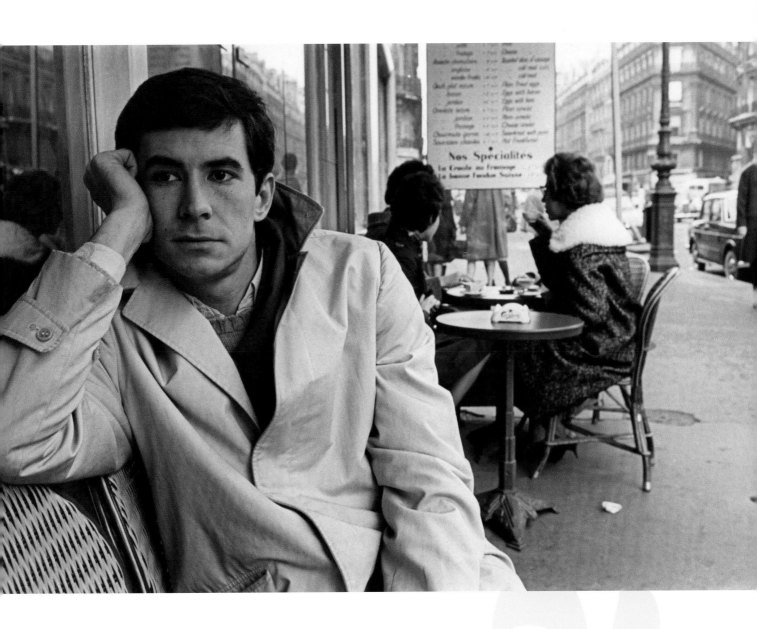

NICOLAS TIKHOMIROFF

Anthony Perkins during the filming of
Five Miles to Midnight, Paris, 1962.

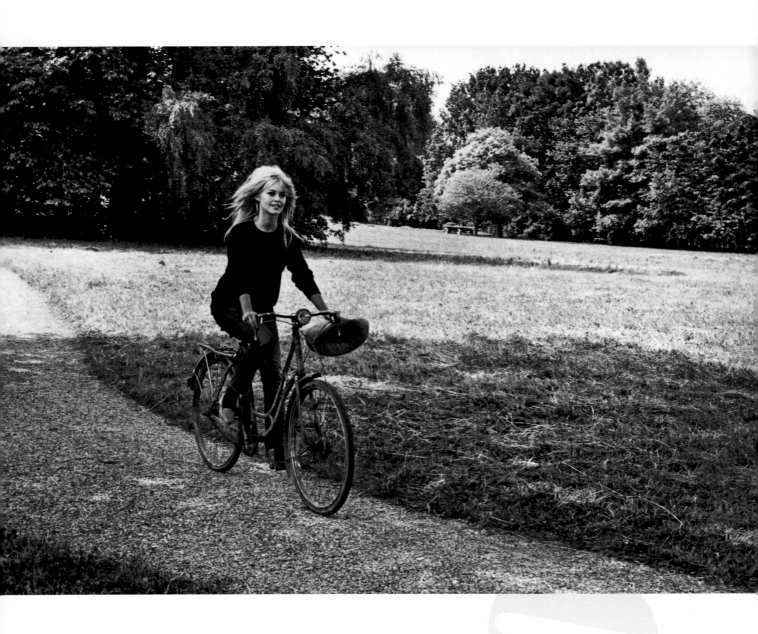

RAYMOND DEPARDON

Brigitte Bardot riding
through the Bois de
Boulogne, Paris, 1960.

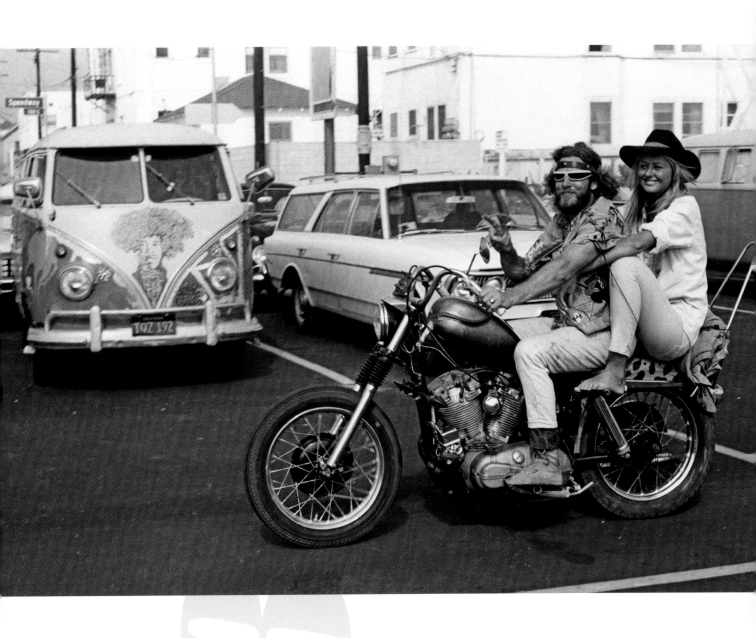

DENNIS STOCK
Bikers, California, 1968.

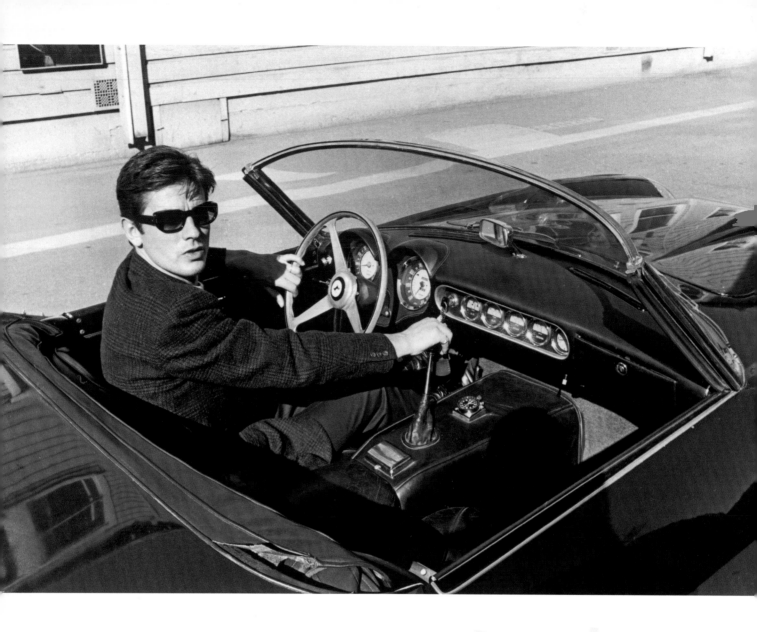

WAYNE MILLER

Alain Delon during the filming of
Once a Thief, Hollywood, 1964.

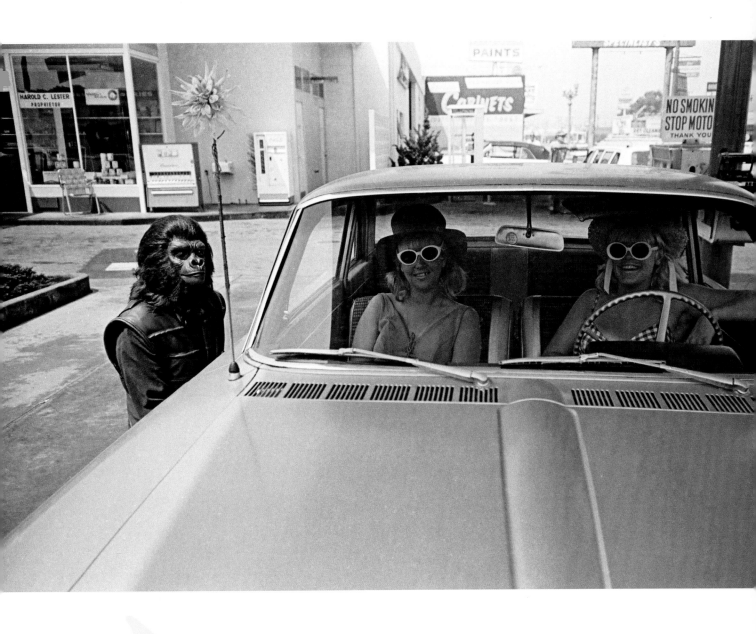

DENNIS STOCK

On the set of *Planet of the Apes*,
Hollywood, 1967.

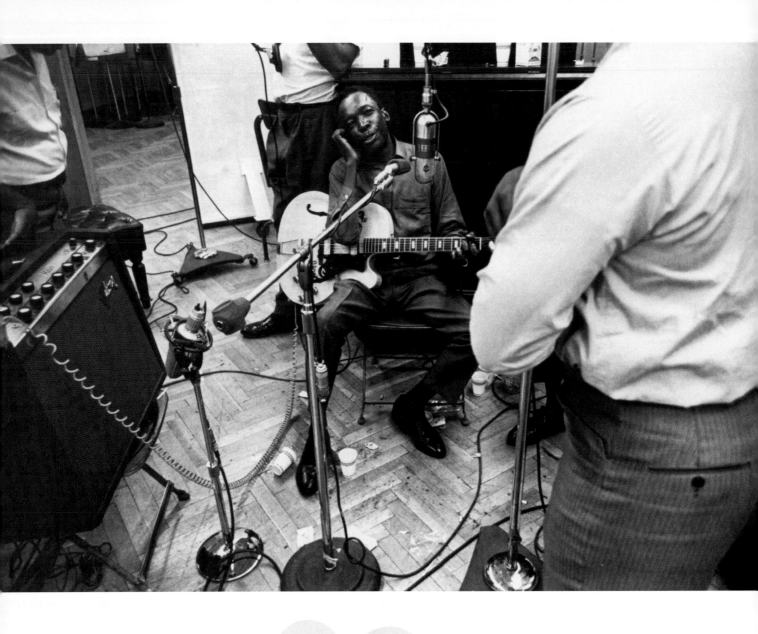

John Lee Hooker in
the recording studio,
New York, 1968.

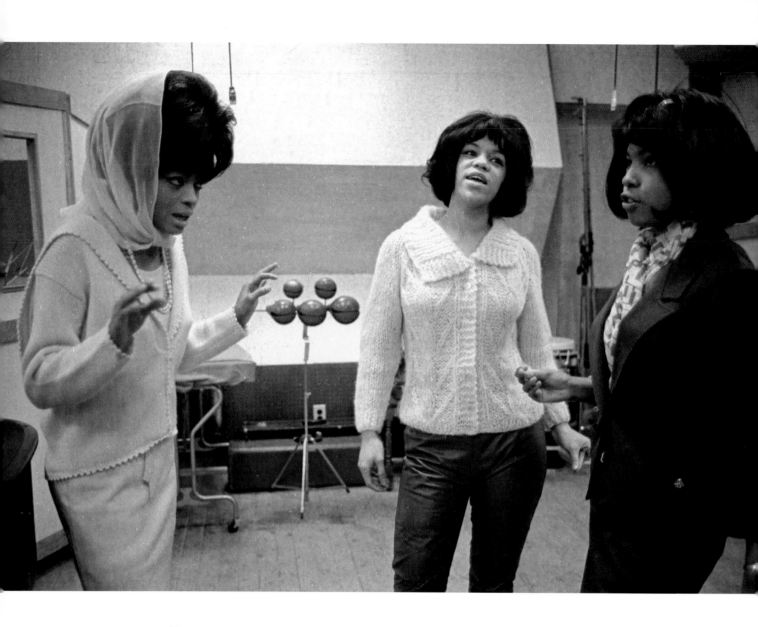

BRUCE DAVIDSON

The Supremes at the Motown recording
studios, Detroit, Michigan, 1965.

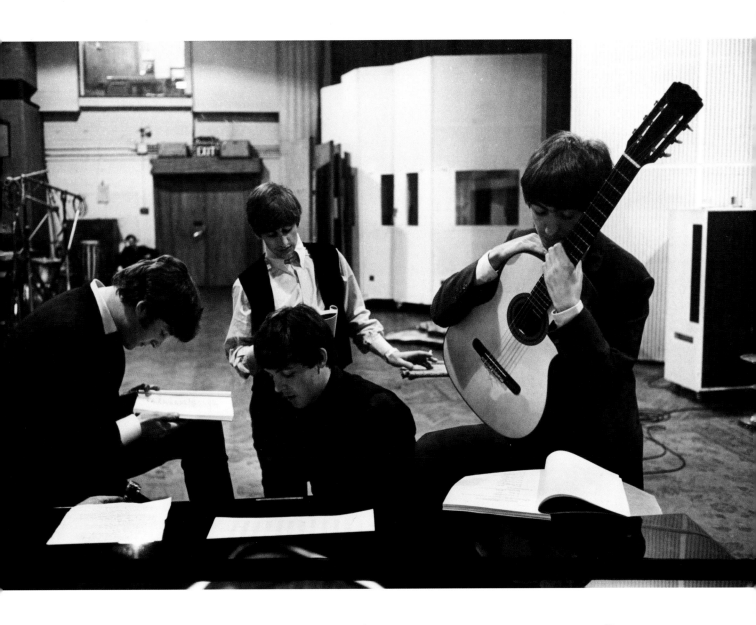

The Beatles at Abbey Road
Studios, examining the script
for their film *A Hard Day's
Night*, London, 1964.

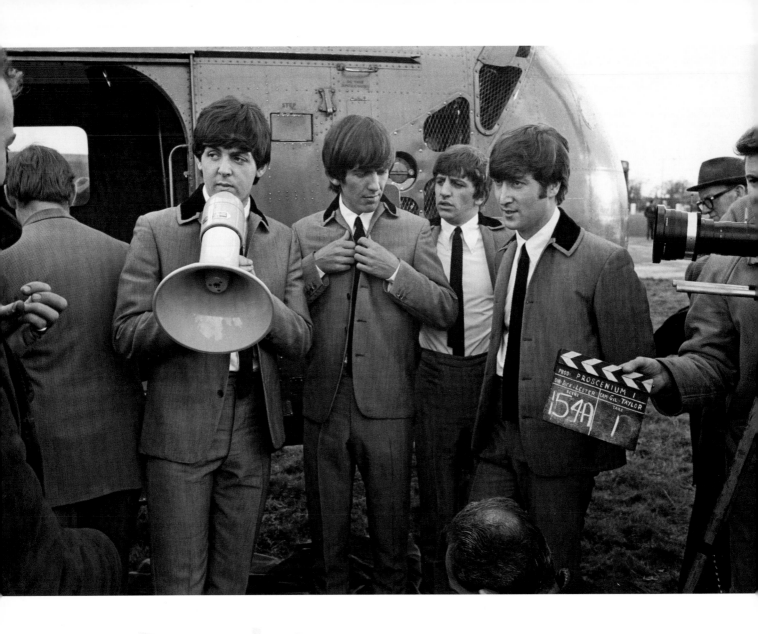

DAVID HURN

The Beatles during the
filming of *A Hard Day's
Night*, London 1964.

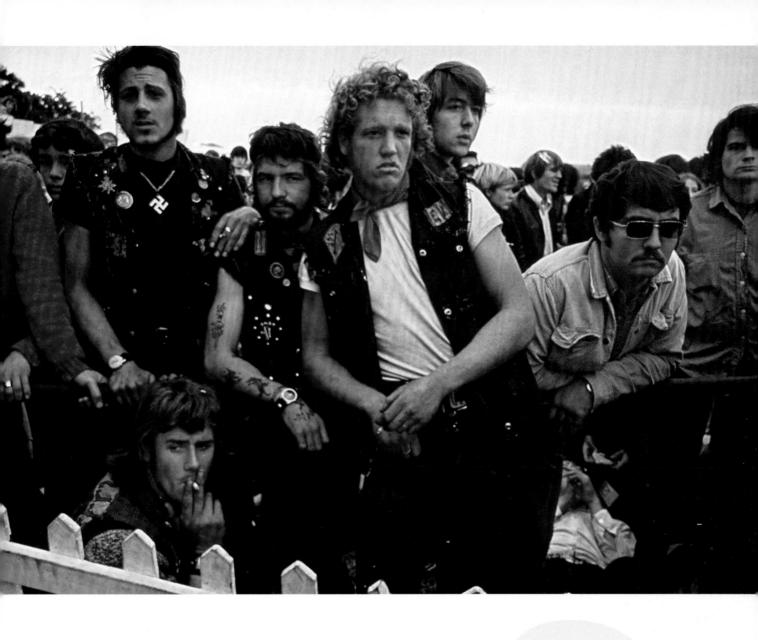

DAVID HURN

Hells Angels, Isle of Wight Festival,
England, 1969.

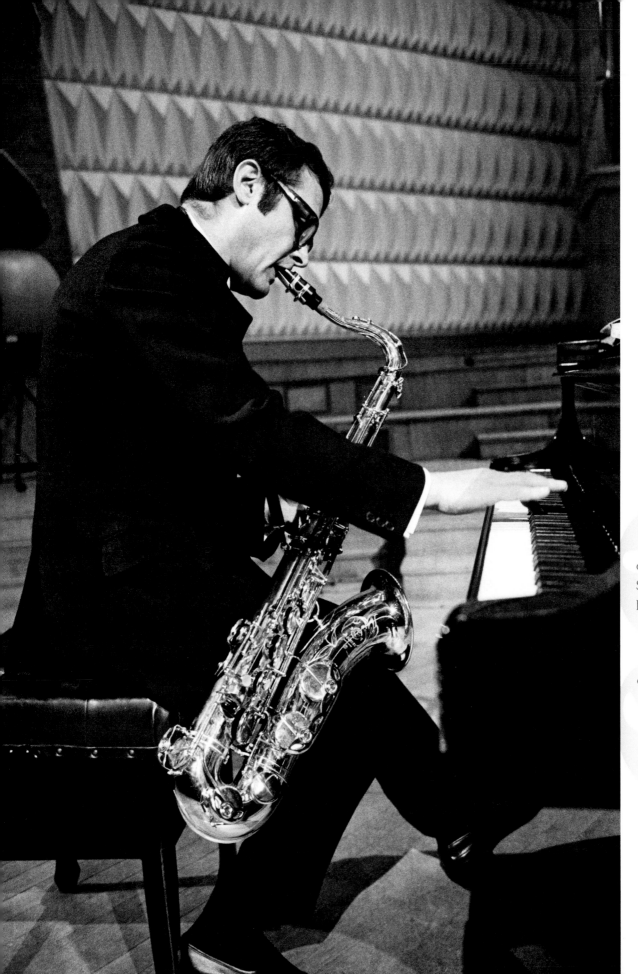

GUY LE QUERREC
Stan Getz,
Paris, 1969.

GUY LE QUERREC
Miles Davis,
Paris, 1969.

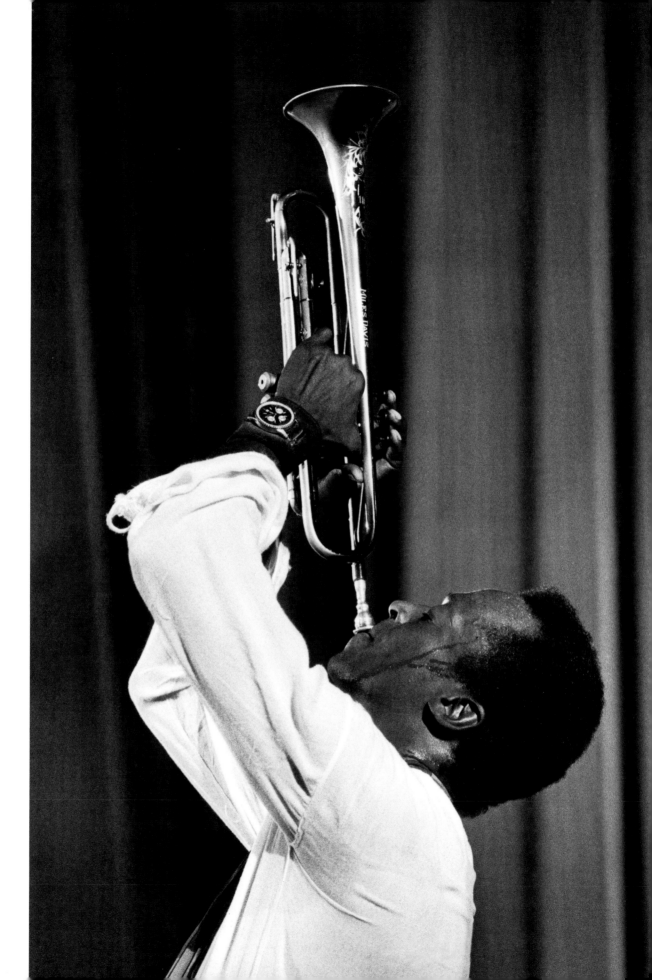

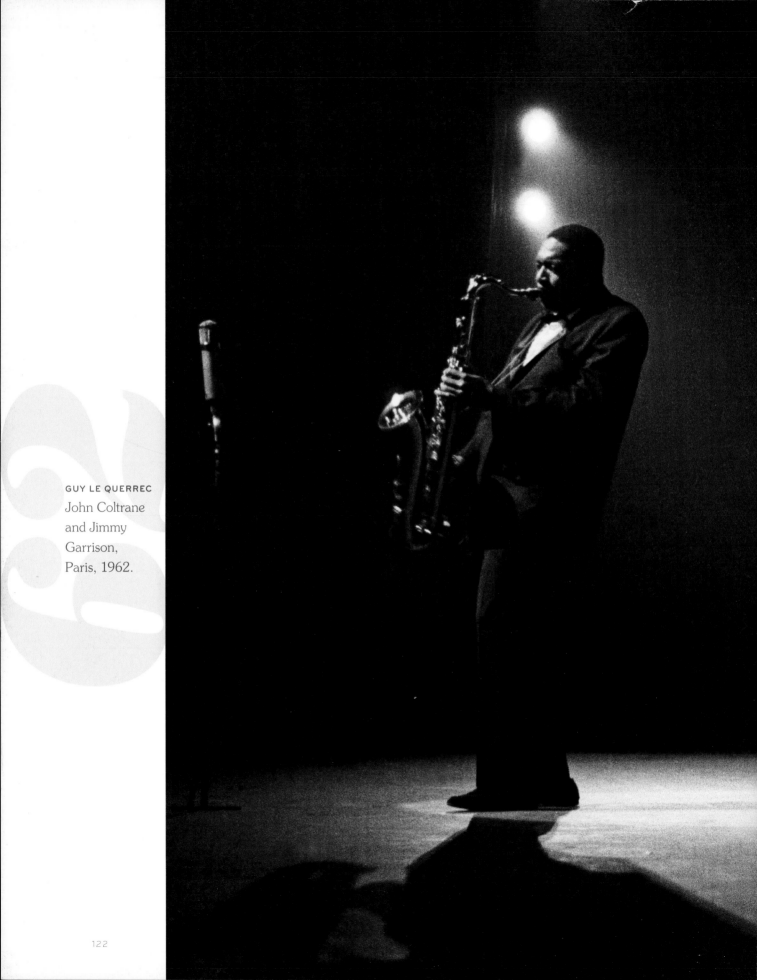

GUY LE QUERREC
John Coltrane
and Jimmy
Garrison,
Paris, 1962.

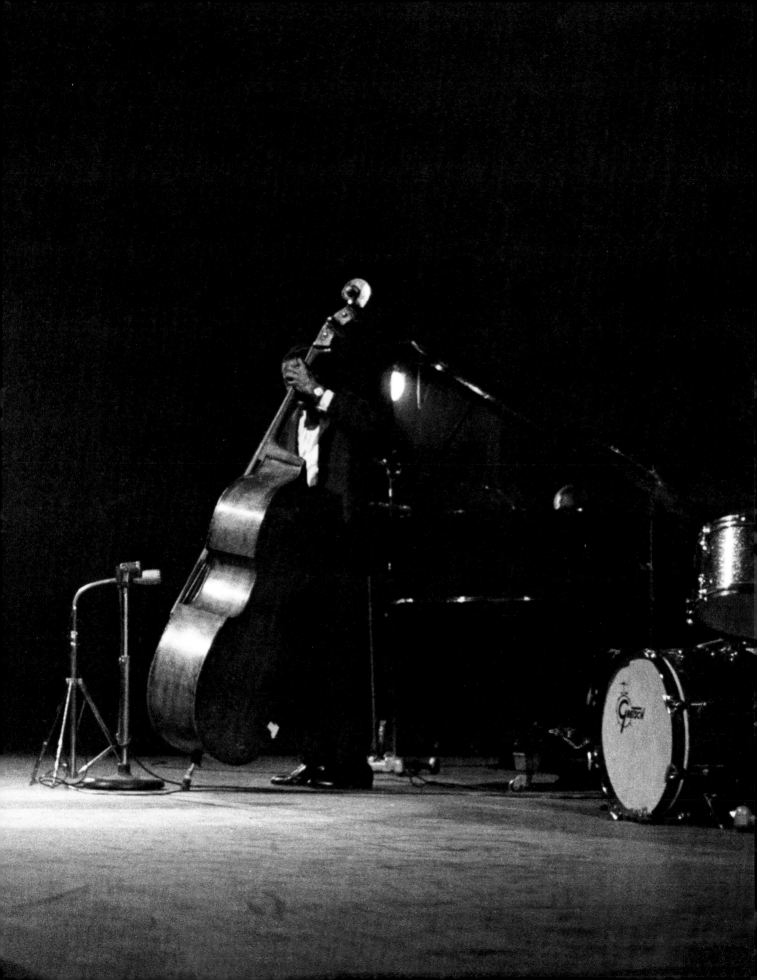

My idea of a
is one that's
of a famous

good picture in focus and person.

ANDY WARHOL, *ANDY WARHOL'S EXPOSURES*

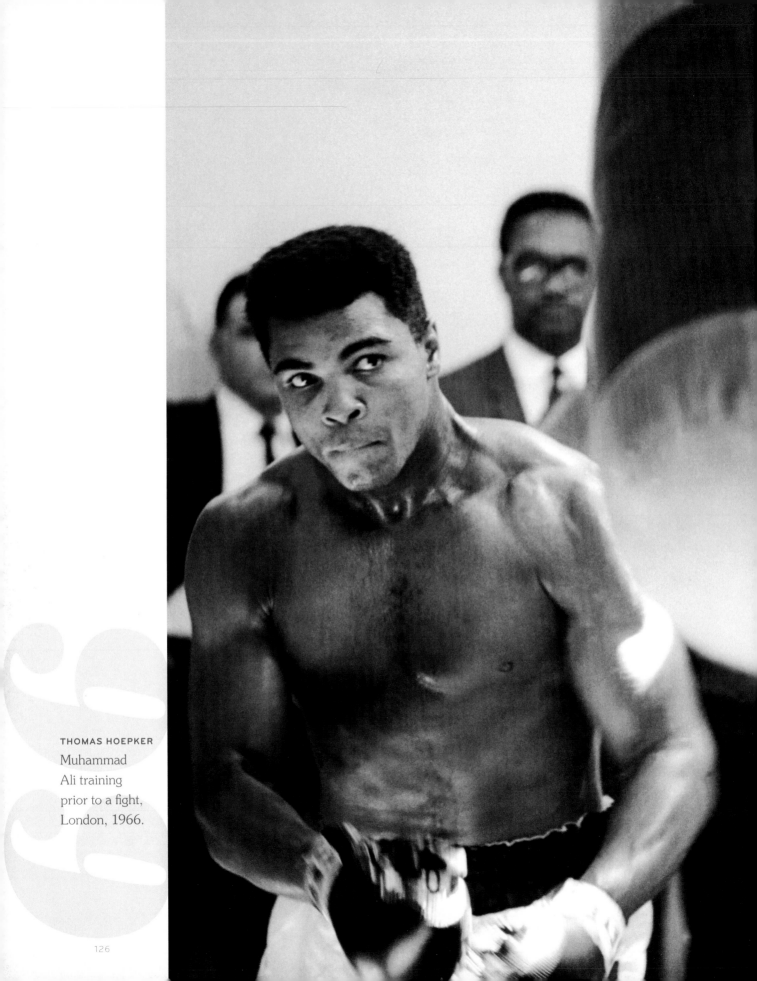

THOMAS HOEPKER
Muhammad Ali training prior to a fight, London, 1966.

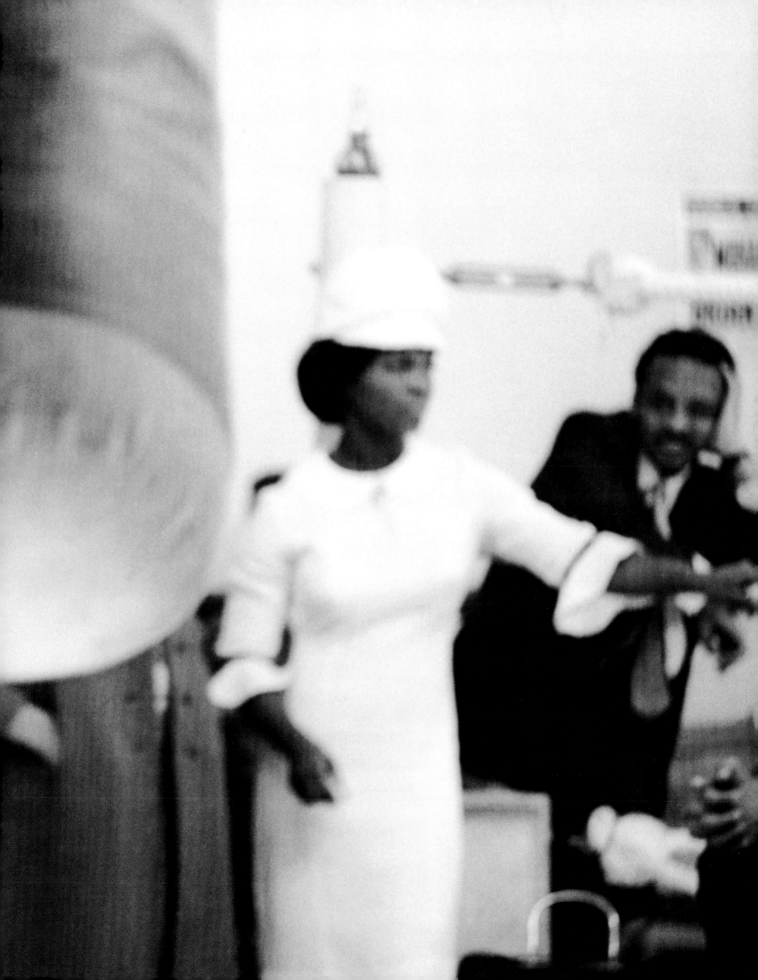

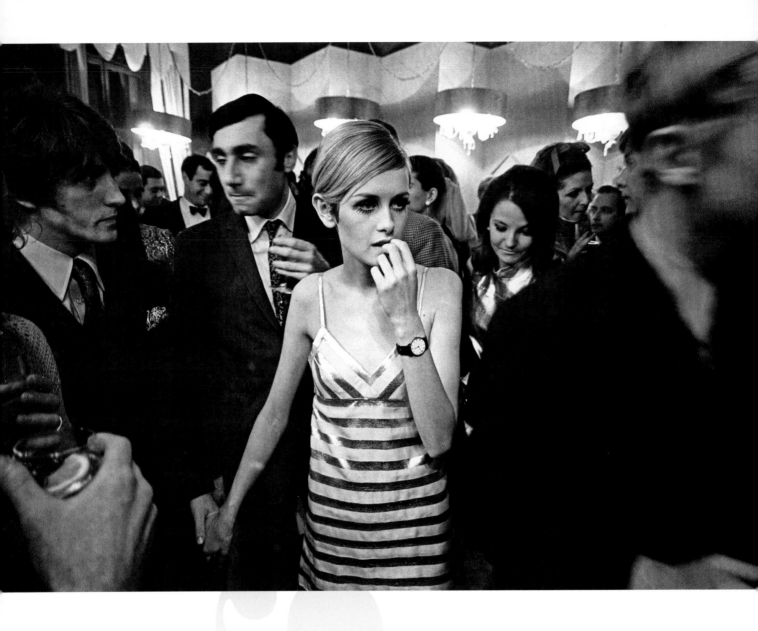

BURT GLINN

Twiggy with Justin de Villeneuve,
London, 1966.

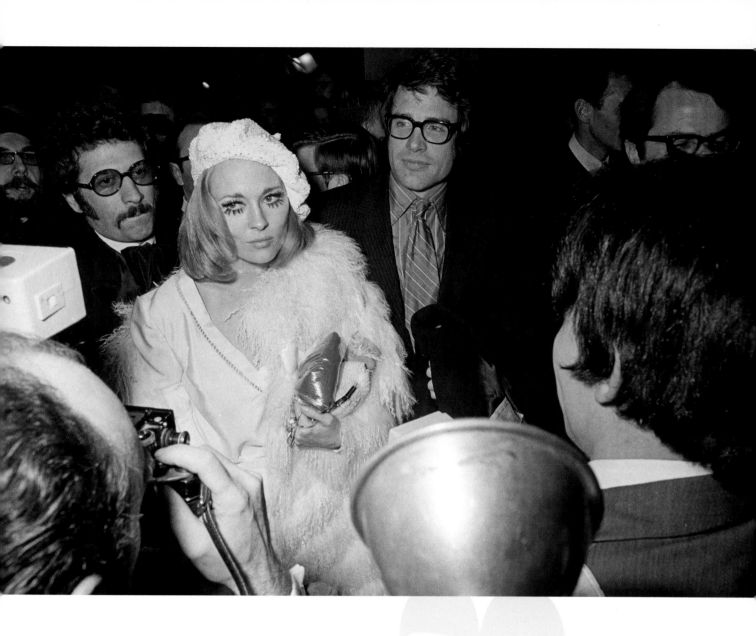

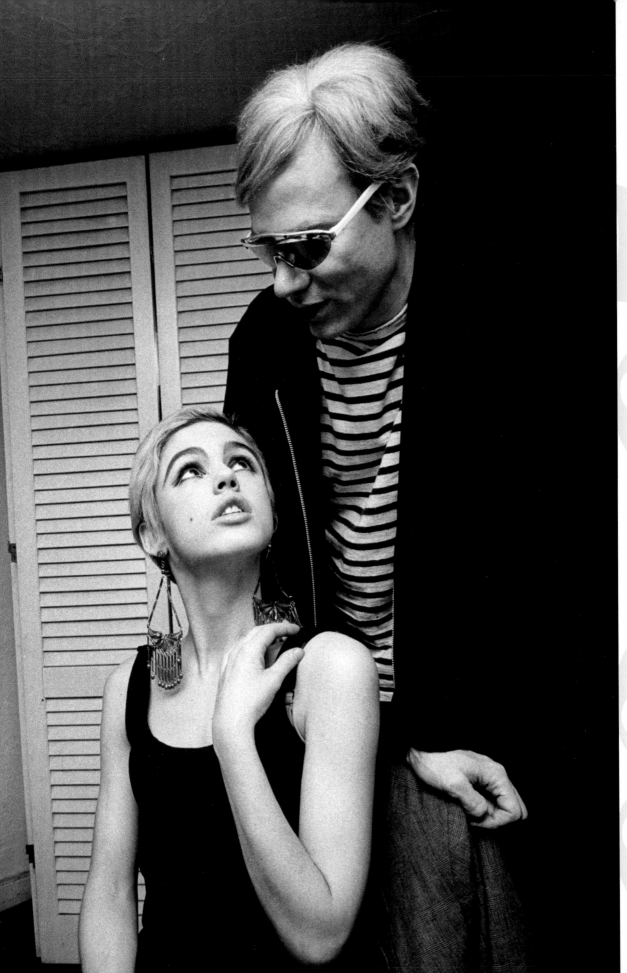

BOB ADELMAN
Andy Warhol and
Edie Sedgwick
at a dinner party,
New York, 1965.

PHILIPPE HALSMAN
Alfred Hitchcock
and François
Truffaut,
California,
1962.

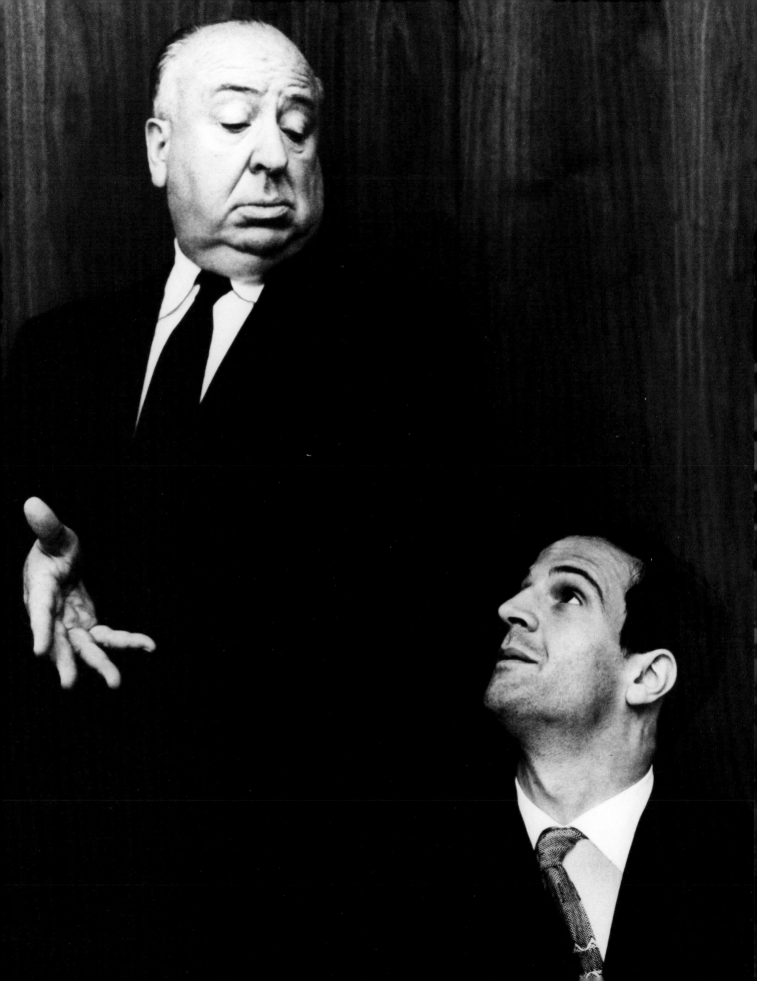

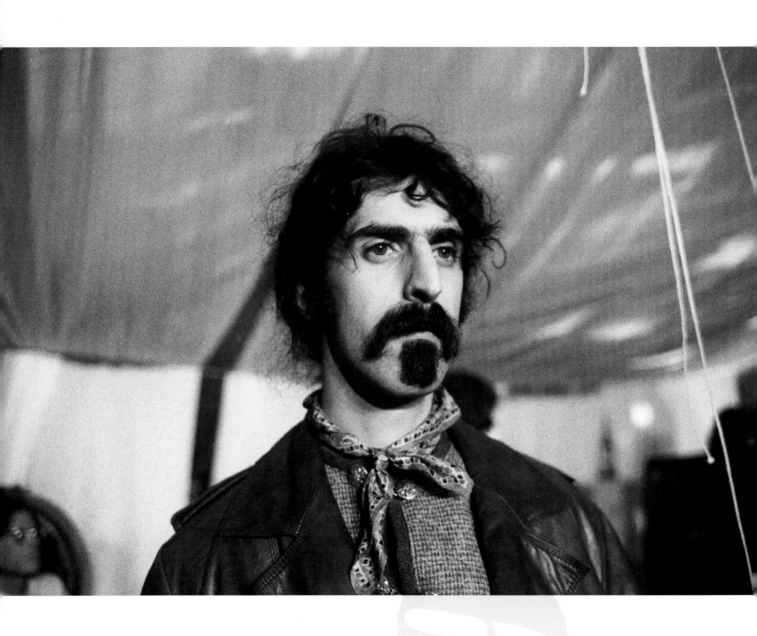

GUY LE QUERREC
Frank Zappa, Amougies Pop
and Jazz Festival, Belgium, 1969.

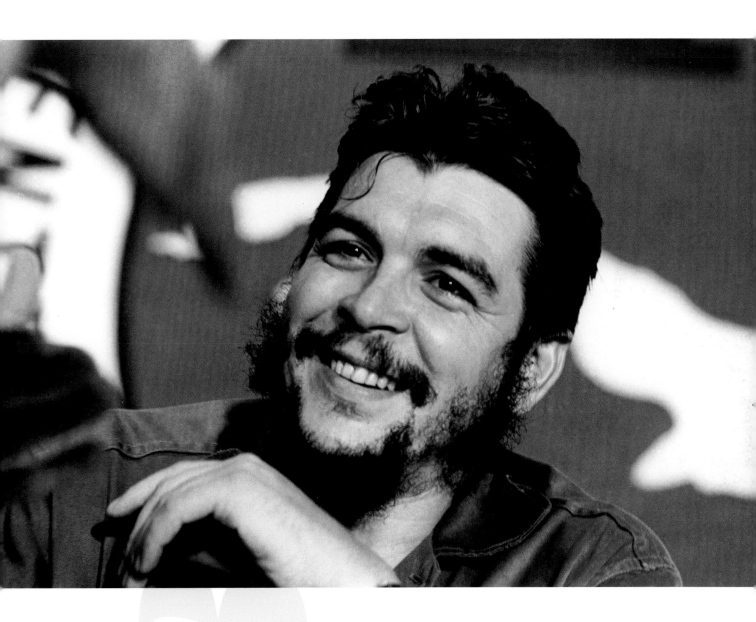

Ernesto "Che" Guevara during a dinner
given in honor of exemplary workers,
Havana, Cuba, 1963.

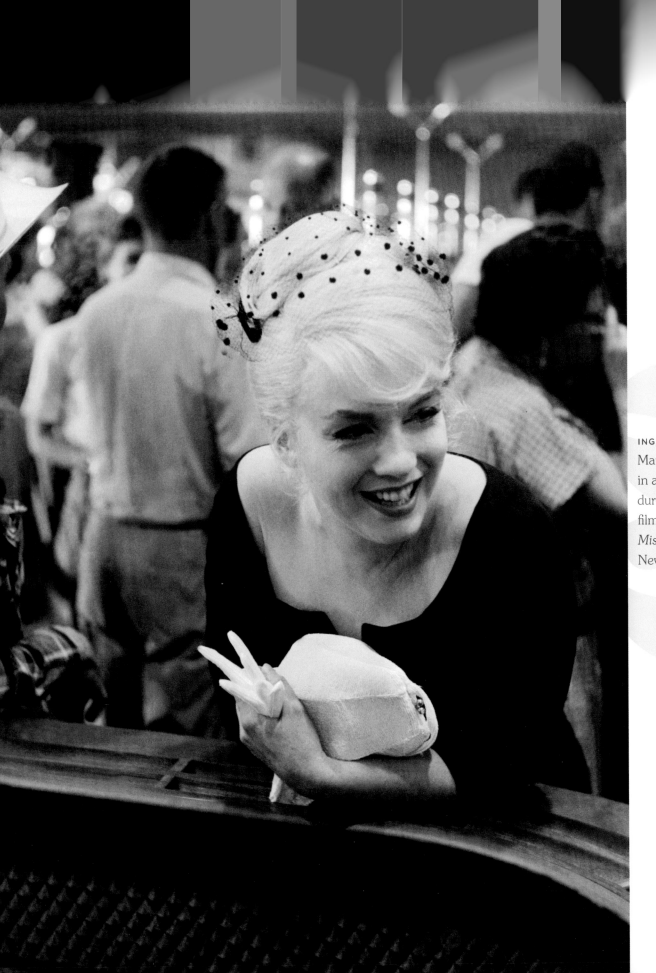

Marilyn Monroe in a casino during the filming of *The Misfits*, Reno, Nevada, 1960.

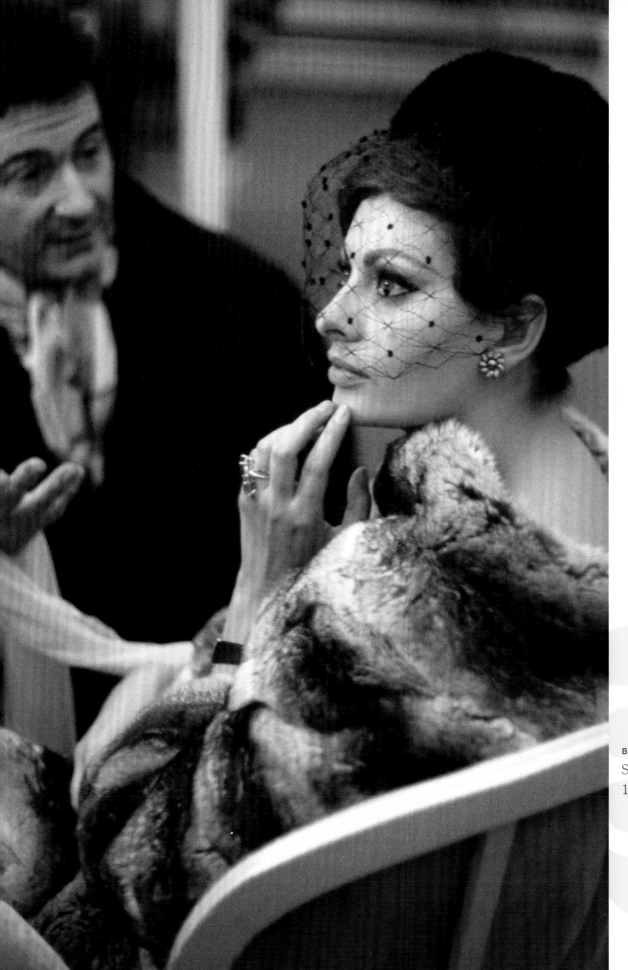

135

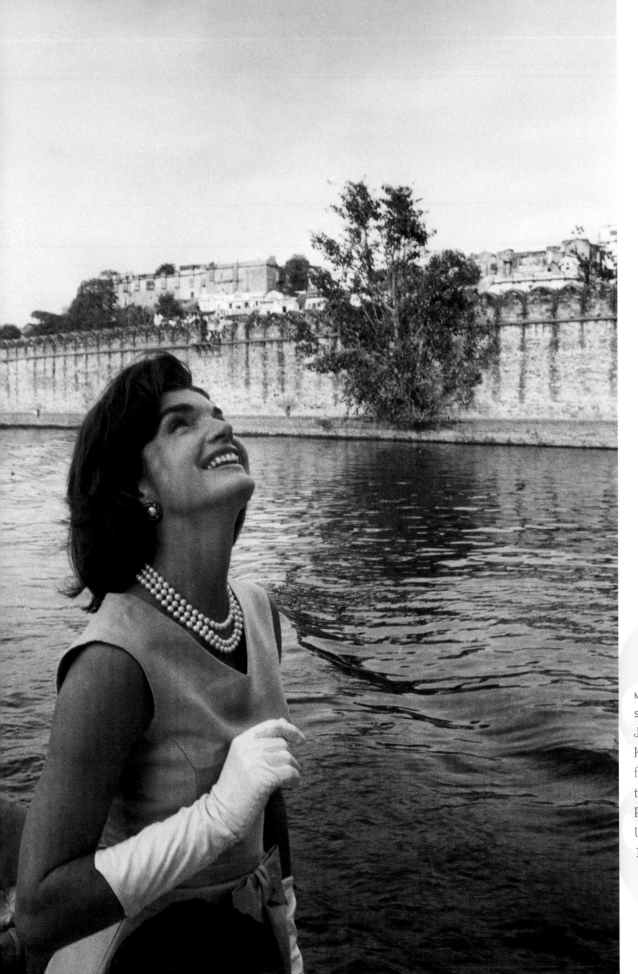

MARILYN
SILVERSTONE
Jacqueline
Kennedy returns
from a visit to
the Taj Lake
Palace Hotel,
Udaipur, India,
1962.

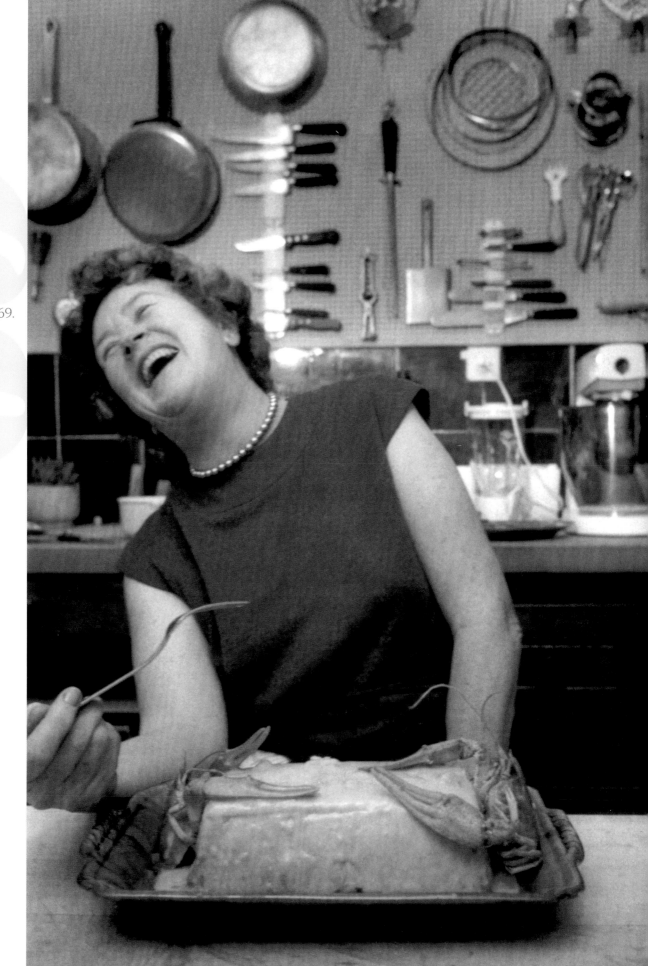

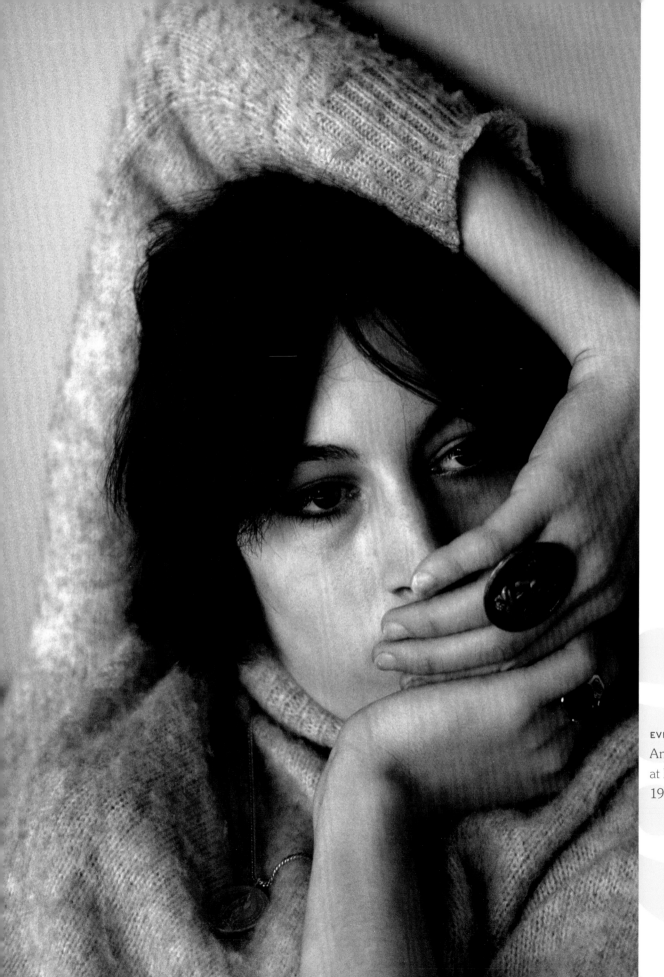

EVE ARNOLD
Anjelica Huston
at home, Ireland,
1968.

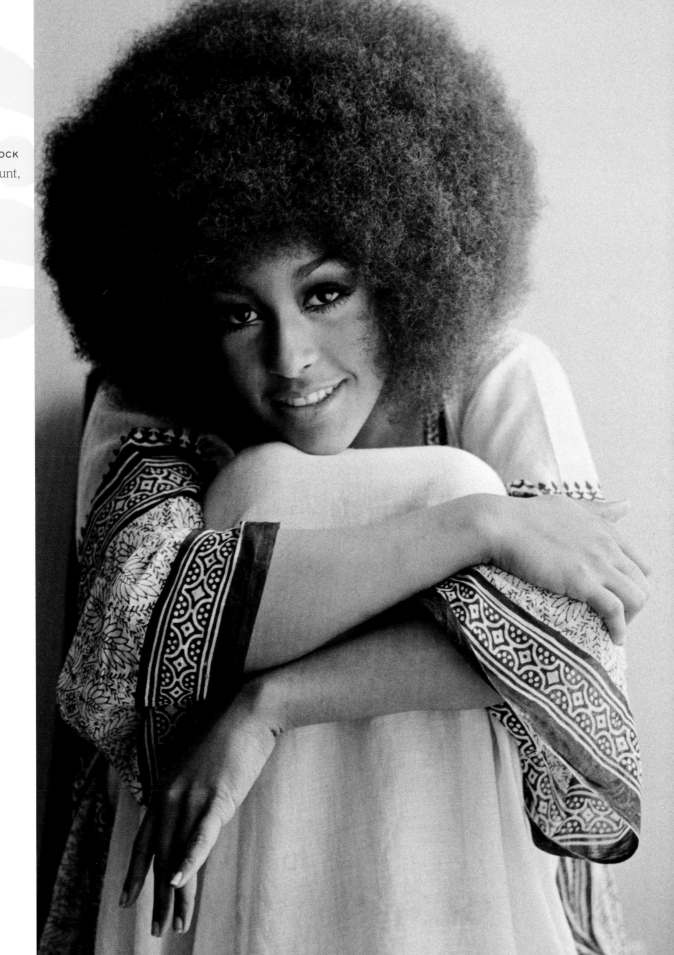

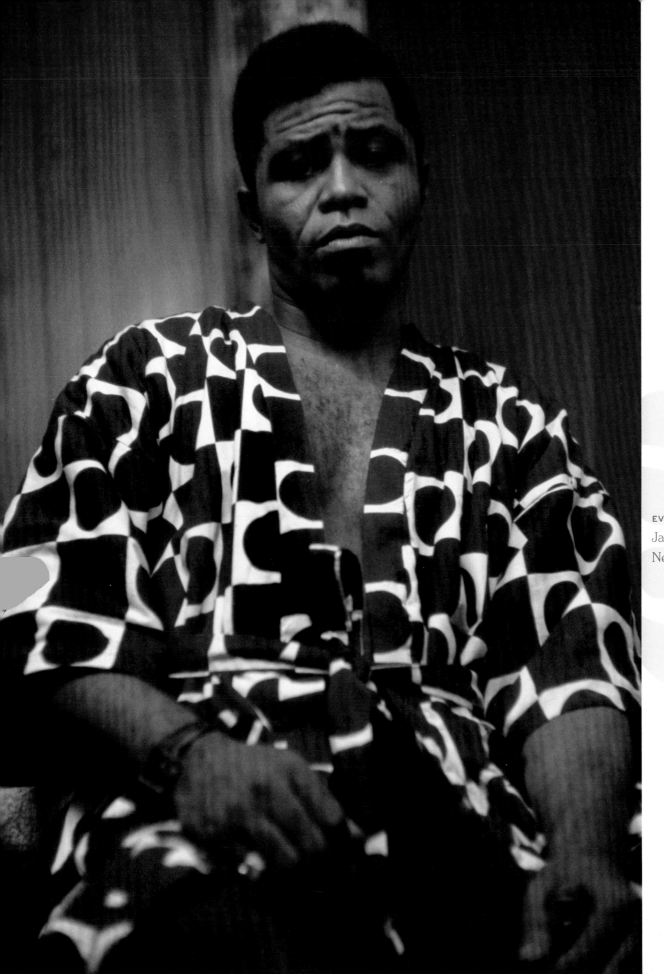

EVE ARNOLD
James Brown,
New York, 1968.

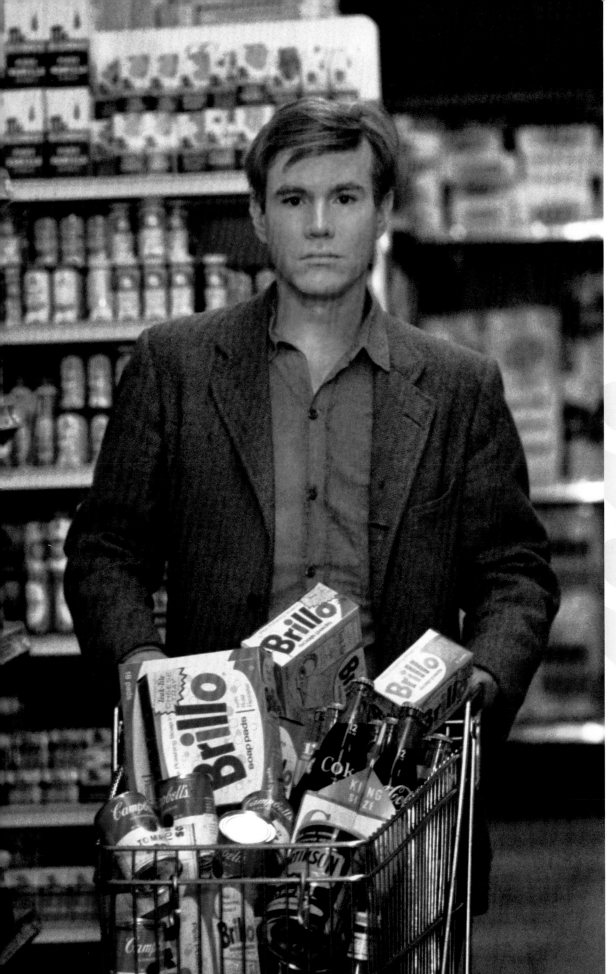

141

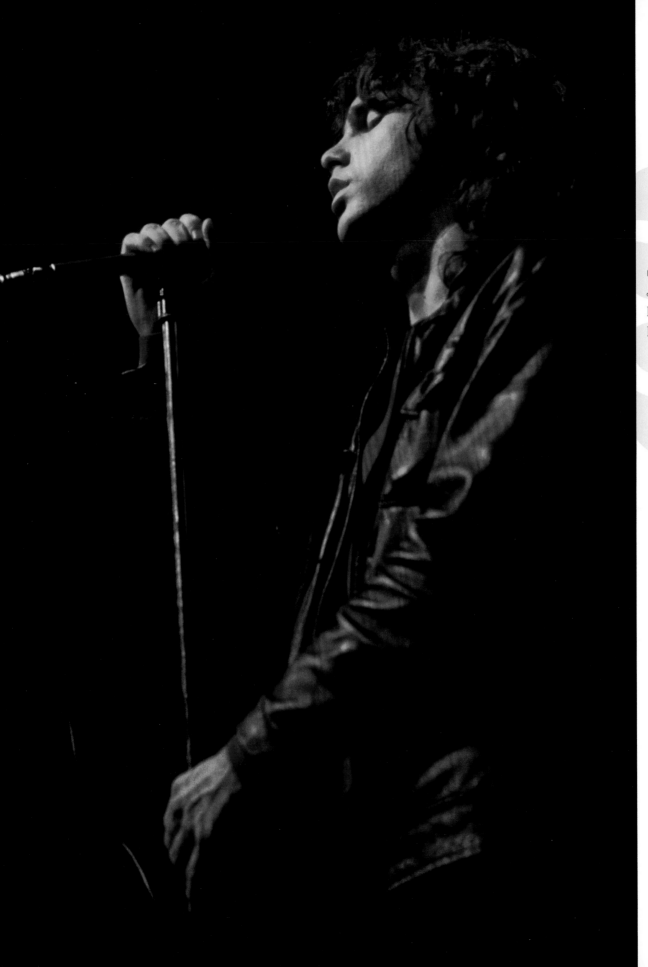

ELLIOTT LANDY
Jim Morrison,
Fillmore East,
New York, 1968.

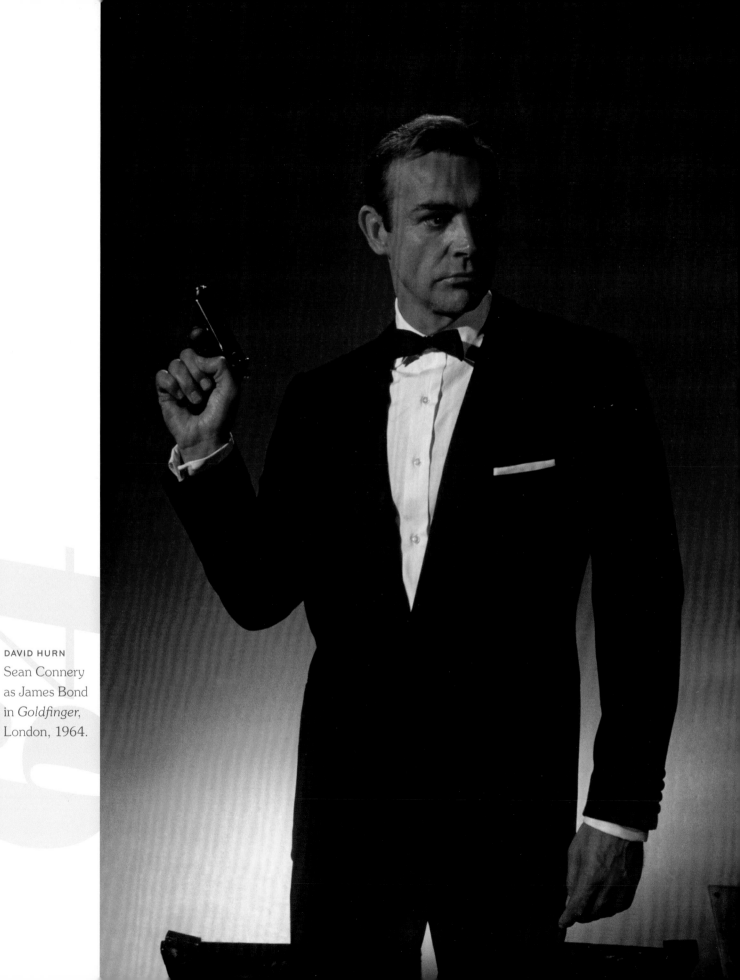

DAVID HURN
Sean Connery
as James Bond
in *Goldfinger*,
London, 1964.

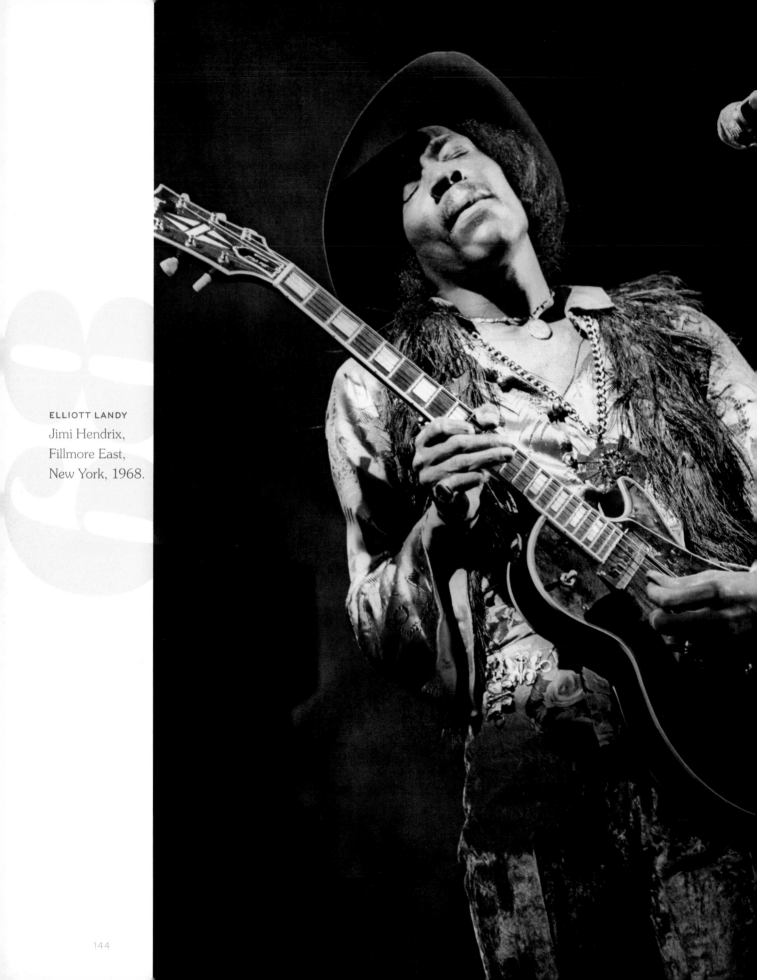

ELLIOTT LANDY
Jimi Hendrix,
Fillmore East,
New York, 1968.

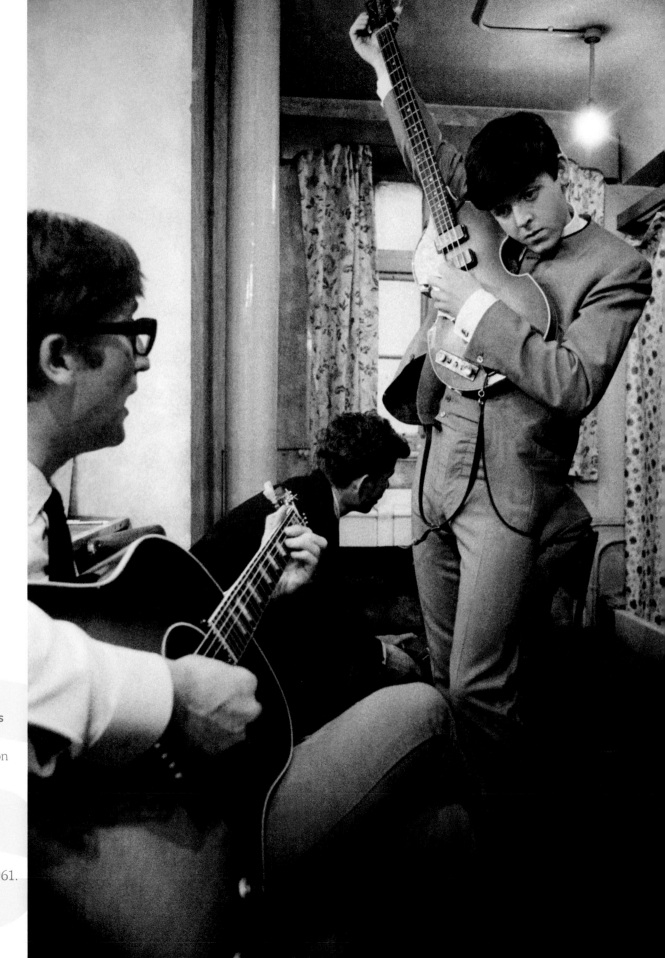

ELLIOTT LANDY

Janis Joplin, Joshua Light
Show, Anderson Theater,
New York, 1968.

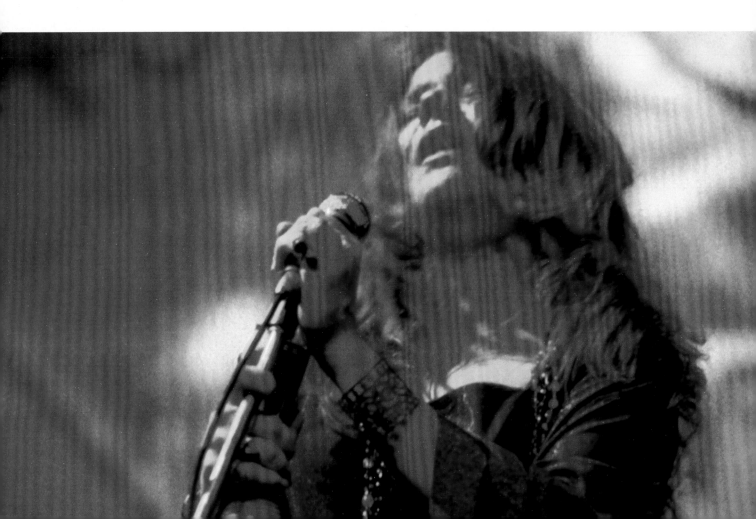

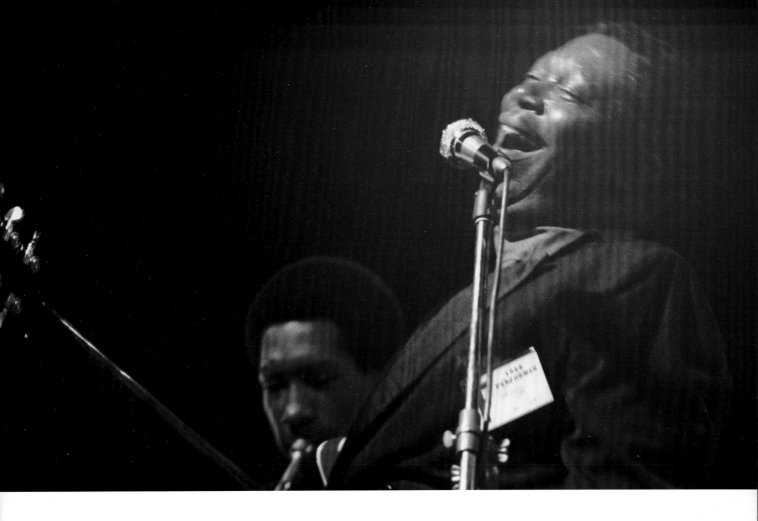

ELLIOTT LANDY
B.B. King, Fillmore East,
New York, 1968.

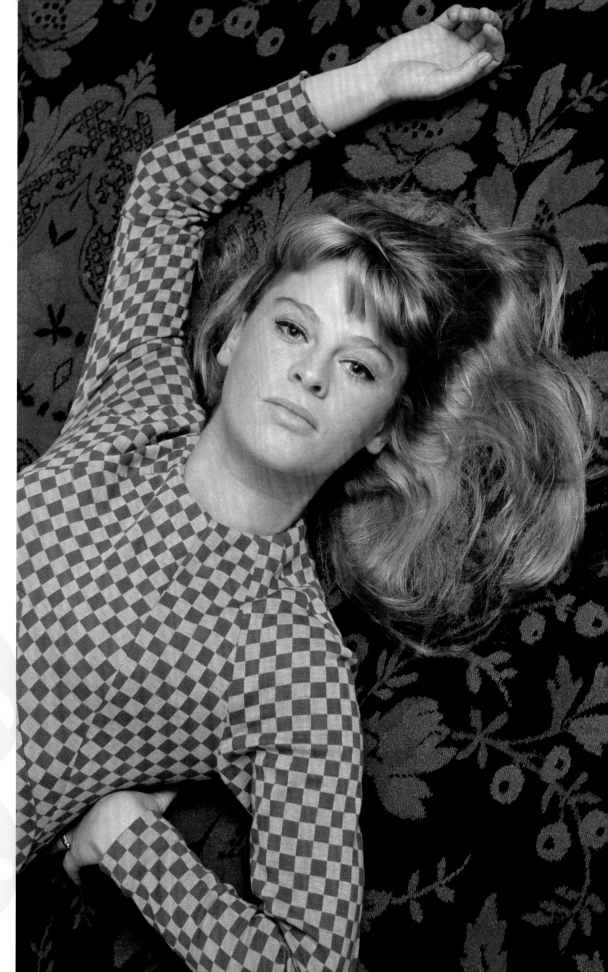

DAVID HURN
Julie Christie in
the film *Darling*,
London, 1965.

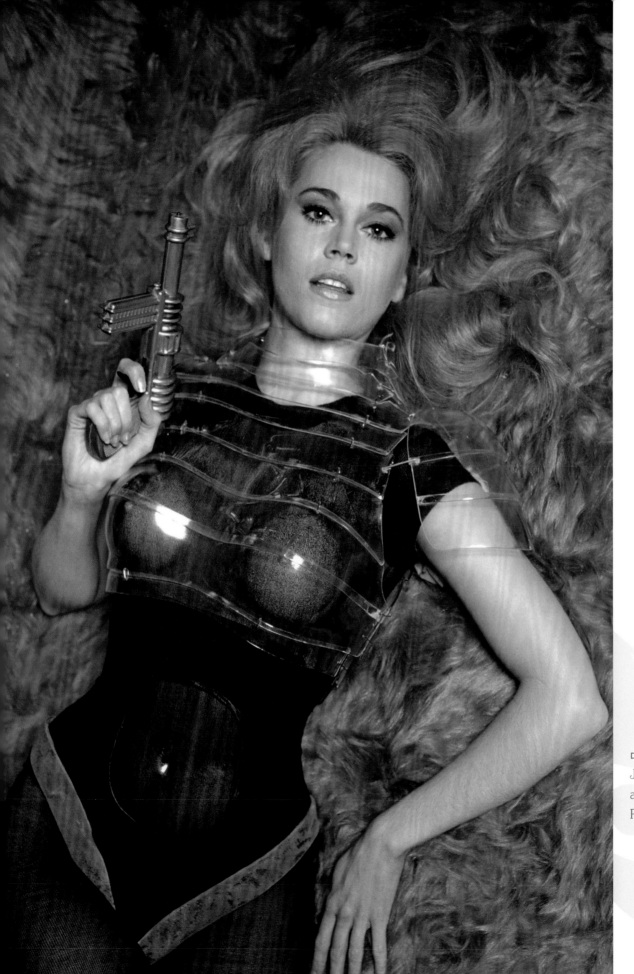

DAVID HURN
Jane Fonda
as Barbarella,
Rome, 1967.

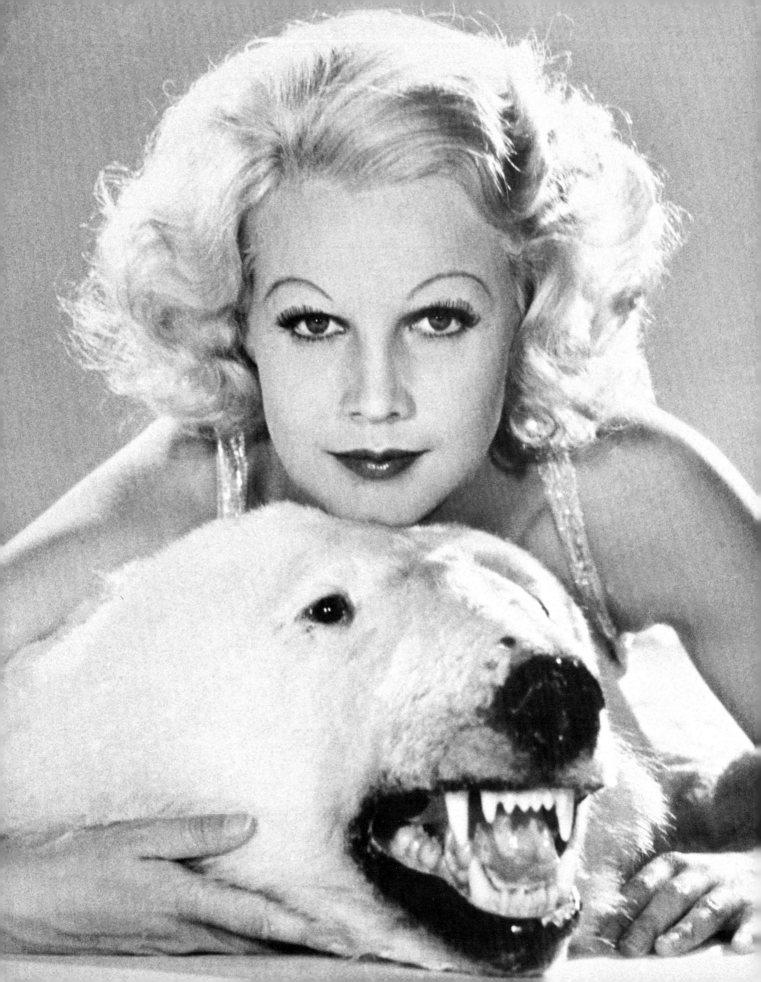

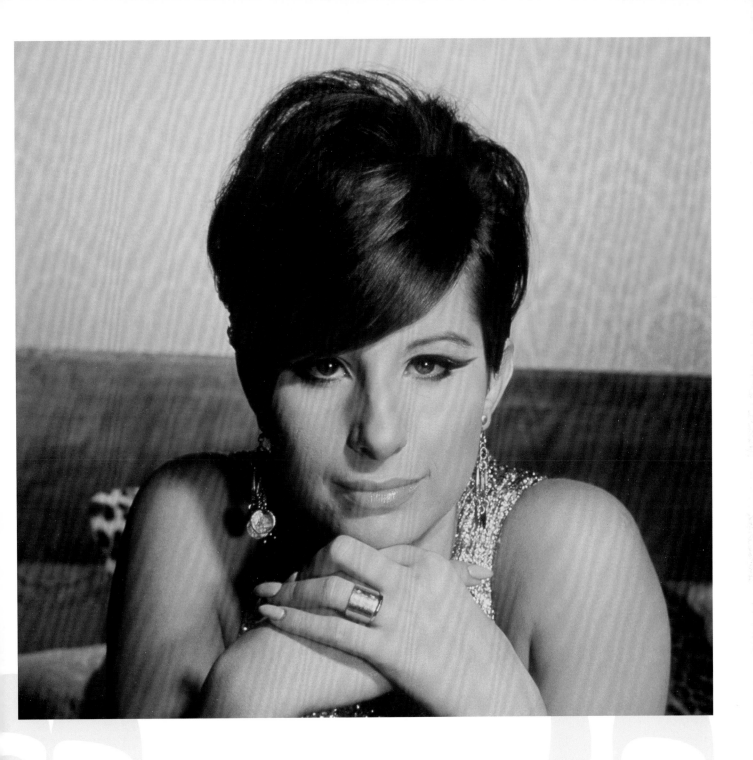

PHILIPPE HALSMAN

Carroll Baker during the filming
of *The Carpetbaggers*, 1963.

PHILIPPE HALSMAN

Barbra Streisand posing at home
for *Cosmopolitan*, New York, 1965.

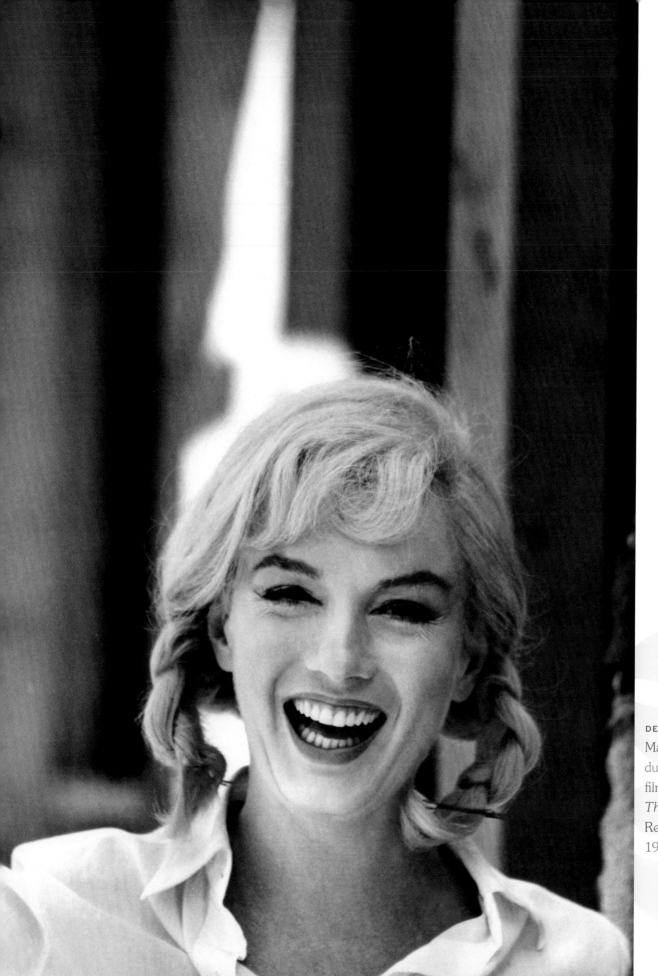

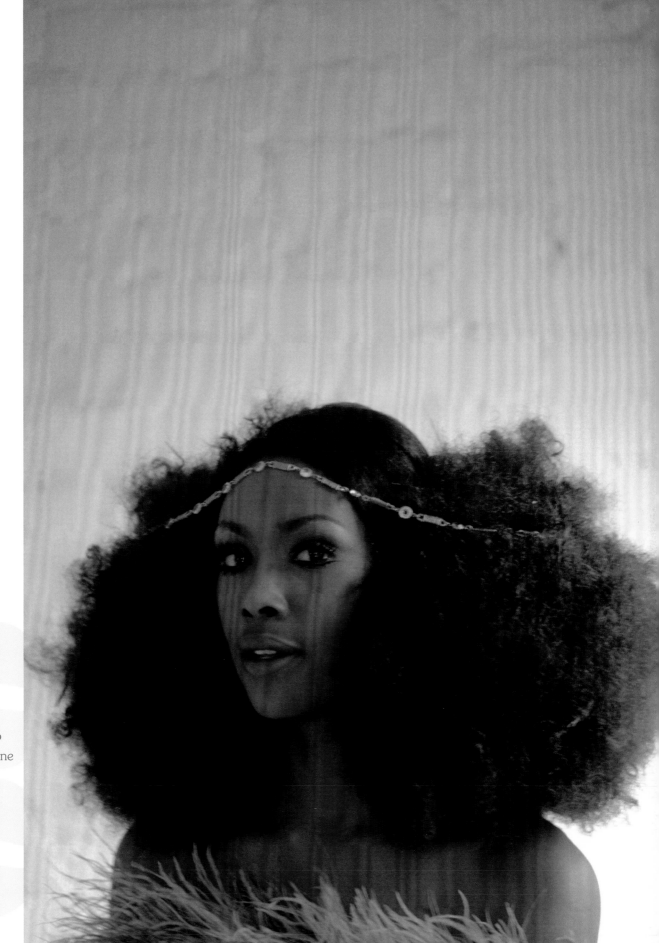

EVE ARNOLD
Model Arlene
Hawkins,
New York,
1968.

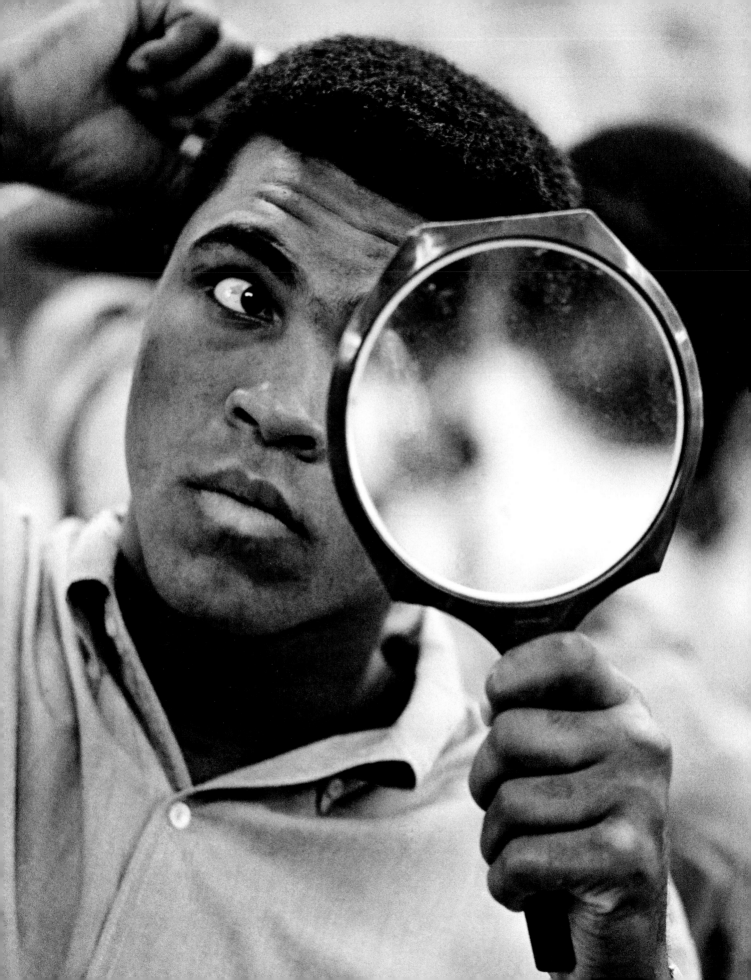

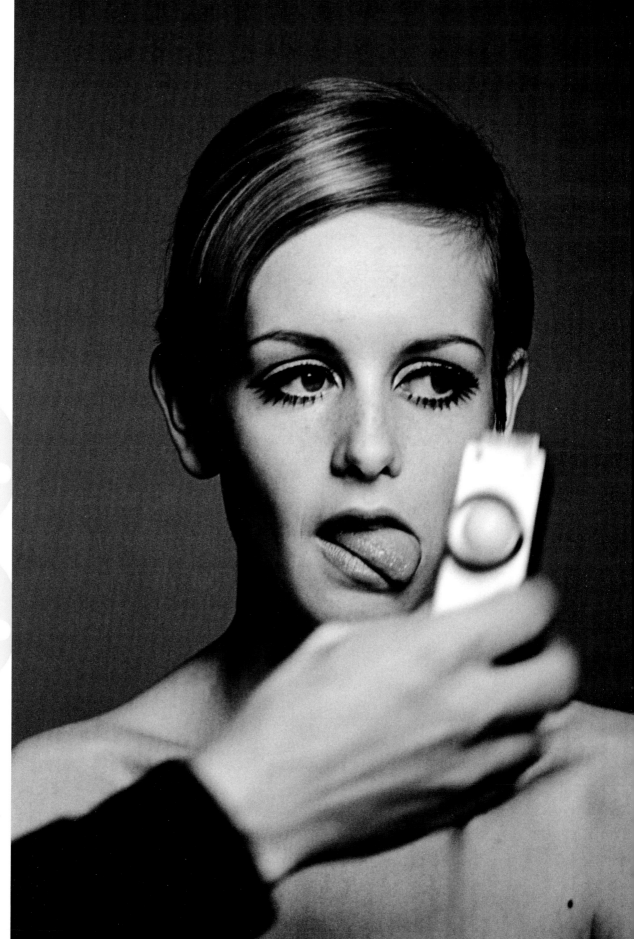

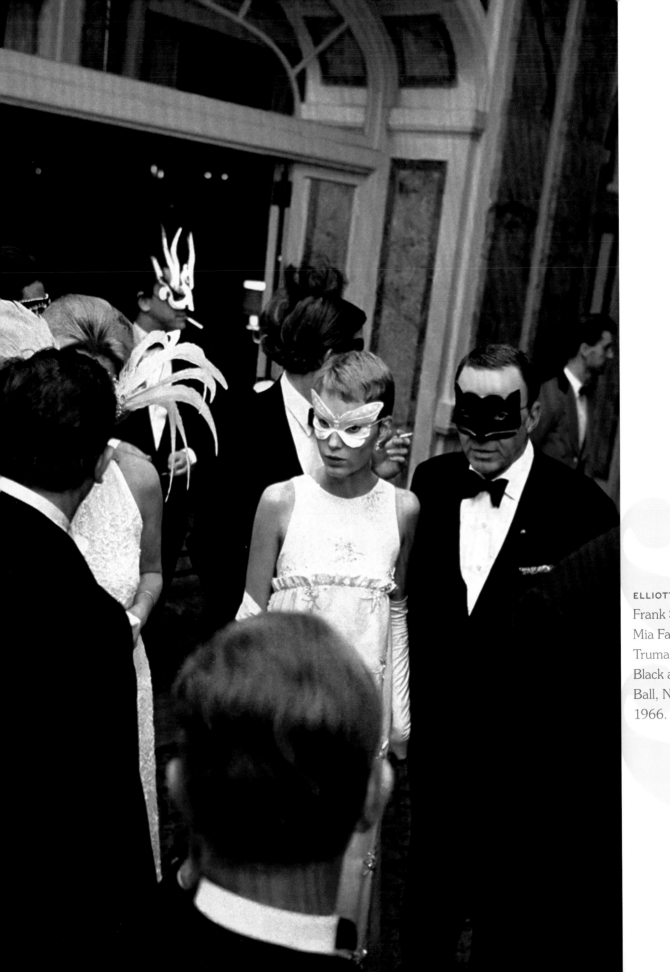

ELLIOTT ERWITT
Frank Sinatra and Mia Farrow at Truman Capote's Black and White Ball, New York, 1966.

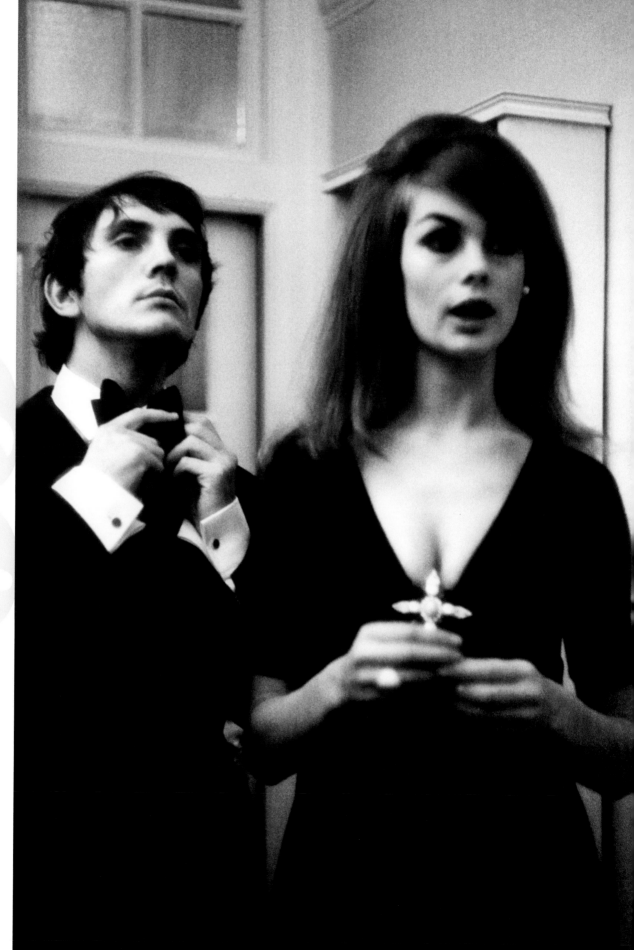

EVE ARNOLD
Terence Stamp
and Jean
Shrimpton
dress up for
the opening
night of
Modesty Blaise,
London, 1965.

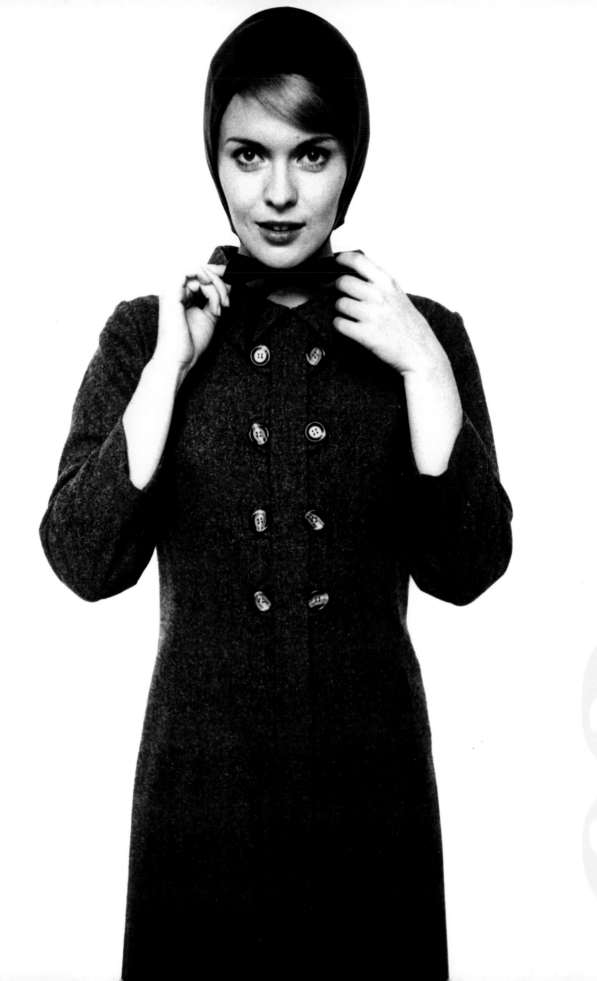

DAVID HURN
Jean Seberg,
1963.

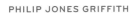

PHILIP JONES GRIFFITH

Paul McCartney and John Lennon on stage
during the Beatles' early years, England, 1961.

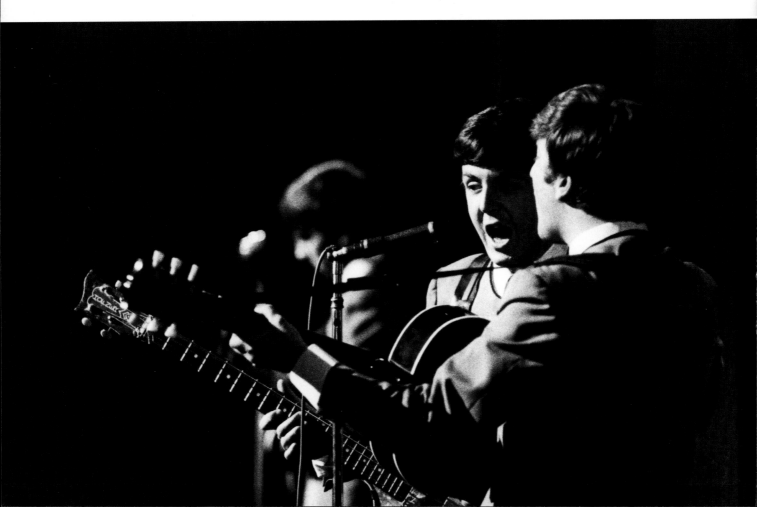

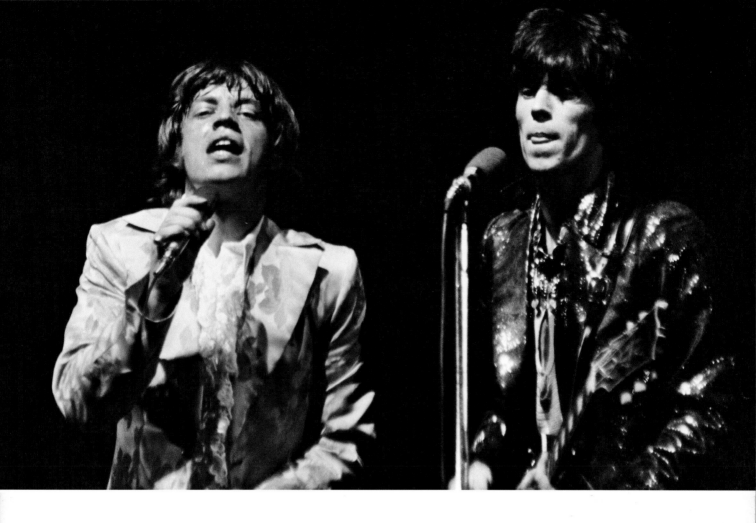

GUY LE QUERREC

Mick Jagger and Keith Richards
at the Olympia, Paris, 1967.

DENNIS STOCK

Venice Beach Rock Festival,
California, 1968.

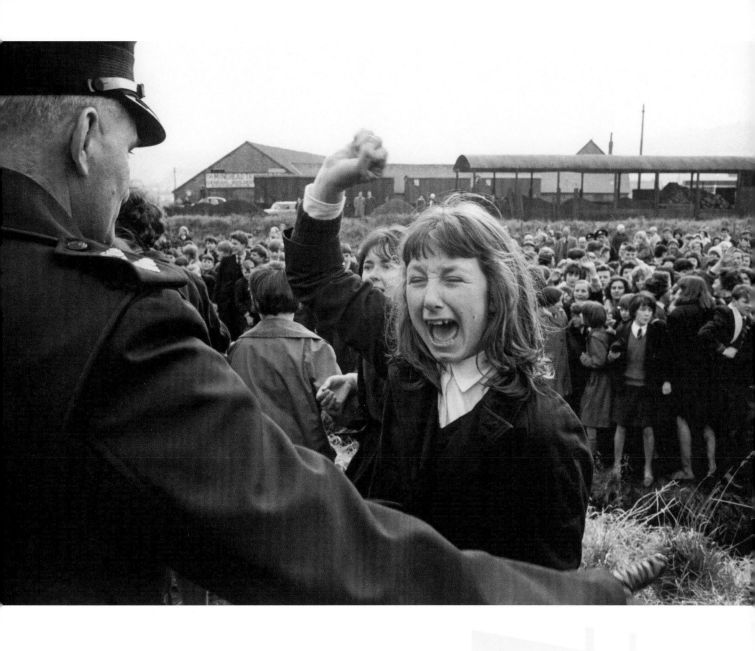

DAVID HURN

Police restrain fans who line the
railway bank in the hopes of seeing
the Beatles as their train passes
through, during the filming of
A Hard Day's Night, London, 1964.

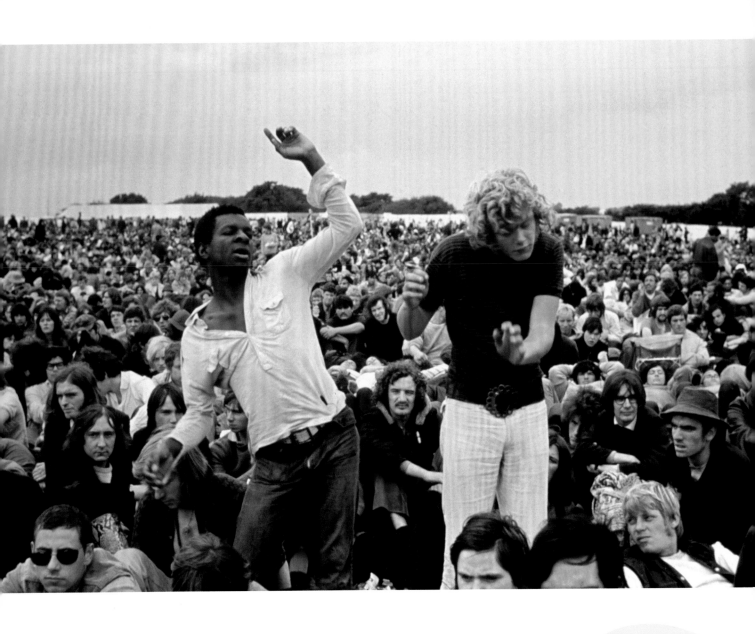

DAVID HURN
Isle of Wight Festival,
England, 1969.

JOSEF KOUDELKA
Music Festival,
England, 1969.

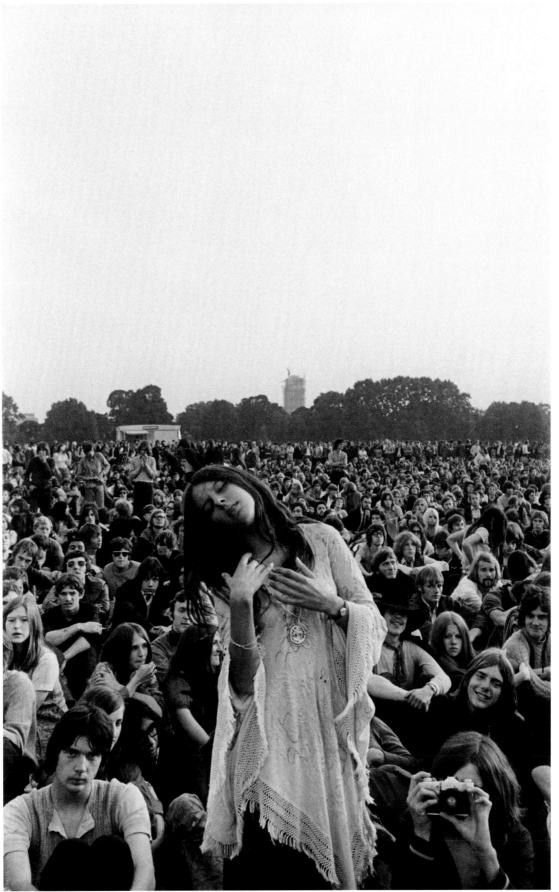

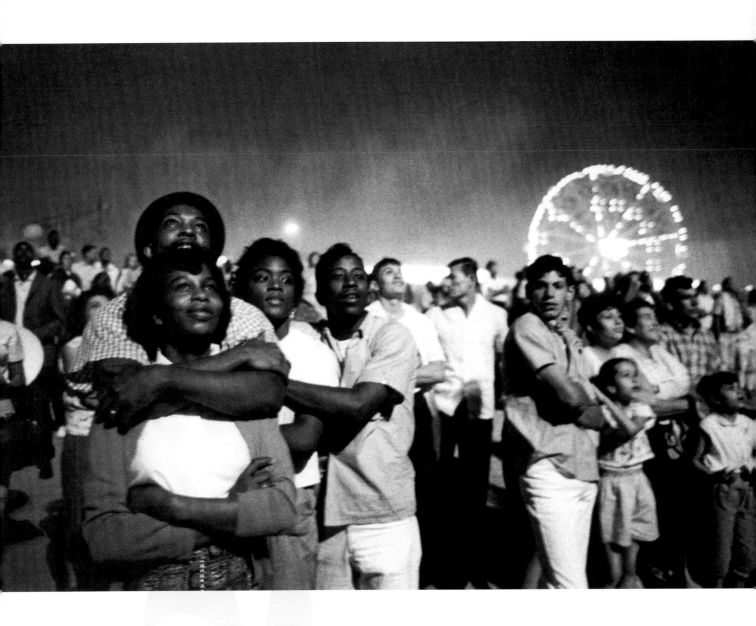

BRUCE DAVIDSON

Coney Island, New York, 1962.

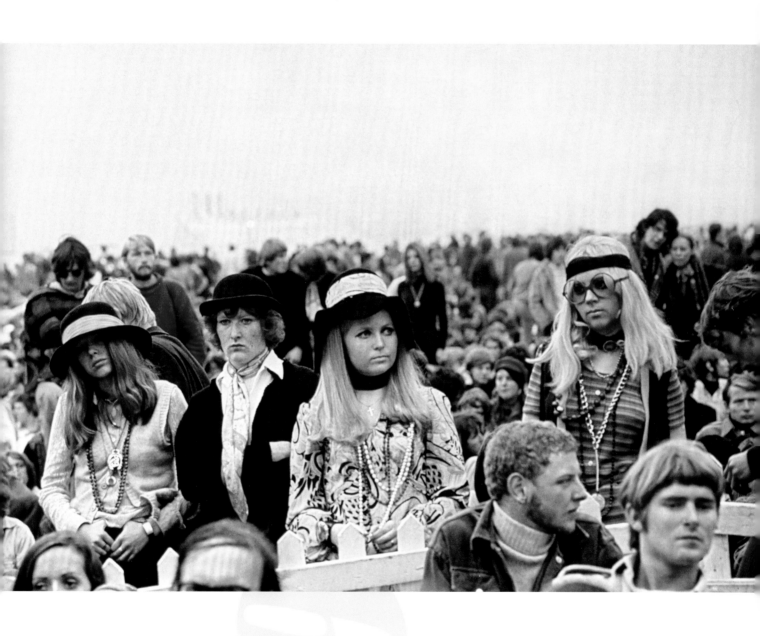

Fans at the Isle of Wight Festival,
England, 1969.

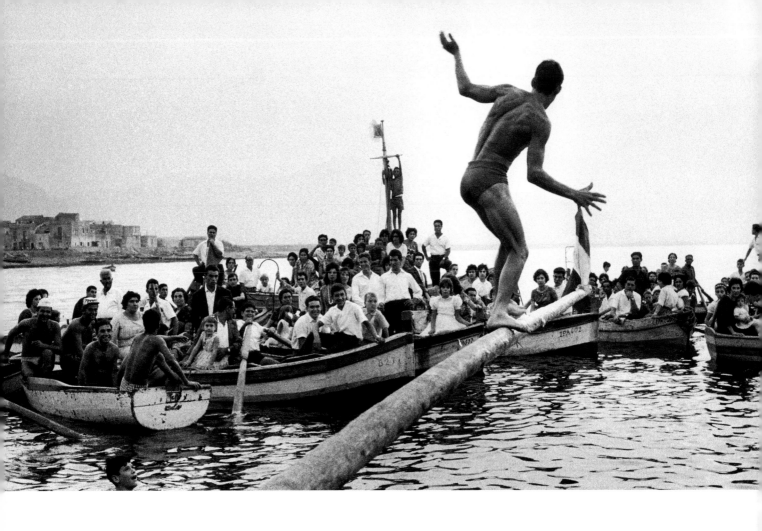

FERDINANDO SCIANNA

Sicily, Italy, 1964.

LEONARD FREED
Divers on the banks of
a canal near Dortmund,
Germany, 1965.

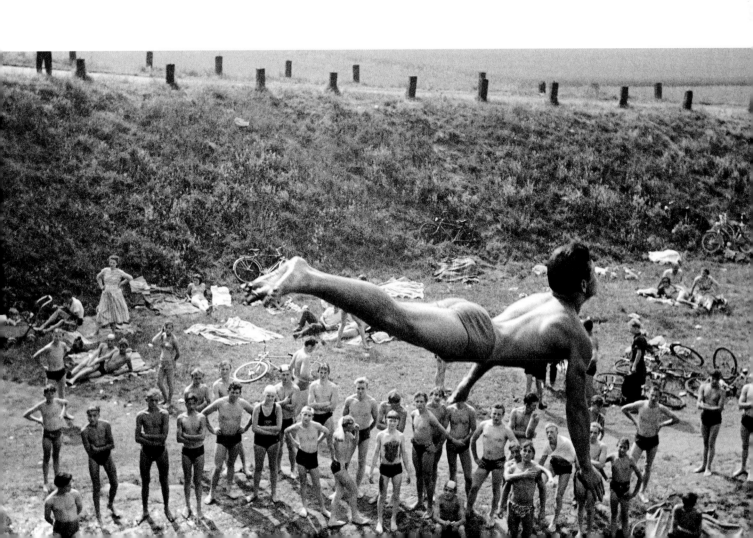

Robert Kennedy with one
of his children, Hyannis Port,
Massachusetts, 1967.

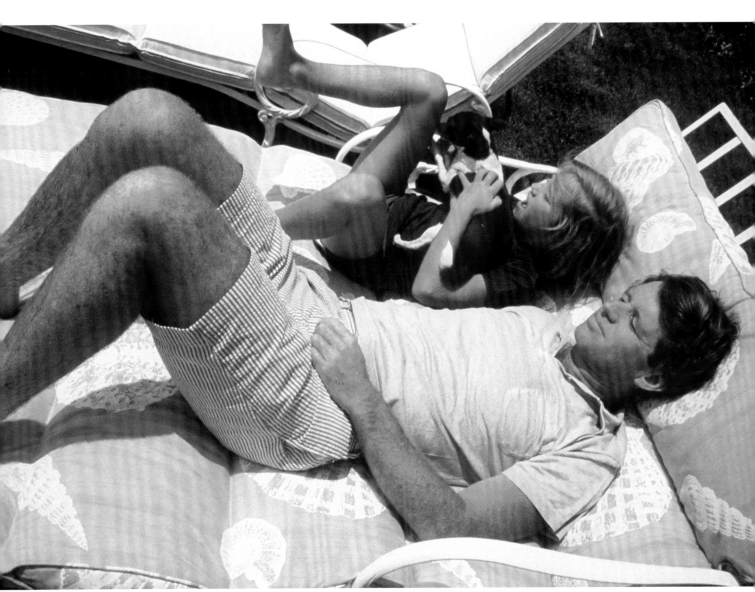

BURT GLINN

Four sunbathers on leopard-
skin-printed rafts, Las Vegas,
Nevada, 1968.

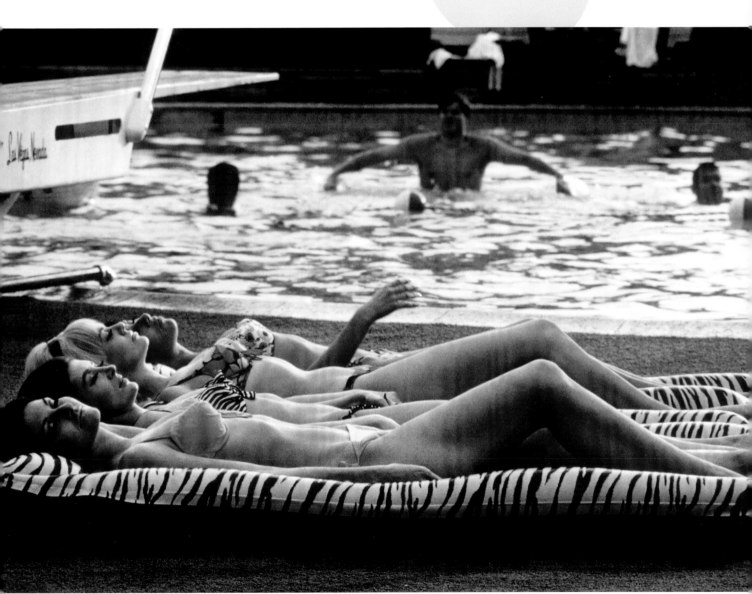

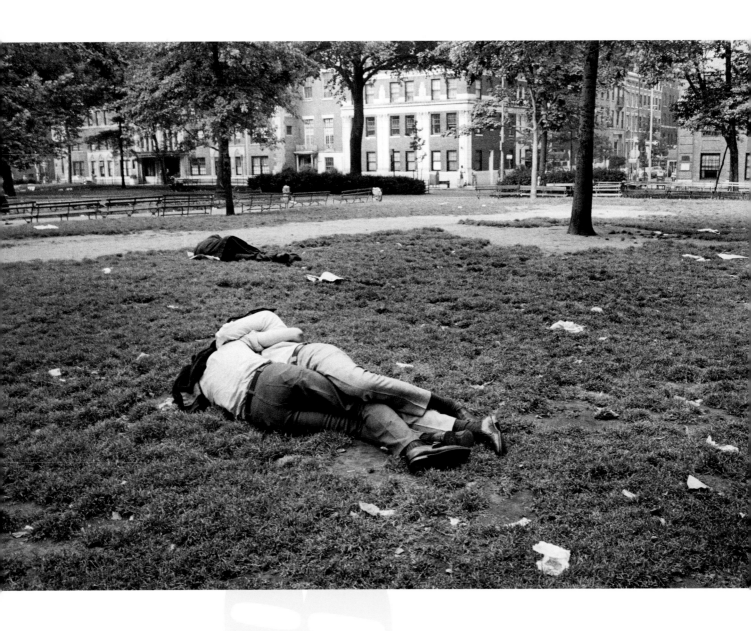

RICHARD KALVAR

Two men entwined, Washington
Square Park, New York, 1968.

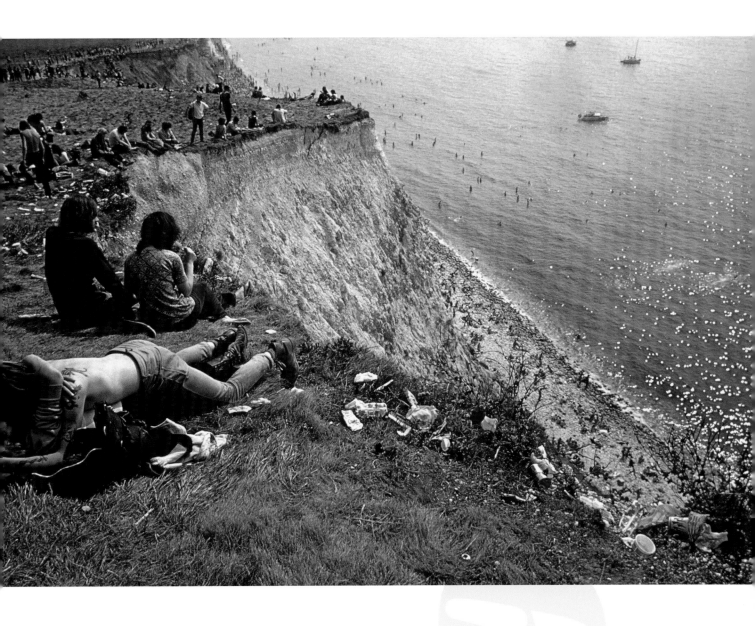

DAVID HURN

A young couple lying on the edge
of a cliff amid the litter, Isle of Wight
Festival, England, 1969.

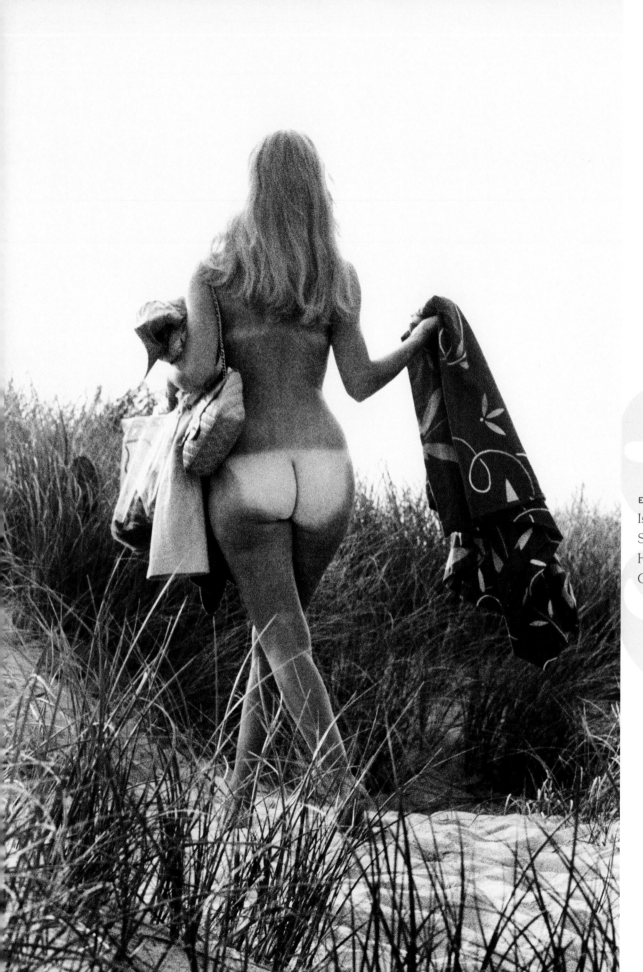

ELLIOTT ERWITT
Island of Sylt,
Schleswig-
Holstein,
Germany, 1968.

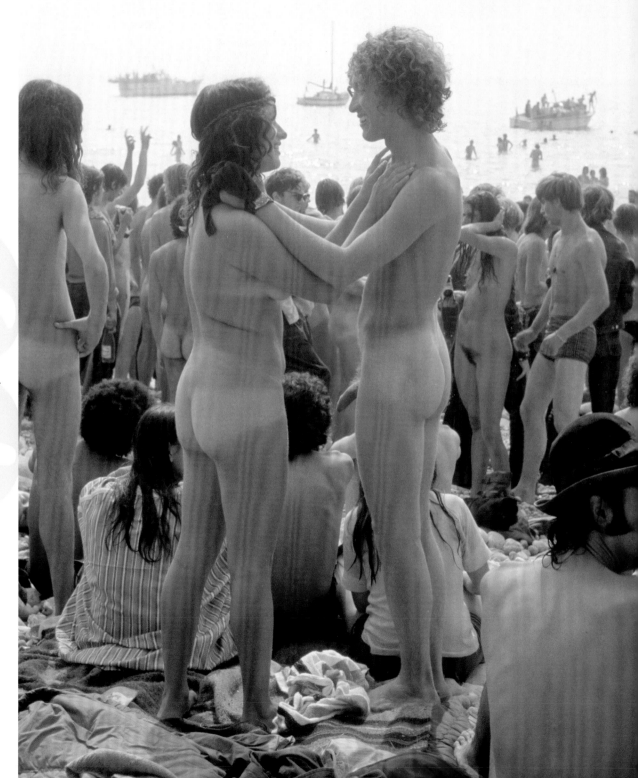

DAVID HURN
Isle of Wight
Festival,
England, 1969.

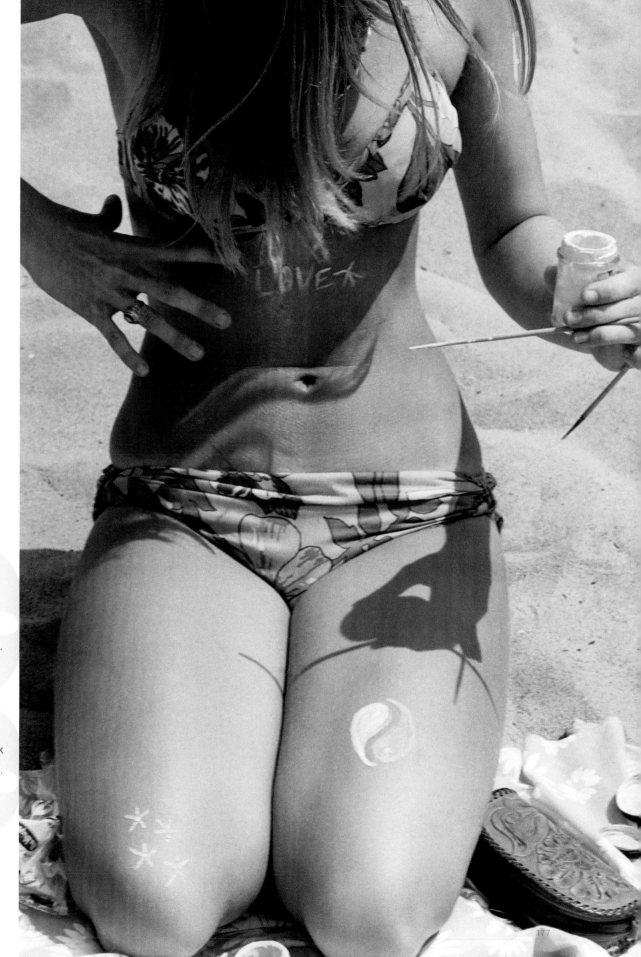

177

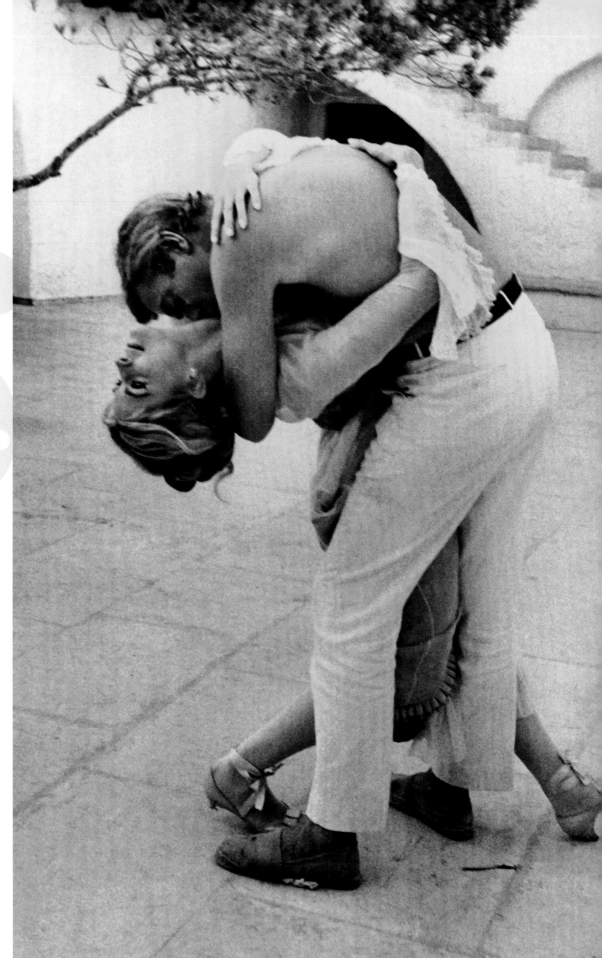

Candice Bergen
and Michael Caine
demonstrate the
final dip in the last
step of the tango
during the filming
of *The Magus*,
Mallorca, Spain,
1967.

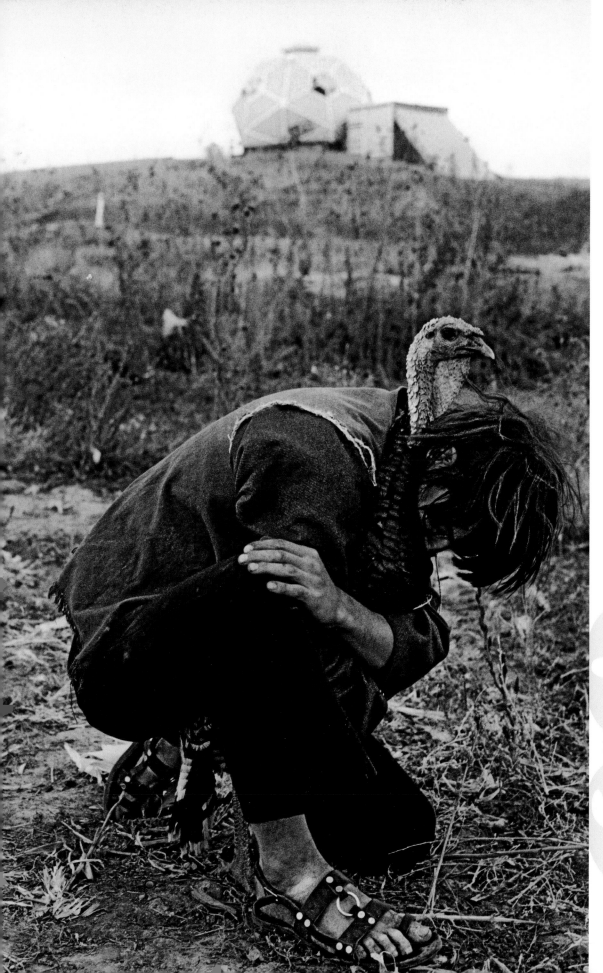

DANNY LYON
Man hugging
a turkey, 1968.

179

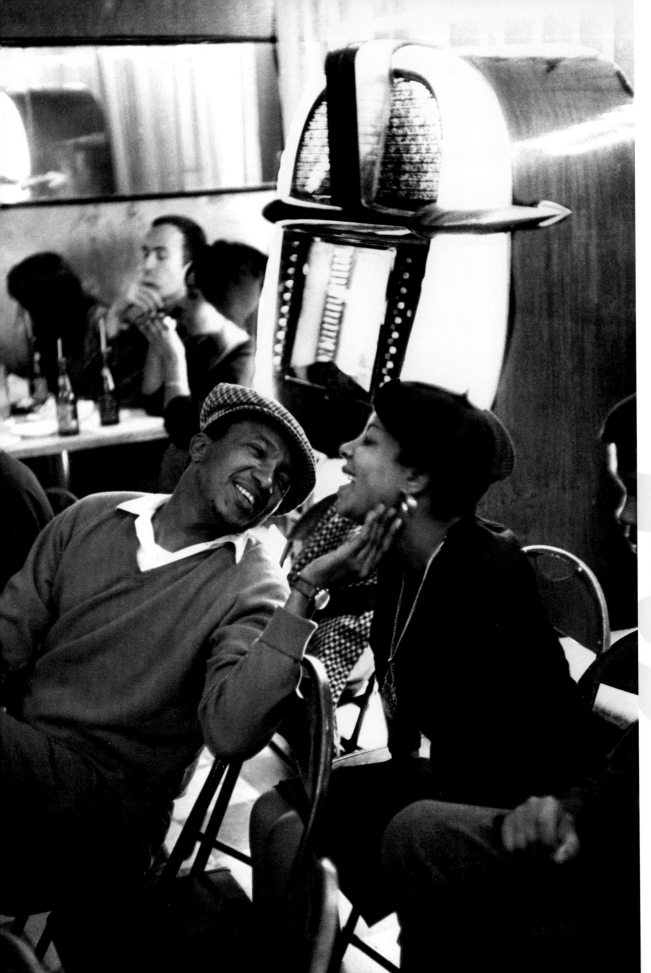

IAN BERRY
Couple
at a café,
Johannesburg,
South Africa,
1961.

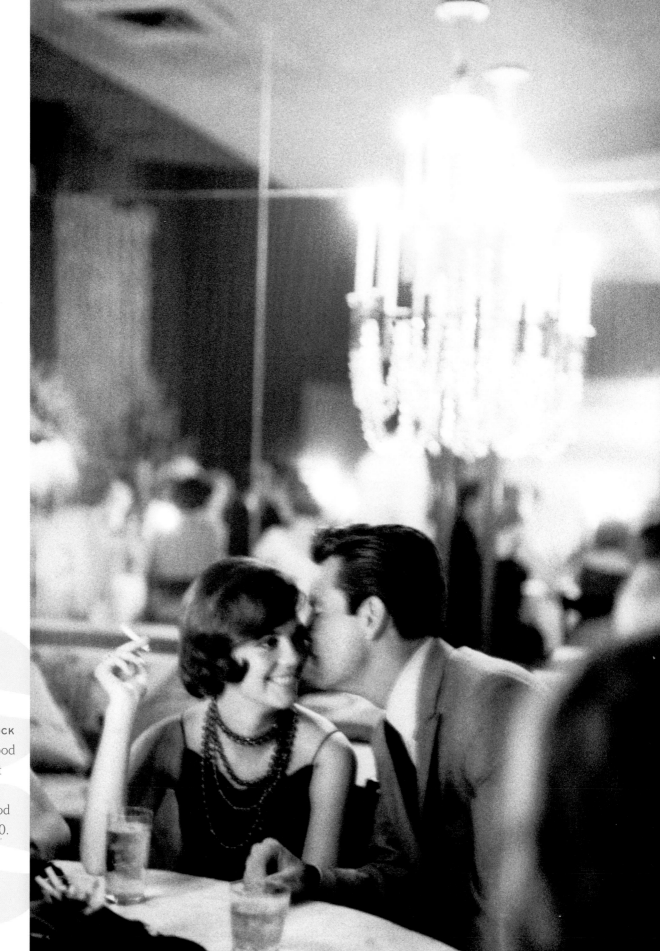

LEONARD FREED
West Berlin, Germany, 1965.

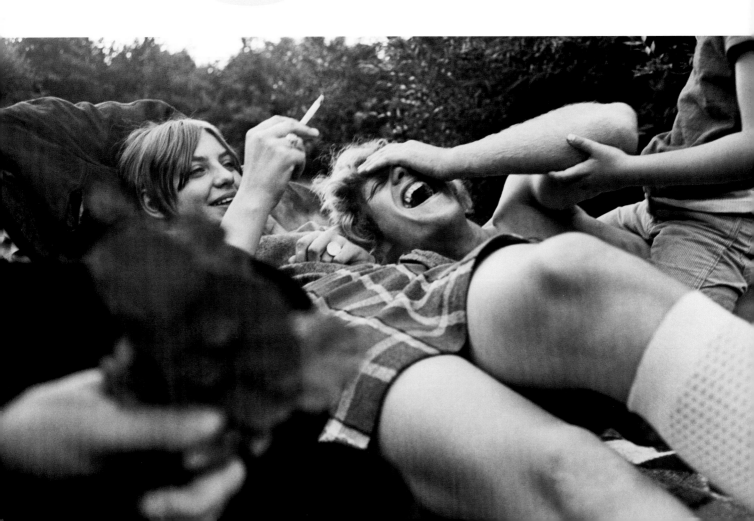

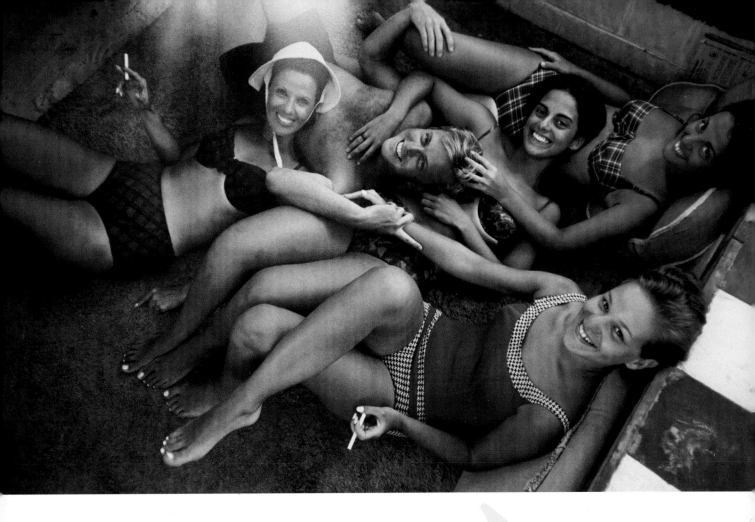

RENÉ BURRI

Fashionable and wealthy youth, known as jeunesse dorée, partying over the weekend, Brazil, 1967.

The '60s are gone, dope will never be as cheap, sex never as free, and the rock and roll never as great.

ABBIE HOFFMAN

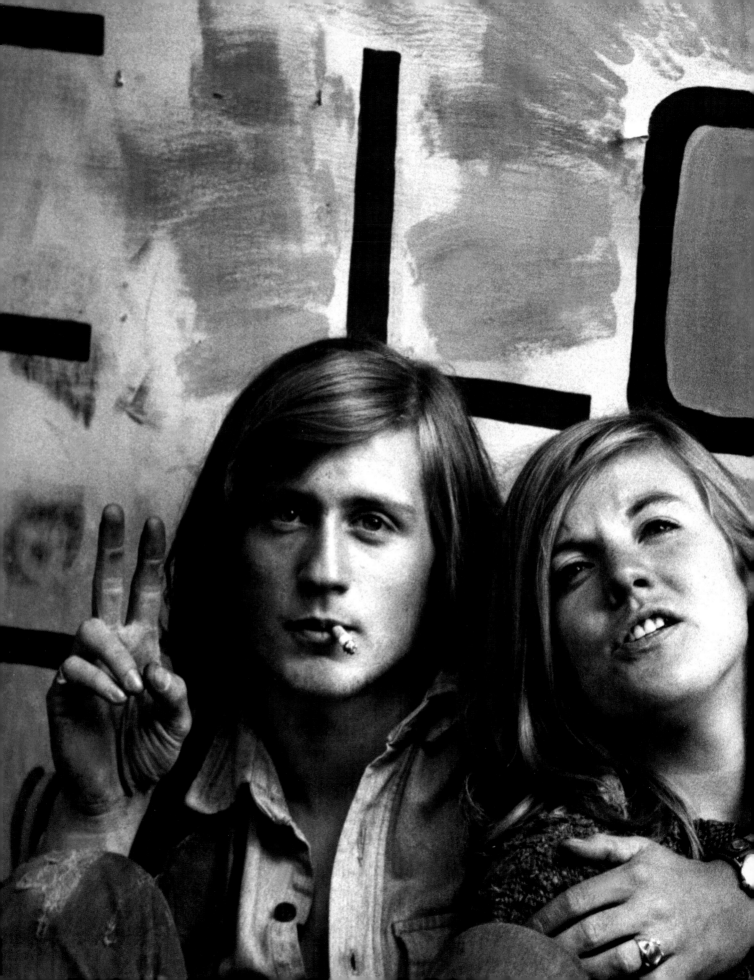

BURT GLINN
Two young protestors
rest outside the
convention hall
during the turbulent
Democratic National
Convention, Chicago,
Illinois, 1968.

Index

Photographers

PROJECT MANAGER: Deborah Aaronson
EDITOR: Laura Tam
DESIGNER: Sarah Gifford
PRODUCTION MANAGER: Jules Thomson

Library of Congress Cataloging-in-Publication Data

Pop 60s / introduction by Anthony DeCurtis; Magnum Photos.
 p. cm.
ISBN: 978-0-8109-9526-0
1. Documentary photography. 2. Nineteen sixties—Pictorial works.
3. Portrait photography. I. DeCurtis, Anthony. II. Magnum Photos,
inc. III. Title: Pop sixties.

TR820.5.P67 2008
779'.997392—dc22

 2008018661

Printed and bound in China
10 9 8 7 6 5 4 3 2 1

Abrams books are available at special discounts when purchased in quantity for premiums
and promotions as well as fundraising or educational use. Special editions can also be created
to specification. For details, contact specialmarkets@hnabooks.com or the address below.

HNA
harry n. abrams, inc.
a subsidiary of La Martinière Groupe
115 West 18th Street
New York, NY 10011
www.hnabooks.com

Page 2:
EVE ARNOLD
Marilyn Monroe,
1960.